shooting
stars

To
JORDAN.

Best wishes

Robert.

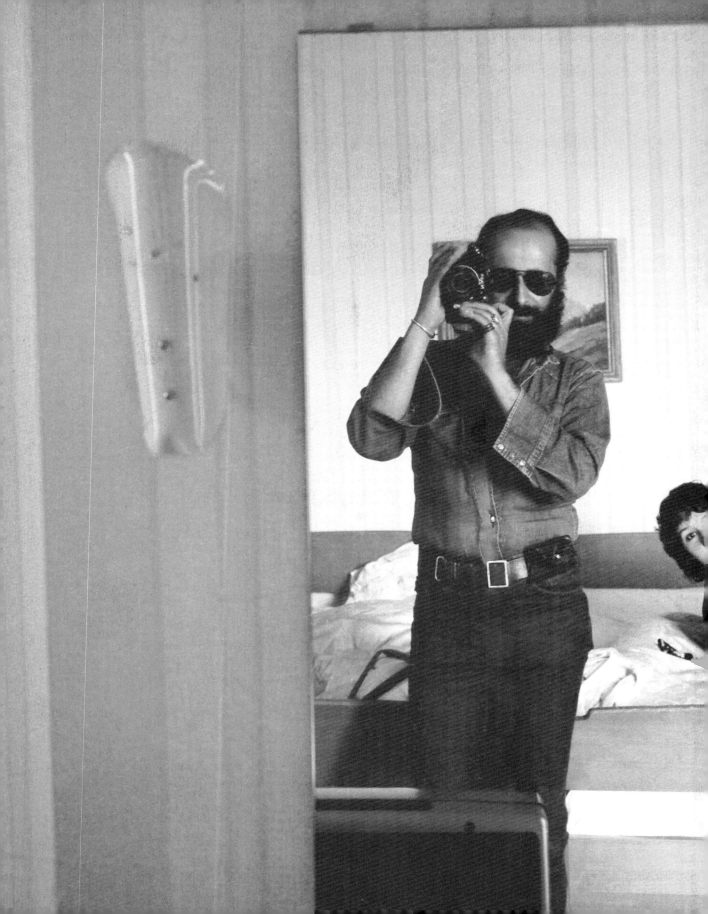

richard young
shooting
stars

metro

Published by Metro Publishing Ltd,
3 Bramber Court, 2 Bramber Road,
London W14 9PB, England

www.blake.co.uk

First published in hardback in 2004

ISBN 1 84358 096 9

British Library Cataloguing-in-Publication Data:

A catalogue record for this book is available from
the British Library.

Design by www.envydesign.co.uk

Printed in Spain by Bookprint

1 3 5 7 9 10 8 6 4 2

Text copyright Richard and Susan Young

All pictures © Richard Young Photographic Ltd

Visit www.richardyoungonline.com

Papers used by Metro Publishing are natural, recyclable
products made from wood grown in sustainable forests.
The manufacturing processes conform to the environmental
regulations of the country of origin.

To my beautiful family
Susan, Dan, Sam and Hannah

acknowledgements

WHEN I FIRST DECIDED THAT I WANTED TO BE A PHOTOGRAPHER, I was very relieved to have finally found a direction in my life and, more importantly, something that I really enjoyed doing. I could easily have gone back into the menswear business – or have been led astray – but luck and fate were to take me by the hand. I still sometimes have to pinch myself in disbelief that I, a young, uneducated lad from Hackney, was able to enter this extraordinary, glamorous life of showbusiness and celebrity. Every morning when I wake up I feel so fortunate to know that I am doing a job I love, and that feeling has not diminished at all over the last thirty years. I have had the privilege of working with so many fantastically talented and interesting people over the years, from the world of theatre, film, music, sports and the arts, as well as politicians, world leaders and spiritual leaders. Without them I would not have a job. Roll on the next thirty years.

Of course, I am ambitious. I have always wanted to be at the top of my profession, and the only way to achieve that has been with a lot of hard work and determination. But nothing I do would be possible without the love and support of those around me who continue to have faith in me, and I want to thank them for being there. Firstly, big thanks to Jeffrey Kwinter for putting a camera in my hand in the first place; you opened up a new world for me, and I have never looked back.

To Dave Benett, my partner in crime, thank you for putting up with me and being such a loyal friend; and thanks too to all the other photographers I have worked with over the years throughout the world. To the whole team at Rex Features, the best syndication agency in the world, to Nikon for making the most incredible cameras, and to Gray of Grays of Westminster for his continued enthusiastic support. To everyone at Vanity Fair, particularly Graydon Carter and Sarah Marks for holding some of the best parties I have ever been to. To *Ritz* magazine, Bailey and David Litchfield who opened up many doors for me in the early days, to The Hospital for creating such a wonderful exhibition, and huge thanks to Mission-Media for your creativity and energy. Dylan Jones at *GQ* – you've been a great support. Big thanks to Flash Photodigital. To my PA Linda Deverell, whose good energy, patience and sense of humour even at the most stressful times have been vital in the making of this book; I could not have done this book without you – you're the best. To the wonderful Pilar for looking after us all so well. To my mum and dad, and to my sisters Rochelle and Karen. A big thanks, of course, to John Blake for taking me on; and to all the PRs, picture editors, restaurateurs, security guys, doormen and club owners too numerous to mention.

Most of all I would like to thank my wife Susan for your endless support and love since we met. I could not have done it without you. And my heartfelt thanks go to my three children, Dan, Sam and Hannah, for putting up with an absent father over the years. Thank God you have all grown up to be decent, caring, kind, honourable and hard-working people; I am very proud of you all. And last but not least, to Riitta, who remains in our hearts always.

Richard Young
London, June 2004

a tribute from

phil collins

WHEN I FIRST CAME INTO CONTACT with Richard, he was a very naughty boy, trying to take photos of me when I really didn't want him to!

Then like a frog to a prince, a transformation happened. He seemingly suddenly became the really nice, polite conscientious man that he is today. He is indeed a friend. It is he who I call if I want something special done. I trust him, I like him and he takes great photographs.

Congratulations, Richard!

'Richard Young always gets the shot he wants, not
by pushing or shoving or hanging off trees and lampposts
but by knowing the shot he wants and being
gracious about getting it.'

DAVE STEWART

Foreword by

James Herbert

SOME YEARS AGO I WAS ABOUT TO EMBARK on a new novel, a horror story called *Creed*, and I'd decided its main protagonist would be the antithesis of the conventional mainstream hero. My guy would be, to quote the manuscript itself, 'a sleaze of the First Order'. He would be cowardly, sly and shallow. He'd also be a cheat, a liar, and only interested in making a fast buck. Did I mention devious, too?

This sounded good to me – interesting, fun to write about – but what kind of debased occupation would such a dubious character have? It came to me in a flash: I'd make my anti-hero a paparazzo. All those vices mentioned seemed to go with the territory.

Inspired, I got in touch with Richard Young; it was 1989 and he was surely this country's most famous paparazzo photographer and he kindly allowed me to accompany him on a typical working day and night. I followed him around from newspaper offices to photographic syndicates and film processors, from the Old Vic to the fashionable San Lorenzo, and later on from art gallery opening nights to more chic restaurants, from celebrity-crowded social events to the trendiest of nightclubs. It was a pretty lively experience.

However, what struck me was how warmly Richard was greeted at each venue and the respect he received from everybody he met – restaurateurs, newsmen, chauffeurs, doormen, minders, and even the celebs he photographed. All seemed to know him. For

myself, I found Richard Young to be generous with his time, informative and very cool.

He was a good man, a friendly man who totally destroyed my perception of the paparazzo I had in mind for my story. (In the end my anti-hero had to be pure invention.) Not only that, the day with him radically changed my misconceived view of the paparazzi in general – they turned out to be a good bunch, tenacious and dry-witted, as well as ever patient.

I also discovered Richard is good company and has a wry sense of humour. Most of all, though, he's a superb photographer – as this book of his work affirms. Most of his shots are beautifully composed even if taken hurriedly, and he has a sharp instinct for the precise moment to shoot. In my view, and speaking as an ex-art director, many of his photographs are pure works of art.

But one incident that occurred during my nighttime odyssey with Richard still makes me chuckle. We were outside Langan's Brasserie (incidentally, Richard Young and just a few of his fellow lensmen are respected enough to be allowed inside many venues while most of the others are barred) waiting for that unique shot of Jack Nicholson leaving with his then lover Angelica Huston. Unfortunately, another diner, who obviously thought himself more important than he actually was, stepped outside first to be confronted by the adrenaline-charged scrum of photographers. This unfortunate person made the grave mistake of shoving Richard aside.

In sheer reaction, Richard immediately retaliated by giving the aggressor a hefty kick in his self-important butt, which sent him nicely and meekly on his way. That was the steely side of Richard Young, the man not to mess with.

One last thing about my friend. Often I bump into Richard doing his job at film premières or other celeb-full occasions and he always takes the trouble to photograph me just to make me feel important even though we both know his picture editor will never use it.

Richard Young, you see, is a perfect gentlemen.

paul getty jr

siena

IN 1974 I RETURNED TO LONDON having spent four years living in New York. Although I had spent some time travelling across America on a Greyhound bus, I spent most of my time in New York. I missed London and wanted to come back home.

After I arrived back in London, I started working for Jeffrey Kwinter at his bookshop in Regent Street. Sometimes Jeffrey would send me off on various missions to photograph authors who were of interest to him. He loaned me a camera, a Nikon F Photomic FTN, and I taught myself how to use it by wandering around London photographing things that interested me. I would ask anyone in processing labs or camera shops for tips on how to improve my skills.

In June I moved into a first-floor flat on Stonleigh Street, Holland Park. I was still working in the bookshop, tinkering about with the camera and making videos – Jeffrey would interview authors, and I would film them. In the evenings I would meet up with friends at Julie's wine bar; that's where I met a bunch of Americans who, as it turned out, only lived a few doors from me. Craig Copetas was living in London and making a living as a writer for *Rolling Stone* magazine. I started hanging out with him and he used to invite me to dinner parties at his house. There were always interesting people there: writers, artists and lots of pretty girls.

Craig and I became firm friends. On one occasion he came knocking on my door and invited me to have lunch with him at the Hard Rock Café. Craig had just got back from interviewing Paul Getty Jr and his fiancée Martine in Rome, and that was whom we were going to have lunch with. He told me to bring my camera.

Paul had been kidnapped in 1973 and only released after an agonising captivity in which his right ear was cut off in order to force the Getty family to pay the ransom. I had no idea who he was, and I knew nothing about his kidnapping. I was into my music, books and eastern philosophy – I didn't actually know what was going on in the real world. On the way Craig told me who Paul was and explained the story. Before lunch we took a stroll through Hyde Park and I took some photos of Paul and Martine by the Serpentine. We had lunch together and, later on, were joined by an American writer living in St James's: William Burroughs. We had a great time, got on really well and actually ended up hanging out together all weekend.

On Monday Craig suggested that we might be able to sell the picture of Paul and Martine to a newspaper, as there was a lot of interest in them. Off we went to Fleet Street, and the first building we came to housed the *Evening Standard*. We walked in, got introduced to the picture desk and handed over the film. They loved the story and the pictures and I got a cheque for £30. I was absolutely thrilled: it was a lot of money to make in those days.

Some time later, Paul got in touch with Craig and asked if we would like to cover his wedding in Tuscany that summer, so we approached the *Daily Express* and did a deal with the picture editor. We would supply them with exclusive pictures and story of the wedding, and in return the *Express* would give us plane tickets, a hire car and expenses. This was my first real assignment. I was still working in the bookshop and didn't even own a camera yet.

Craig and I flew to Pisa and then drove to Siena in a Fiat Panda – thank God we were both skinny back then, as there is not much room in those cars. We found a small hotel, which was awful, had a bite to eat and settled down for the night. The next morning we drove to the house of Paul's mother Gail to find out that the wedding had happened the night before! Craig and I were in a panic: we knew the paper would be mad if we went back empty-handed. Paul and Martine woke up around lunchtime. We explained to them what had happened and asked them if they would very kindly get back into their wedding clothes and re-enact their wedding. Amazingly they did. We then jumped back into the Panda, raced back to Pisa and managed to get on to the last flight back to London. The following morning at the crack of dawn I delivered my film to the *Express* who told me they already had pictures of the wedding, so what had happened? I told them that whatever they had were rehearsal pictures – mine were the real thing. I got a spread the next day on their News On Camera page. I was over the moon. The seeds of a new life for me were sown. Slowly but surely I started picking up my borrowed camera on a more regular basis, and a photographer was born.

elizabeth taylor and richard burton

the dorchester, london

1
9
7
5

I CONTINUED WORKING WITH JEFFREY at the Village Bookshop in Regent Street for most of 1975. In early February, after a drunken lunch with friends in Julie's wine bar, I wandered off to Holland Park for a walk. I sat down on a wall and a beautiful blonde girl walked past me. I tried to chat her up, but she completely ignored me. I thought nothing more of it, wandered back home, and as I was passing a supermarket on Holland Park Avenue out walked the same girl with a large bag of shopping. I apologised to her about my behaviour earlier in the park and offered her tea and cakes at Julie's, which she accepted. Her name was Riitta and she came from Finland. That was that. We spent the next seven years of our lives together.

For most of that year Riitta and I had nowhere to live, and no money. I was earning a small wage at the bookshop and messing around with the camera, mainly taking photographs of things that interested me personally. Occasionally I would be asked to cover jobs by the *Evening Standard*.

We married in November at Chelsea registry office with only two witnesses, friends with whom we were living at the time. We pooled our money and celebrated with lunch at San Lorenzo, a restaurant that would come to play a large part in my life in the years to come.

That very same week the *Evening Standard* told me about a party that Elizabeth

4

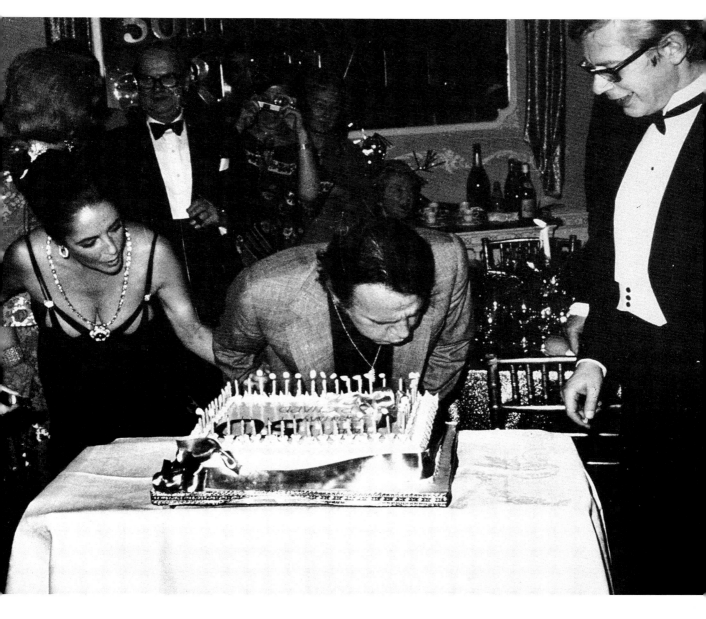

Taylor was holding for Richard Burton's fiftieth birthday at the Dorchester. They told me there probably wasn't much chance of me getting in, but to go down there anyway and see what I could get. Chaos was reigning when I arrived; the place was filled with press, photographers and TV crews. We were told there would be no interviews or pictures, so we could all go away.

My face was not known in those days, so I thought I would try and make it work to my advantage. Perhaps I should discreetly amble into the hotel and see what I could get …

I had noticed one of the Dorchester's press officers slipping through a door, so I went in after her. I followed her down a few corridors and then lost her. I carried on and found myself in what is

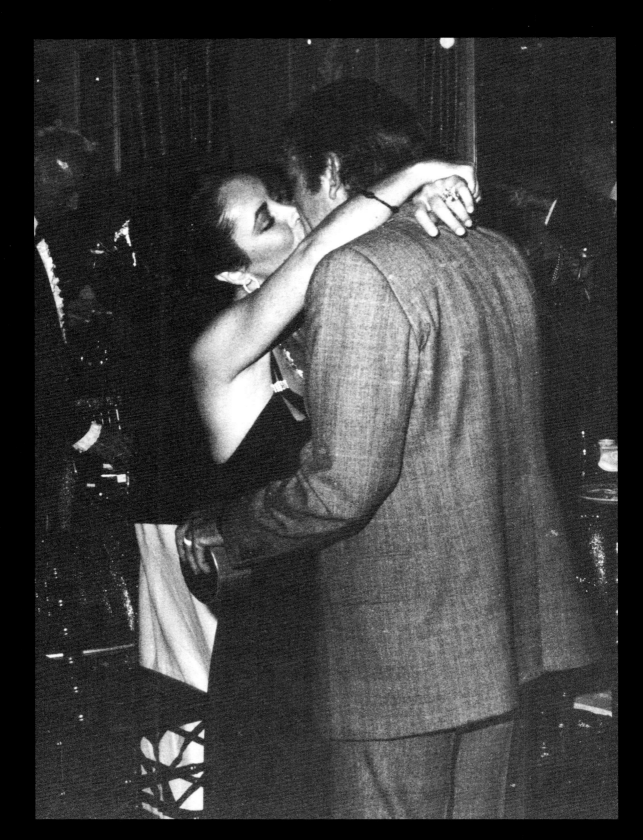

referred to as the Gold Room where a few waiters were hanging around. 'Are you with the band?' someone asked. 'Yes,' I replied, so one of the waiters showed me into the ballroom where the party was being held. The room was empty except for the DJ setting up in the corner. I went up to him and explained that I was a photographer with the *Evening Standard* and asked him not to split on me. He agreed and let me stand with him while he was setting up. After a while I asked if I could have a go at spinning a few discs. He showed me what to do and, as I was quite competent, he decided to go off to the bar for a quick drink. Well, I say a *quick* drink – actually he didn't come back for three hours. I had no complaints. Suddenly I had become guest DJ at Elizabeth Taylor's party and I was quite enjoying myself: the party was in full swing, and I even played a few requests! The real DJ came back just when a huge birthday cake was wheeled into the room. Richard and Elizabeth went hand in hand to blow out the candles. I sneaked around the guests, got as close as I dared and took a couple of shots. Elizabeth looked up but probably thought it was one of the guests taking snaps. She then turned to Richard and gave him a passionate kiss, at which point I became a little bolder and took a couple more shots. Again she looked around, slightly perplexed. I decided not to push my luck any more and went back to my spot by the DJ.

However, when Elizabeth walked on to the dance floor to dance with one of her guests, I couldn't resist taking another couple of pictures.

That was it: my cover was blown. She came storming over to me and, without asking any questions, put her nose right in front of mine and said, 'I think you'd better leave … now!' And that's exactly what I did.

When I came down to the lobby, I was immediately surrounded by photographers desperate to know what I'd got. Before I knew it, a *Daily Mirror* photographer had pushed me into a taxi. The *Mirror* processed my film and said it wasn't very good. I'd used the wrong flash – it just wasn't powerful enough – but I still had a grainy image, and I was the only person in the world to have that image. That was good enough for me. The *Mirror* used it big on pages one and three the next day. I immediately got a call from the *Evening Standard*: what the hell did I think I was doing giving the picture to the *Mirror*, especially as they had given me the tip-off? It was my first big mistake. I hadn't even thought about the politics of the job, I was so naïve. I apologised, got all my material back from the *Mirror* and gave it straight to the *Evening Standard*. They syndicated my pictures worldwide for me, and out of those pictures I made enough money to put down a deposit on a rented flat for Riitta and myself in St Quintin Avenue, North Kensington.

That day I decided to give up my day job at the bookshop. What a week it had been: I'd got married, got a flat and got myself a career.

1
9
7
5

rod stewart and britt ekland

earl's court, london

'VE PHOTOGRAPHED ROD ON AND OFF since the beginning of my career. He has always been a very easy person to work with, a real professional who just gets on with the job without any airs and graces. He's really just a lad – always larking around – and doesn't seem to take himself too seriously. I've photographed him with all his girlfriends over the years, and there have been quite a few. I don't know how he does it, but Rod has certainly been with some very beautiful women.

I took this picture at Earl's Court during an after-show party, and it has become more and more interesting over the years. At the time, this was *the* look, but after nearly thirty years I think it has become quite a classic image: his hair, the make-up, the open shirt and tight trousers – it really evokes that era. Rod had just broken up with Dee Harrington, and had started dating Britt – they always seemed like a well-matched couple, and I thought they complemented each other well.

It felt great to have a job I enjoyed so much and I worked long hours, giving it my all. Life was good, although there was a shadow on the horizon: Riitta had been diagnosed with breast cancer. We were shocked, but not unduly concerned as she made a good recovery from the operation, and we pretty much carried on as normal, getting great shots every night. The stars and the publicists were becoming aware of who I was, and I started to feel that I was becoming part of the showbiz scene …

1976

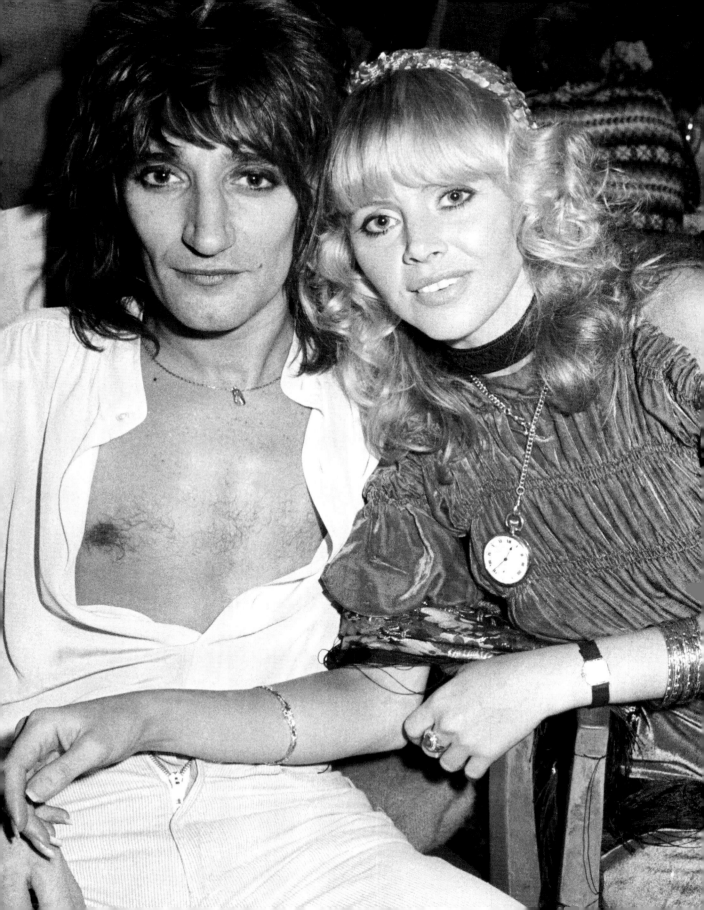

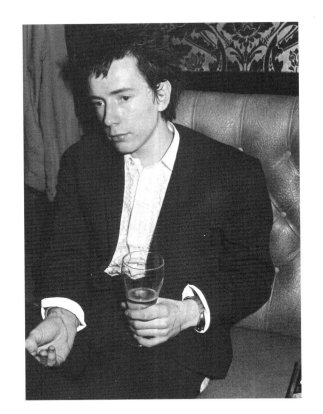

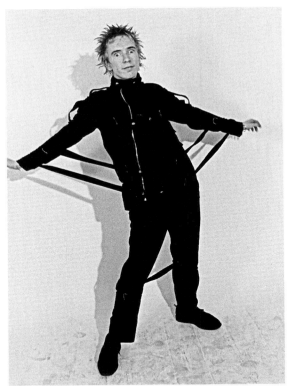

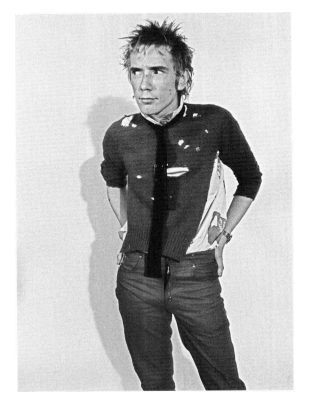

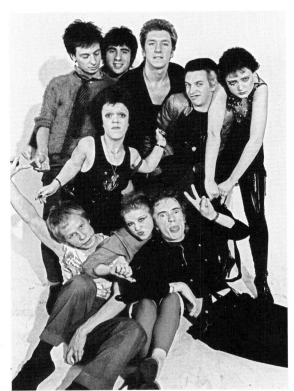

johnny rotten

notting hill, london

WHEN THE SEX PISTOLS WERE AT THE height of their fame, the *Evening Standard* suggested I go on the road to photograph them. We travelled up to Leeds, Bradford and various other northern cities. There were quite a few journalists doing this mini-tour, but we had a problem: at each town we visited, the local councils wouldn't allow the Pistols to play because they were considered to be blasphemous and obscene. The upshot was that we invariably had to shack up in the hotel bar and drink copious amounts of Guinness.

I was one of the first photographers to shoot the original Pistols line-up, pre-Sid Vicious. The three studio pictures opposite were taken at a studio in Campden Hill Road, Notting Hill Gate. I'd asked Johnny at one of their gigs if I could do a studio session of the band and their friends. I booked the studio but, as it was my first studio shoot, I didn't really know what to do. I didn't have a lot of money, so I could only afford to hire the venue and a lighting technician for two hours.

Looking back, I was still rather green. I had heard it was a good idea to play music when you did a photo shoot – it was supposed to help everyone relax and get them in the mood. So I put my favourite musician on the record player: Neil Young. As one, the Pistols turned on me, and Johnny Rotten screamed, 'What the fuck do you think you're playing?' I obviously still had a lot to learn.

marc bolan and gloria jones

london

IN 1958, AT THE AGE OF ELEVEN, I was sent to William Wordsworth secondary school in Hackney. I had wanted to go to a nice, private, Jewish secondary school, but as I'd been quite a rascal they wouldn't let me in. Sitting next to me on my first day was a boy I had seen around and about; his mother had a stall near the one my dad had in Berwick Street market, Soho. She sold fruit and veg, my dad sold hosiery. This boy was the smartest dresser in the school: even at age eleven he would turn up in handmade three-piece Harris-tweed suits, handmade shoes from a shoemaker in the East End and John Michael shirts. His name was Marc Feld. He would later become Marc Bolan.

We became firm friends. He used to tell me that one day he would be famous – he didn't know what for, but he was such a charismatic guy I believed him anyway. I really admired the way he dressed, and tried to copy his style whenever I could afford to. It was difficult because he always had more money than me. We used to bunk off school every Friday afternoon to avoid sports (it wasn't cool to be seen running around and breaking into a sweat) and would jump on to the number 73 bus which would take us straight into the heart of Soho. We would walk around the streets looking in the windows at men's clothing, dreaming of perhaps owning a suede jacket one day. Then we'd stop for a cup of frothy coffee at the Two I's coffee bar before sauntering off to our parents' stalls in Berwick Street to try and cadge a few quid.

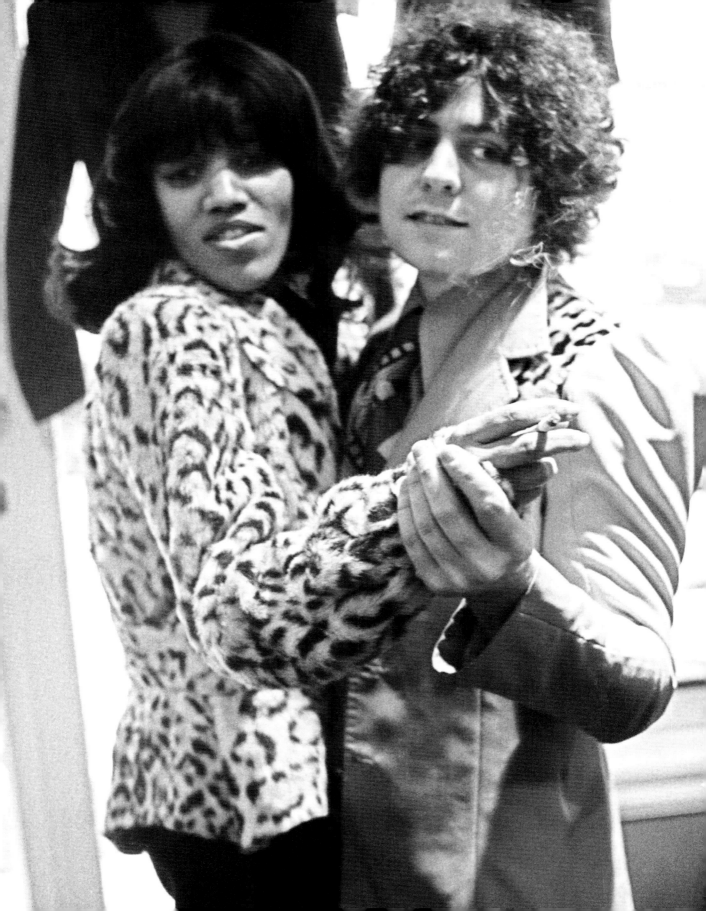

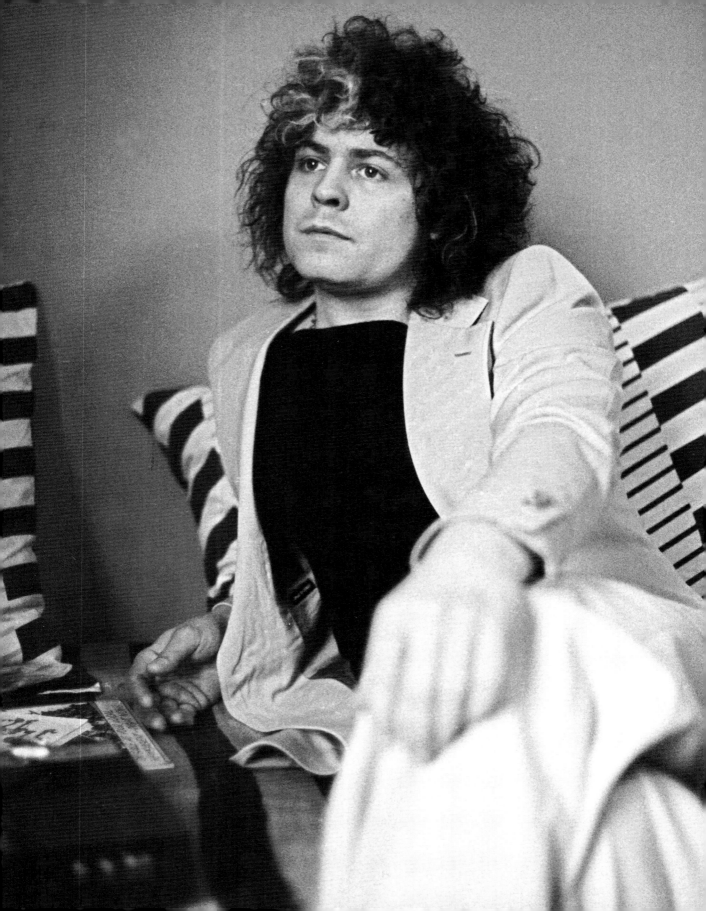

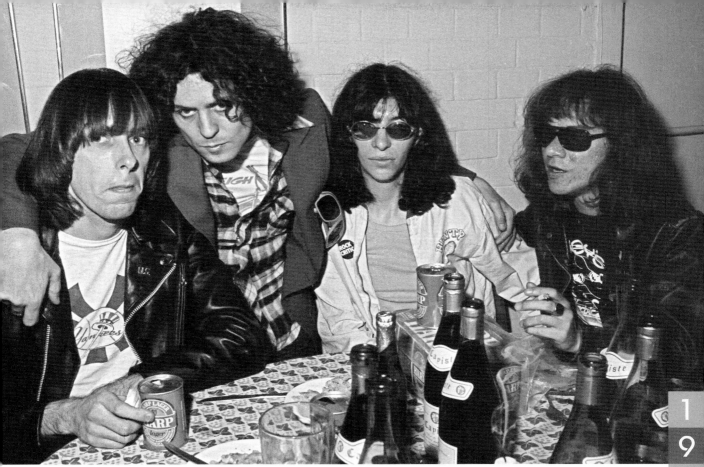

When Marc was fourteen he moved from the area to south London, and I left school. I got my first job as a menswear salesman at a shop called Smart Weston in Dalston High Street. Marc and I lost contact until around 1965 when I was working at one of the best menswear shops in London, Sportique in Old Compton Street which was owned by John Michael. One day, out of the blue, Marc walked into the shop. At that time he was just beginning to establish himself as a singer-songwriter, and I had been reading in the music press that he was starting to make waves. It was so good to see him and we gave each other a big hug. After a long chat I asked him if he might have a job for me, as I dreamed of moving into the world of showbusiness.

Believe it or not, he actually said, 'Why don't you become my photographer?' I told him I couldn't because I didn't have a camera and didn't know how to take photographs.

I bumped into him briefly in New York in the early seventies, and then didn't see him for a few years, by which time I was established as a photographer. We would see each other around London, usually at Maunkberry's, and we would often chat about the old days. He was very proud that I had finally made something of my life.

I photographed Marc and Gloria many times over the next eighteen months until his untimely death in 1977. I was so shocked and saddened when I heard about his accident on Putney Common. I had lost a dear old friend.

ryan o'neal

south molton street, london

IN THE EARLY DAYS OF MY CAREER, I was mainly a paparazzo photographer. In fact, I would later become known as King of the Paparazzi! I was one of the first people doing street photography in London; it was a very lonely existence, but that was OK – I've always been a bit of a loner. I would hang around outside theatres, restaurants, clubs, first nights, parties and film premières. If I was really lucky, I'd have a good tip-off, which would be very useful. I didn't drive a car or bike back then, so I pretty much walked everywhere – unless it was really late, when I might just stretch to a cab! Over the next few years a few more guys appeared on the scene, so I started to have a bit of company on those lonely doorsteps.

I would find out where the stars were staying through my contacts – doormen, limousine drivers, restaurateurs – and then I would either hang about outside or, especially if it was cold, go inside and sit in the lobby, order a coffee and read the paper. When the person I was waiting for came out I would jump up, run outside and try and get a shot of them on the street. Mostly I would ask politely if I could take their picture, and if that didn't work I would take the shot anyway and face the consequences later. I carried on like this until I met my second wife Susan. She suggested that I should be the one on the inside, so I started to take a lot of PRs out to lunch and apologised to them in case I had sometimes been out of order.

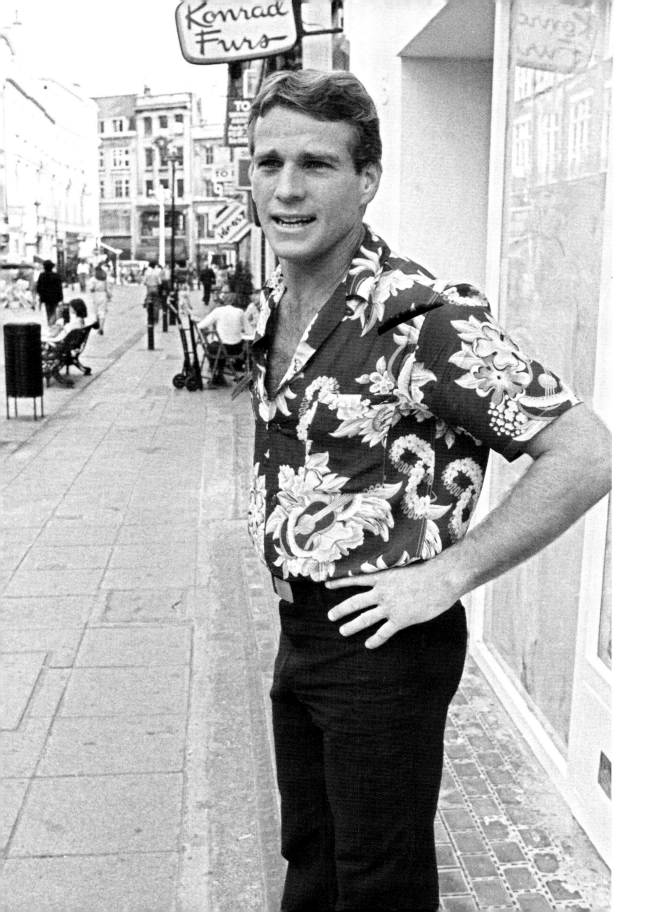

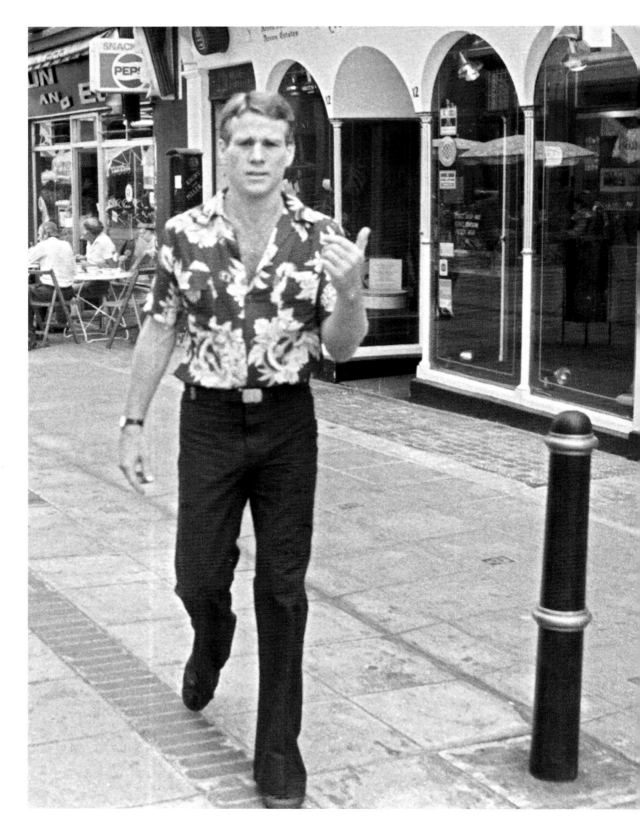

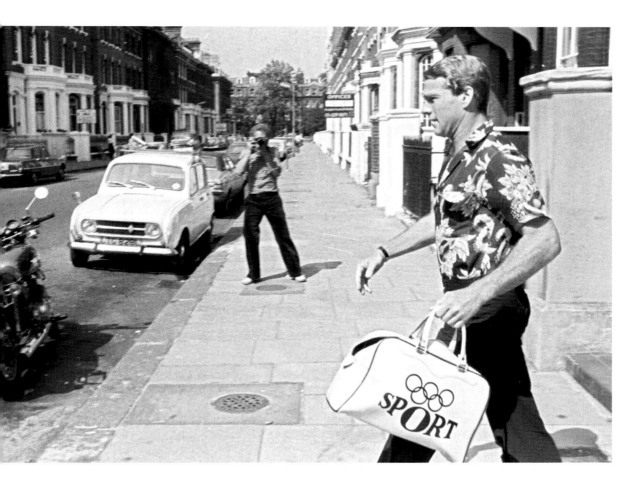

I explained you have to crack a few eggs to make an omelette, and I hoped that I could convince them that we could work together in the future. In short, I felt that I should be invited in instead of being on the outside. Many came on board, the rest followed later and since then I never go anywhere unless I am invited and have an invitation in my hand.

Those early days were a lot of hard work and also a lot of fun.

This picture of Ryan O'Neal is one of my really early paparazzo shots. I had heard he was staying at Blakes Hotel in Chelsea, so off I went early one morning and waited for him to emerge. Around eleven o'clock he came out and jumped into his waiting car. I quickly found myself a taxi and raced after him. We struggled to keep up with him, but, when his car finally came to a halt in South Molton Street, I was right behind him. I quickly took some pictures of him walking down the street, no problem. He then went into a shop, so I just hung around waiting for him to emerge. When he finally came out I said, 'Look, I just want to get a few shots, can you pose up?'

'Sure,' he replied. 'You guys really do work hard!' We agreed that once I got my shot I would leave him alone – and that's exactly what I did.

andy warhol

the factory, new york city

I WAS FLOWN OUT TO NEW YORK by a record company to shoot a rock concert at Radio City Music Hall. I managed to wangle a few extra days out of the trip in order to do some serious clothes shopping, catch up with my old mates and just generally hang out. I was staying at the Waldorf, spending time with Craig Copetas (the guy who helped me get my very first shot of Paul Getty). Elizabeth Taylor happened to be attending a function while I was there, so I got some nice pictures of her and Senator John Warner, her husband at that time. I always love it when a surprise photo opportunity comes my way.

I was also working with *Ritz*, David Bailey and David Litchfield's social celebrity magazine, and this opened up many doors for me – literally. *Ritz* commissioned me while I was in New York to pop in and photograph Andy Warhol at the Factory in Union Square. Andy also had his own magazine, *Interview*, which was along the same lines as *Ritz*, so there was a strong connection there. I had met Andy before in London; he was friendly and was happy for me to take pictures.

Andy's life was the ultimate celebration of the life of celebrity. It was a very special time to be part of that world: Studio 54, the constant round of parties, premières and restaurant openings. Everyone was living for the moment; it was totally hedonistic.

The Factory was buzzing, and Warhol was looked upon as the Prince of New York. We all wanted to be part of his world – even if it was only for fifteen minutes!

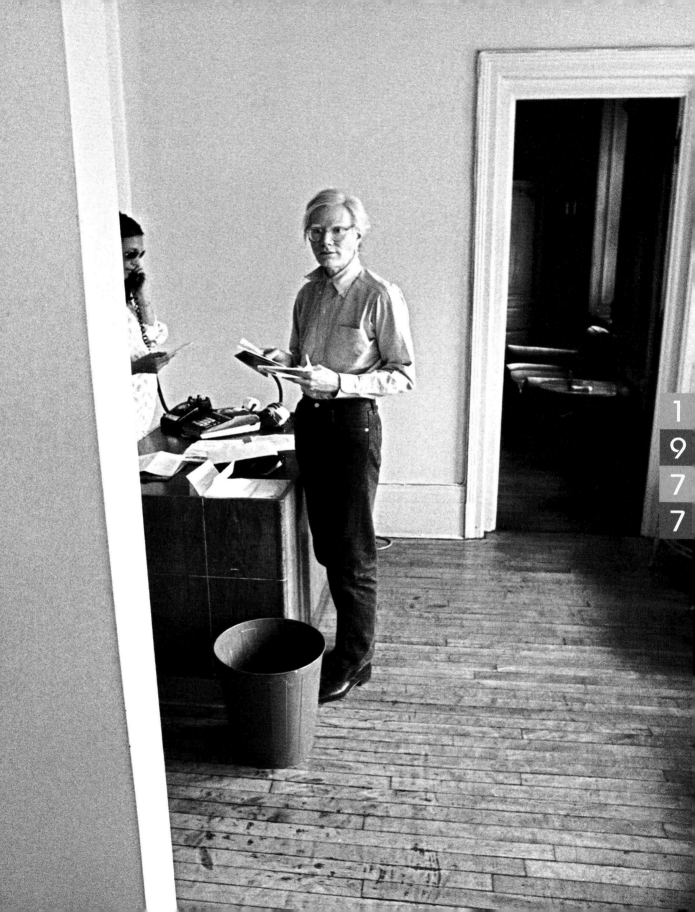

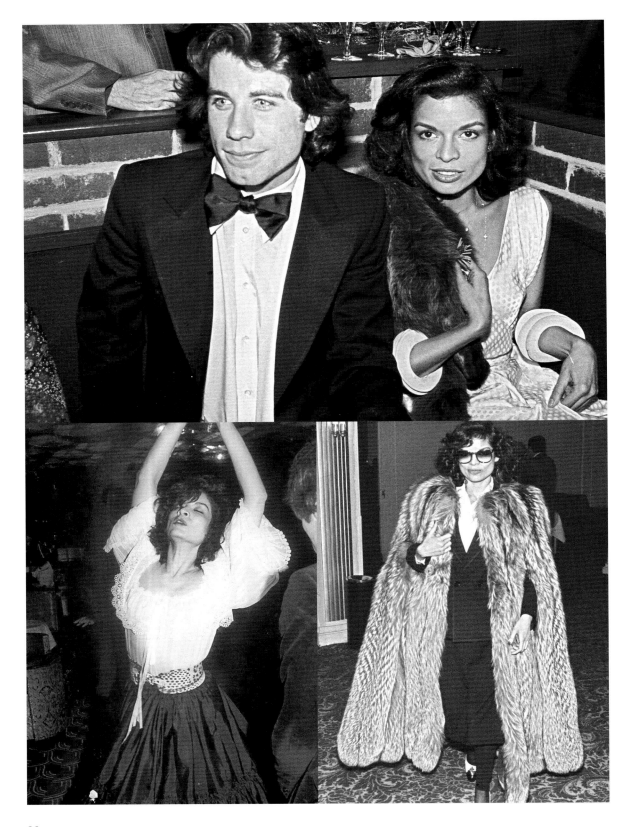

bianca jagger

london

I STARTED PHOTOGRAPHING BIANCA IN 1975 when she was still married to Mick Jagger. I have always found her a fascinating, elegant, enigmatic and stunningly beautiful woman. She was often quite aloof, which I enjoyed as it set her apart from all the other rock chicks. During the mid-seventies she was a permanent fixture on the New York and London party scene. I have photographed her in so many different outfits, at so many different parties, with so many different characters. She was the 'It' girl of her day – with a lot more class, may I say, than many of the girls on the scene now.

She had impeccable style, and was always to be seen at the right parties. After all the years that I have been photographing her, I find that she still keeps herself very much to herself, and I have never really had a conversation with her. I think she is very much of the 'them and us' mentality.

These days she is a more serious person, working as a human rights campaigner. I have a lot of respect for her. Maybe some of the girls out on the scene today could learn a lesson from her and try to be a little classier.

I was still working as hard as ever; in fact, I was seldom at home. However, this year was a really special one for me: Riitta gave birth to our first son Danny. I had also made a bit of money by now, and had saved up enough for a deposit on our first house. Everything was taking shape, and I'd never been so happy.

jack nicholson

dracula première party, claridges, london

I DIDN'T MAKE THE PREMIÈRE but I knew the party was at one my favourite hotels, Claridges. I didn't have an invitation on this occasion, so I decided to gatecrash the party. In those days it was something I did frequently, and it was much easier than it is today. On occasions like these I would ditch my usual attire of jeans, leather jacket and cowboy boots; instead I would dress the part and put on a suit and tie so I looked like I was part of the crowd. I walked straight in and no one approached me. When gatecrashing, always act as if you own the joint. Walk straight through, don't look at or speak to anyone and, if you get approached, be polite! If I ever got asked what I was doing, I would always reply, 'I've already been in and my bags are inside,' to make it look like I was part of the gig. Peter Langan once said to me, 'You're the only bloke who can grease his way through a closed door!'

This was a party worth crashing. It was full of international stars including Jack Nicholson, Warren Beatty, Ringo Starr and James Coburn. Jack is one of my movie heroes – I loved him in *Easy Rider* and *Five Easy Pieces* – and I was excited as I had never photographed him before. Even now, I get a thrill from meeting my music and screen idols.

I consider this to be one of my best portraits. Jack's deadpan expression is priceless. I have photographed Jack many, many times since, and I have taken lots of great shots of him. But this first picture will always be my favourite.

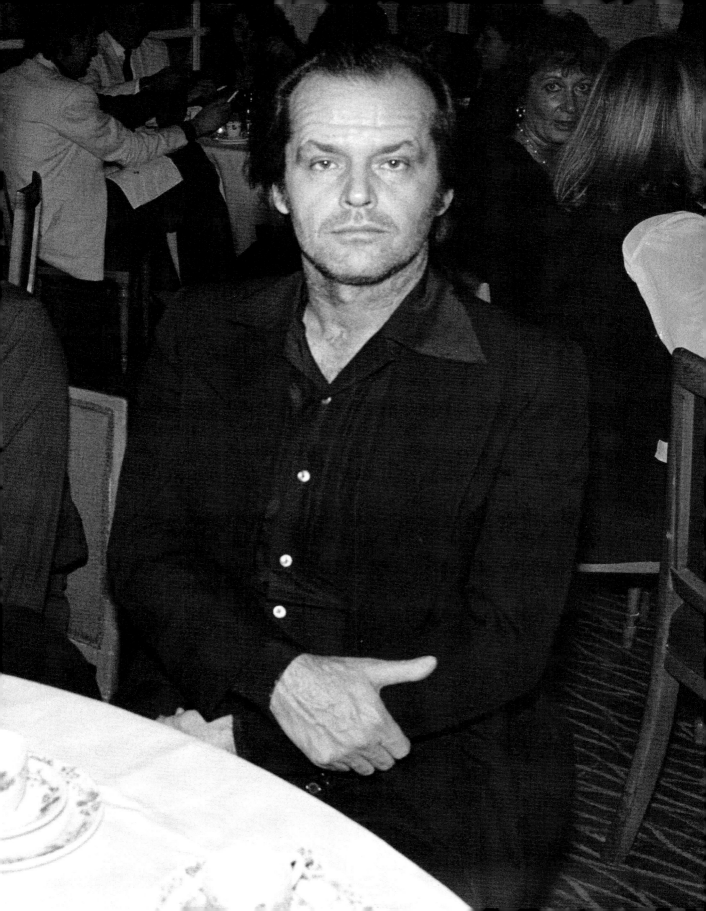

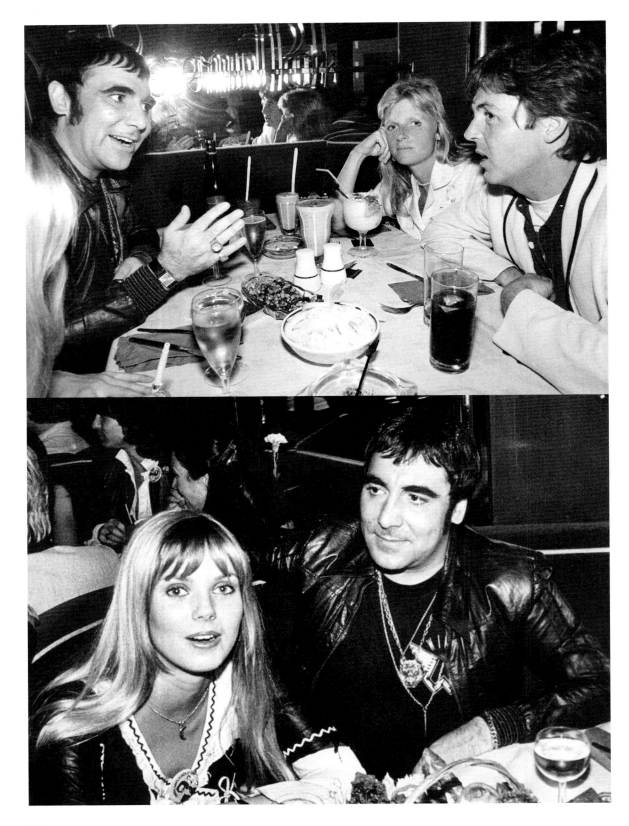

keith moon, paul and linda mccartney

peppermint park, london

PAUL McCARTNEY LOVES BUDDY HOLLY, so he started having anniversary parties to celebrate Buddy's life. This was the first one and the publicists, Rogers and Cowan, invited me to photograph the party at Peppermint Park in Covent Garden. It was a great party, and as usual at the end of the evening I dropped my film off at the *Daily Express*. In those days after each evening's work, whatever time it was, I had to drop all my film off in Fleet Street to be processed and contact sheets were made up by the picture desk. Nowadays, with digital technology, I can download all my images in the comfort of my home at the end of the night. It had been just another night's work for me, another party; it wasn't until the following afternoon that my images took on a new meaning.

I was at a gallery opening in Mayfair when a call came through for me – there were no mobile phones in those days, which could make life difficult. It was the *Express* asking where my negatives were from the previous night. They were in my pocket. They wanted me to rush back as a big news story had developed. Keith Moon had died. After Paul's party he had gone on with his girlfriend Annette Walter-Lax to a nightclub, returned to his flat in Curzon Place, Mayfair, around four a.m. and the next day Annette found him dead. Whatever happened I don't know, but I was the last person to photograph him.

Sadly, the negatives for this job have gone missing – I was less organised in those days. If there is anyone out there who knows where they are, I would love to have them back.

new year's eve party

maunkberry's london

IN THE EARLY DAYS I ALWAYS WORKED on New Year's Eve. This particular year I had an invitation to go and photograph Rod Stewart in concert at the Lyceum. As it was New Year's Eve, I treated myself to a cab; but when I arrived in the Strand I found the show was cancelled as some of his band were unwell. As it was snowing, I decided it would be difficult to get home so I sauntered off down the Strand and made my way to Maunkberry's.

Maunkberry's was *the* club at that time. It was for private members only, and was open every night of the week. As you walked down the stairs into the club Trevor, the manager, was always there to welcome you. Once inside you would pass through a small restaurant area and bar, and in the middle of the room was the dance area with floor-to-ceiling mirrors, left and right. Everybody loved this because it meant that you could watch yourself dancing, which was very important in the seventies. At the back of the room was the stage, and to the right of the stage was a small outside patio where everyone would go for a joint – and other things. This was the funkiest club in London: the music was fantastic, practically every major star in town would pass through at some time or other, and when they left they were often completely wrecked. There was no VIP area, so everyone mingled together. It was a great mix of people.

As I arrived at about ten that New Year's Eve, the place was just starting to warm up.

Opposite above: Elton John and Britt Ekland ▶
Opposite below: (*left to right*) Britt Ekland, Freddie Mercury, a friend, Ron and Jo Wood ▶

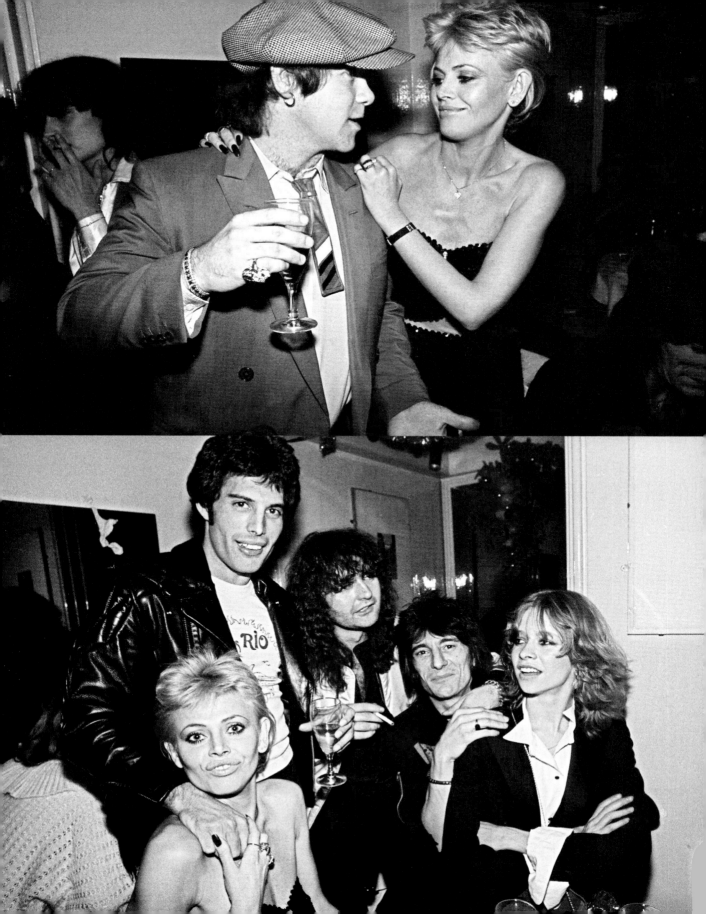

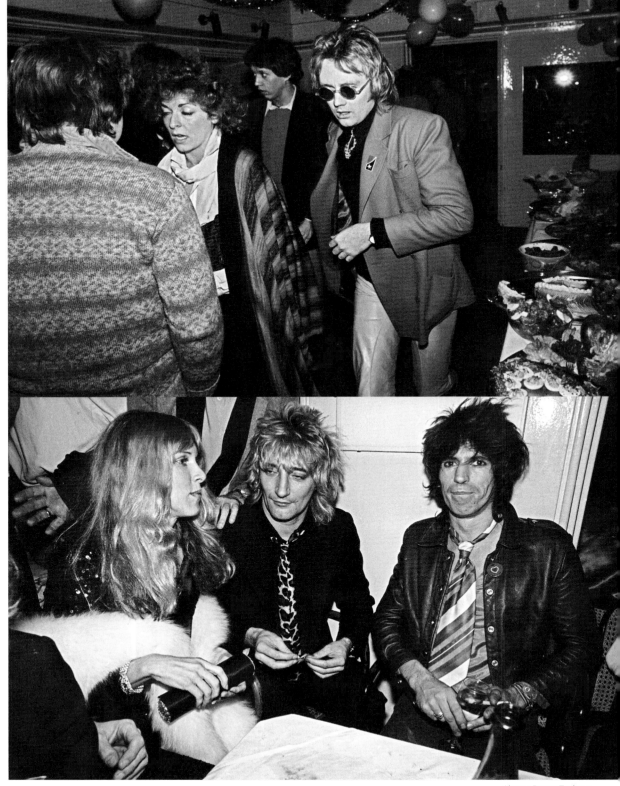

Above: Roger Taylor ▲

Below: Alana Hamilton, Rod Stewart and Keith Richards

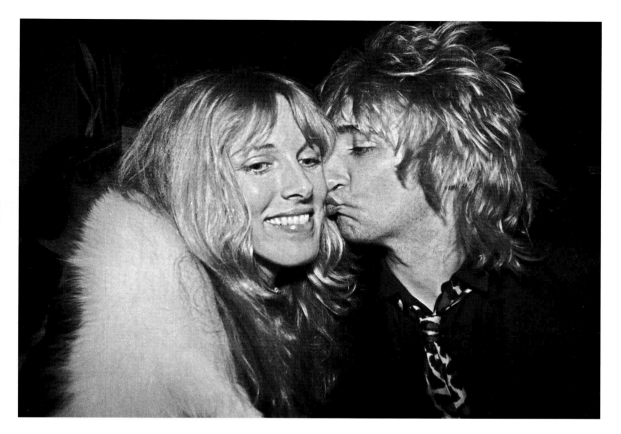

The room was decorated with balloons and tinsel and a buffet dinner was going to be served. The barman had dressed down and decided not to wear any trousers! This wasn't a private party, just a regular night, but Trevor told me to hang around because it could be an interesting evening.

I settled down in the corner with a drink waiting to see who would turn up. The first person to arrive was Elton with his people; Britt Ekland turned up soon after, looking fantastic. Next on the list were Freddie Mercury and Roger Taylor, then Rod Stewart and his new girlfriend Alana walked in. Some time later Keith and Ron arrived with their respective girlfriends. Trevor told me Keith and Ron had called earlier: they

wanted to come down but didn't have any money, and wanted to know if they could set up an account.

It was quite a small club, and all these people were scattered around in various nooks and crannies throughout. I went around the room taking photographs when I felt like it. There were no problems with me being there: no minders, no publicists, no VIP room, no other photographers. Just me! I wish it were still like that now.

Everyone was well in the party mood, dancing, table-hopping, chatting, drinking and smoking. Keith was hanging with Ronnie and Rod. Roger and Freddie were gossiping in a corner, and Britt was hanging out with everyone!

At midnight everyone got up, sang 'Auld Lang Syne' and toasted each other. Girls were kissing girls, boys were kissing boys – and Britt was kissing everybody. Rod was sitting next to Alana in the restaurant area, and I had noticed during the evening that there was a bit of friction between her and Britt, who was Rod's ex. Britt had joined Rod and Alana at their table at midnight and, to everyone's surprise, she started planting kisses all over Rod's face. Rod didn't respond at all – he just sat at the table smiling and looking rather embarrassed. Alana tried to ignore her extraordinary behaviour, but Britt would not stop kissing Rod. Alana brought the whole scene to a sticky end by pouring her champagne down Britt's neck. This did the trick, and Britt finally moved on.

Trevor tried to take Britt's mind off things by playfully picking her up and throwing her over his shoulder. By the time he put her down everyone, including Britt, had managed to see the funny side of things.

I eventually left at around three in the morning, even though the party was still in full swing. I dread to think what time everyone left – I'm sure most of them didn't get to bed at all that night. I have never had a New Year like that, before or since. The *Daily Express* ran a centre spread on the party the next day. As you can see from these pictures, it was quite an evening.

Trevor the doorman with Britt! ▲

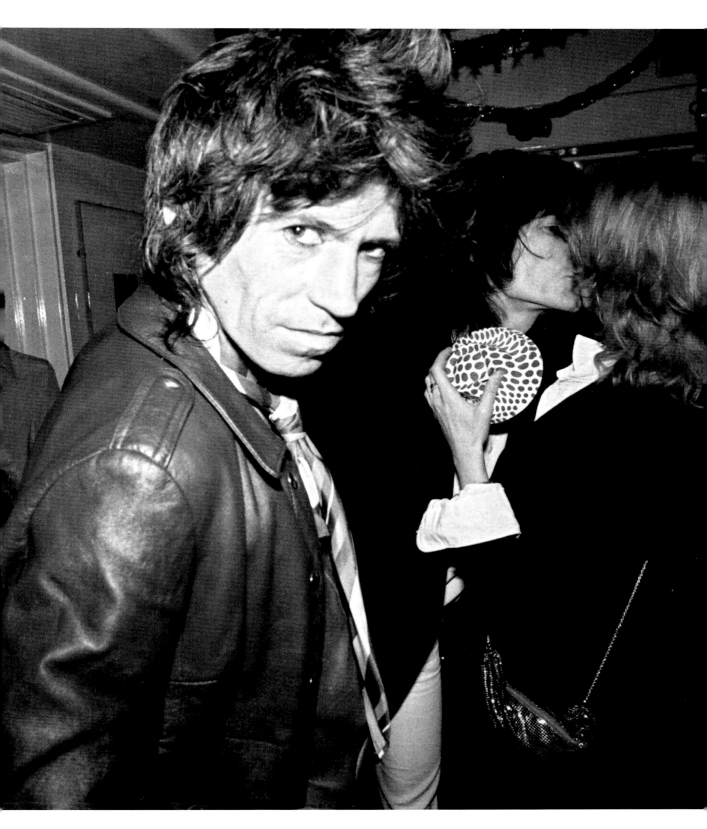

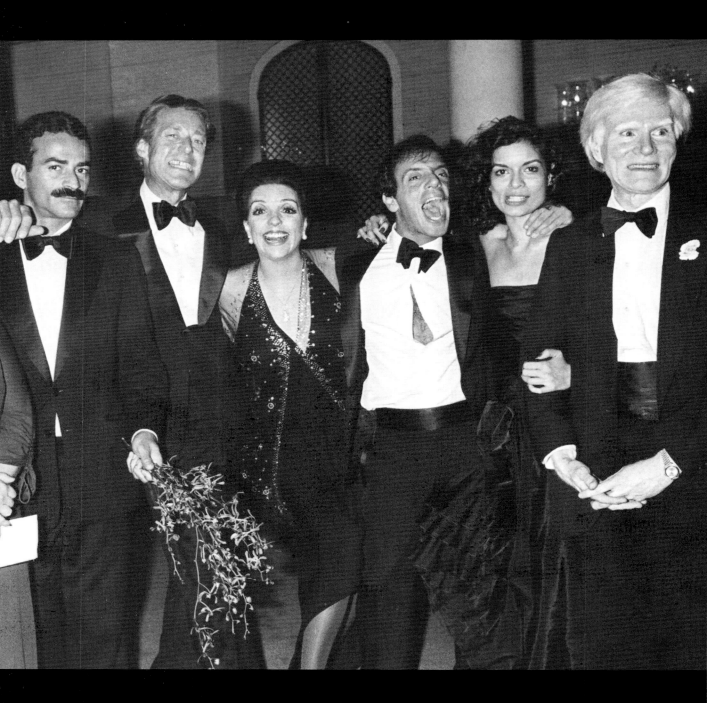

antonio lopez, halston, liza minnelli, steve rubell, bianca jagger and andy warhol

the savoy, london

MARTHA GRAHAM'S COMPANY WAS DANCING at Covent Garden, and Liza Minnelli was singing after the performance. *Ritz* magazine asked me to cover the after-show party at the Savoy hotel. Very often in June and July you'd get a lot of American celebrities over here – it seemed to be the cool thing to do, to be part of the British season. I was really surprised to see Antonio, Halston, Liza, Steve, Bianca and Andy all together – that was more the kind of shot you would have got at Studio 54. On realising the importance of this combination of people, I decided to gather them all together, and as I waited to pose them up for a group shot I could see they were buzzing big time.

The party at the Savoy was on two floors. Princess Margaret was downstairs with her boyfriend Roddy Llewellyn; when Andy, who was upstairs, found out he went over and started taking pictures of the two of them together. They were not happy and tried to have his film taken away from him. You see, there is a little paparazzo in all of us!

This picture sums up the seventies so perfectly for me: these extraordinary characters all together out on the town with only one desire, and that was to have a great time and party all night long.

the embassy club

london

IN THE LATE SEVENTIES, MY FAVOURITE CLUB in London besides Maunkberry's was the Embassy. The Embassy started up a few years later than Maunkberry's, and was owned by Stephen Hayter and fronted by Lady Edith Foxwell. They held some of the most outrageous parties of the late seventies and early eighties. It was the nearest thing we had to New York's Studio 54. Every major artist who appeared in London had their after-show party there, and practically every week there was a themed party of some sort or another. Lots of people dressed up; others hardly dressed at all. As a result, I practically lived in the place. Marvin Gaye was a regular, as were Liza Minnelli, Halston, Bianca Jagger, Diana Ross, Brian Ferry, Keith Moon and Mick Jagger – the list was endless. People still come up to me today and say, 'I remember you from the Embassy days.'

I would go to the Embassy at least three times a week, and always had full access. I used to hang out mainly downstairs in the bar and restaurant area, which was where all the interesting people were. Sometimes I'd join people and chat, and often I didn't get home till the early hours. Poor Riitta hardly ever saw me. My second son Sam was born in July, so now I had two beautiful boys, but this did not stop me working. I loved what I was doing, and wanted to be the best. I wanted to get the most interesting and vibrant shots, and I knew if I slacked I wouldn't be number one.

Nicky Haslam (*left*) with Bryan Ferry ▶

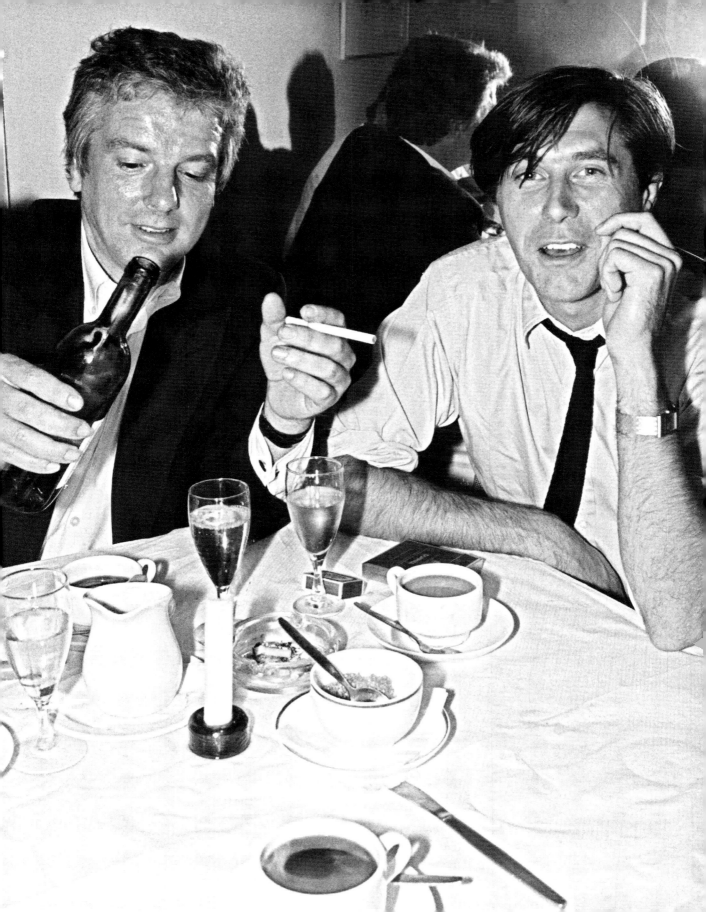

1979

▲ *Above*: Pierce and Cassandra Brosnan
▼ *Below*: Peter Cook and friend
▶ *Opposite above*: Stephen Hayter (*left*)
 with Steve Rubell

1979

mick and chris jagger and parents

hyde park hotel, london

FASHION DESIGNER BILL GIBB had a show at the Hyde Park Hotel, Knightsbridge, and Jerry Hall was modelling. Mick Jagger turned up with his brother Chris and their mum and dad. Mick's old girlfriend Marianne Faithfull was also there. Mick had grown his beard for a film he was making called *Burden of Dreams* about the making of Herzog's *Fitzcarraldo*.

I have always enjoyed photographing Mick, but my relationship with him has blown hot and cold over the years as he can be quite moody. If you get him on a good day, he's charming. I remember when I was once at the bar in Langan's Brasserie he even bought me a beer. Another time I was taking pictures of him going into the Savoy hotel and he was not at all happy, so he nicked the flash off my camera, took out all the batteries and returned the flash which would no longer work. So, Mick, you owe me some batteries!

At the time this was a rare picture, as Mick had never been photographed with his parents. And I don't think I've seen him with a beard since, either.

johnny cash and june carter

grosvenor house hotel, london

CBS RECORDS AND THE COUNTRY Music Festival had arranged for me to photograph Johnny Cash and his wife June Carter. I still, to this day, get a thrill when I have special access to major players in the business – my enthusiasm is as great today as it was thirty years ago. I jumped at the chance to photograph Johnny and June.

I was ushered into his suite in the Grosvenor House Hotel, and spent an hour or so with them. They were extremely warm and friendly. I told them that I was involved somewhat in the country and western scene, thanks to my friendship with a guy called Charlie McCutcheon. Charlie was head of press at Anchor records in the mid-seventies, and I used to use his office there. I set up a table and chair, and even had a telephone installed. I used to go in every day and pretend it was my own office, and Charlie encouraged me.

Charlie is one of the craziest, funniest guys I have ever met. He took me across America on press junkets which always ended up as one long party. We rarely got any work done. Once we did a coast-to-coast tour of country music festivals to promote people like Hank Thompson, Don Williams and Freddy Fender. We kicked off in New York, moved on to Nashville, spending time at the Grand Ole Opry, on to Tulsa and Las Vegas. Charlie would organise extra-curricular activities like drunken helicopter rides over the Grand Canyon and visits to the Jack Daniels distilleries in

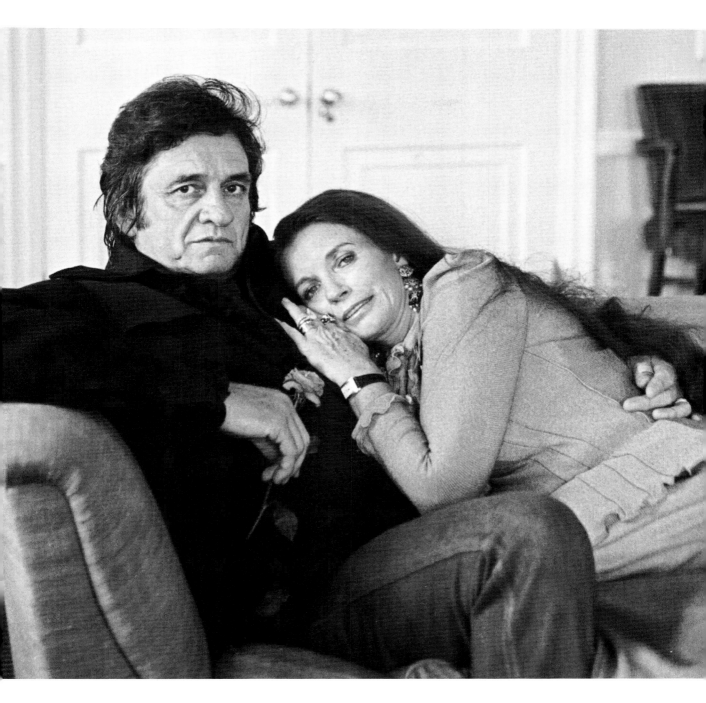

Lynchburg, Tennessee (which happens to be a dry county) – he tried to throw me into one of the vats. We always stayed in the best hotels (which often got trashed) and always ate at the best restaurants. It all became too much for me.

I found being on the road too exhausting, and it took me away from Riitta and the boys, so I called it a day and decided to concentrate on the London scene.

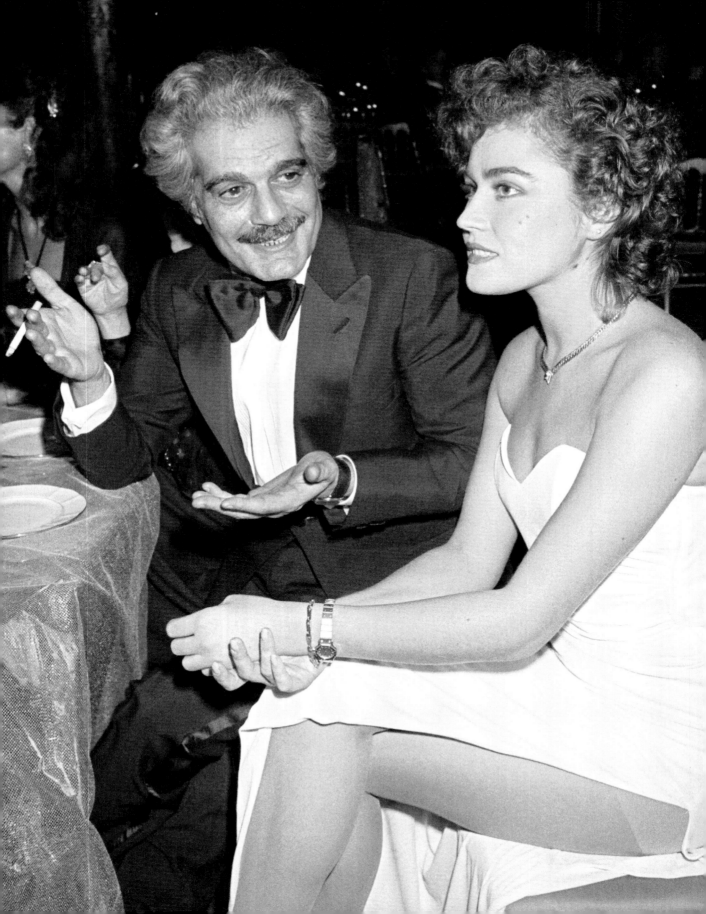

cartier party

place vendôme, paris

ONE OF THE MOST MEMORABLE PARTIES I've ever been invited to was the Cartier party in Paris on the Place Vendôme. We were flown out in two private jets – just the way I like to travel. We were met at Le Bourget airport and whisked off in a fleet of Rolls Royces to the party which was being held in a huge marquee that Cartier had installed for the night. Five hundred of the glitterati and *crème de la crème* of Paris and London descended on Place Vendôme where we ate, drank and danced the night away. There was a great crowd there, all my favourite French idols: Serge Gainsbourg, Catherine Deneuve and Alain Delon. Ursula Andress and Harry Hamlin were also there, as were Omar Sherif and Valentino. At that time I had never been invited to such a glamorous international party.

Believe it or not, when the party had finished at two in the morning we all piled back into the Rollers and caught the private jets back to London. Those kinds of parties are my favourite: being whisked off to a foreign location in private planes, fine food and wine, an interesting mix of people – and back in London the same night.

◄ Omar Sharif and friend

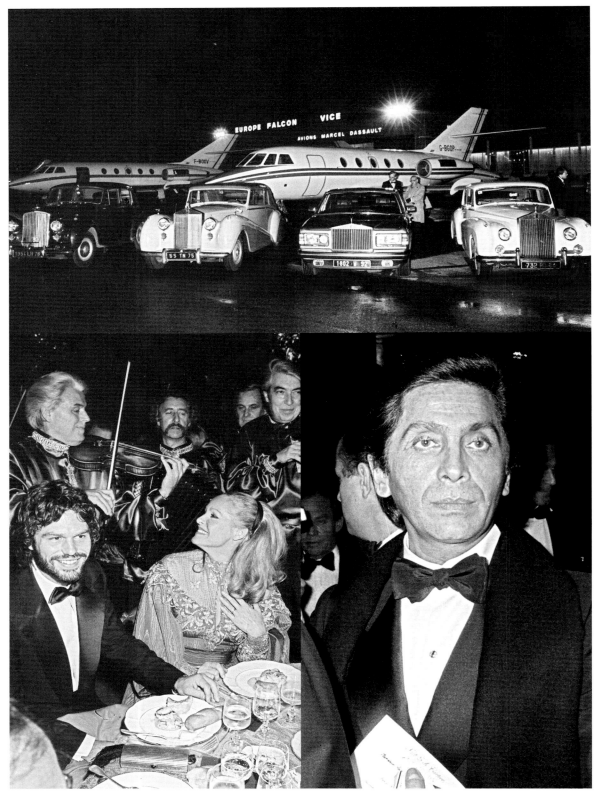

Harry Hamlin and Ursula Andress ▲

Valentino ▲

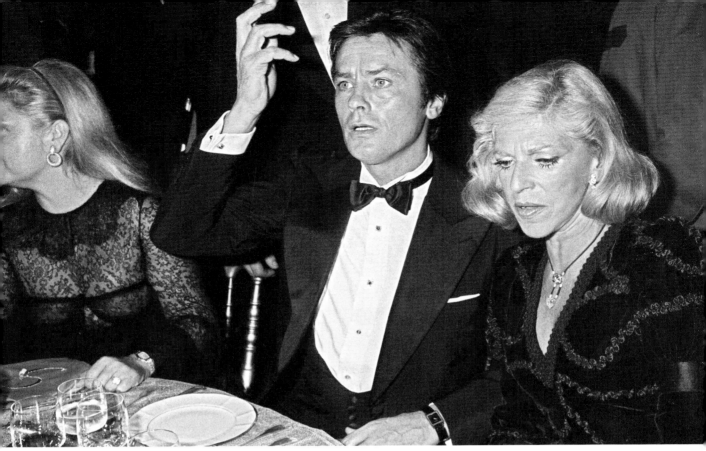

▲ *Above*: Alain Delon

Below: Serge Gainsbourg and Catherine De Neuve ▼

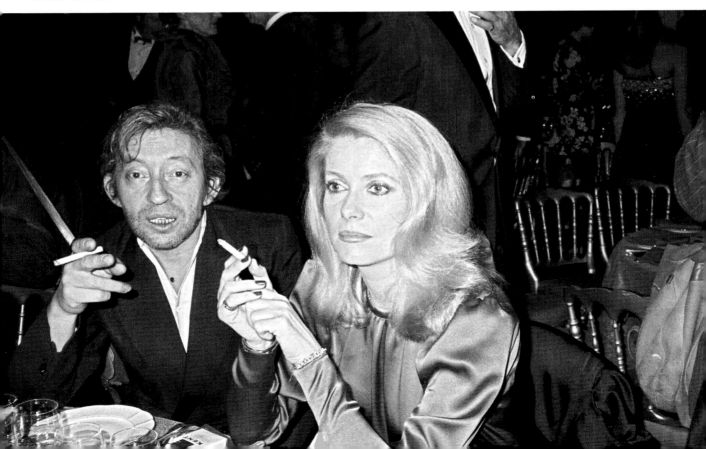

marvin gaye

the embassy club, london

I MET MARVIN GAYE FOR THE FIRST time in London in the early eighties. He was a permanent fixture on the party scene at that time; he had been having difficulties in America and had been spending a considerable amount of time in Europe. I would quite often see him out clubbing: he loved Maunkberry's, the Embassy and was often at Tramp. Beautiful women always surrounded him, and he was very friendly with Stephen Hayter who owned the Embassy and Lady Edith Foxwell.

Marvin and I became very friendly, and he asked me to cover one of his concerts. He liked the images so much he used them on his album *Live at the London Palladium*. On another occasion I suggested that we do a studio session together, to which he readily agreed. I went ahead and booked the studio in Notting Hill, and I made sure it was as late as possible – Marvin was most definitely not an early bird. I gave him the address and date and asked him to be there by six in the evening. I'd hired my lights and a lighting guy, and arrived early to set everything up. I'd decided definitely *not* to play Neil Young this time, but I got in some wine and snacks just to create a cosy atmosphere. Half-past six came and went, and no Marvin; seven o'clock, still no sign. I decided to give it another half an hour. By half-past seven I'm getting a little worried. OK, I thought, another fifteen minutes. Still no sign. I was getting a bit upset by then, so I decided to call him. When I finally got through, he sounded completely out of it.

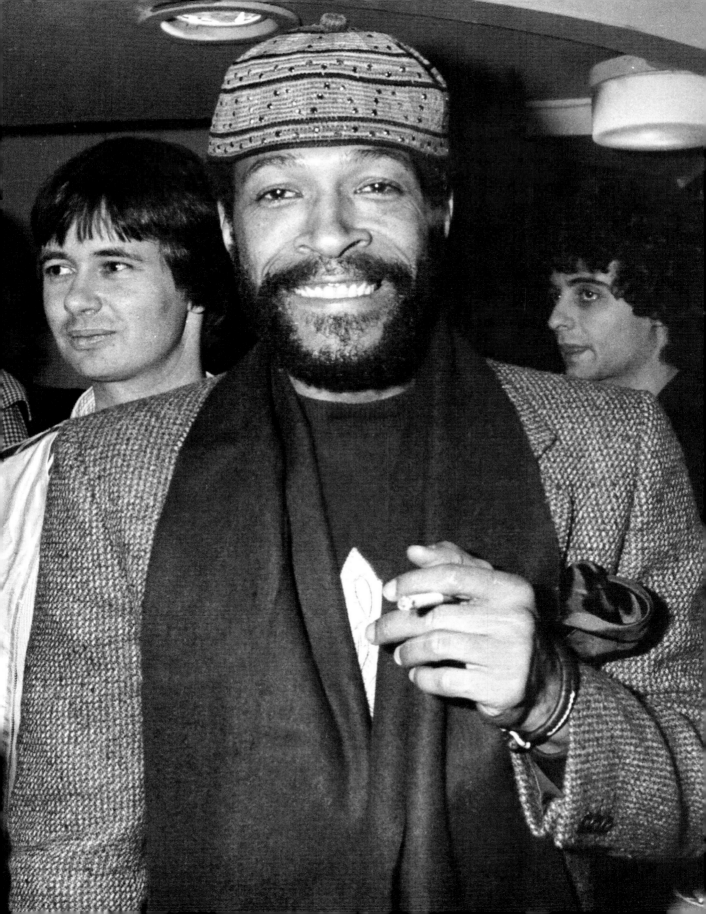

He hadn't remembered and, in fact, couldn't really have given a damn. I realised that I had been a bit naïve: in the state he was in, it was unlikely he would remember very much at all, and, although I was upset and angry, I did realise he was a very troubled man.

This picture was taken before the photo shoot that never was – in fact, I think it was this night I asked him if he'd agree to do the shoot. I haven't seen many pictures of Marvin dancing in a club situation, and I think these are really special images. I would often see Marvin in the company of aristocratic English girls – he certainly seemed to enjoy their company – and here he is dancing with Chantal d'Ortez, Moira Lister's daughter.

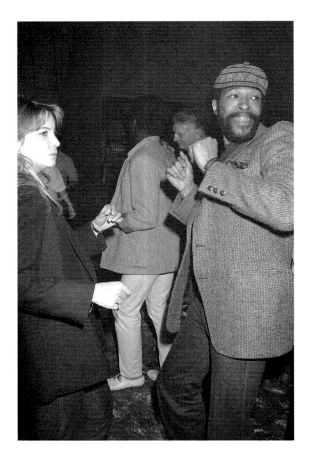

debbie harry

the sanctuary, london

Although things were going well with my work, on a personal level, things were not looking good for Riita and, sadly, I had to admit that she was getting weaker. I tried to carry on as normal – I carried on working crazy hours, not wanting to believe that she would not get better. I loved her and the boys so much that it was too painful to even contemplate. The only way for me to deal with it was to carry on as normal.

Debbie Moore opened a fabulous spa and health club for women only in London's Covent Garden. The Sanctuary, with its shallow pools, little wooden bridges and loads of plants, was very glamorous and a popular location for parties.

Debbie Harry was holding her after-show party there. I had been photographing her since the mid-seventies, and to me she was one of the sexiest rock chicks around – and a great singer too! She arrived at the party with the entire band, and Martin Kemp and Steve Strange were there as well, dressed as bikers – don't you just love that leather? In those days, even when I was invited into a party I would still follow the stars outside and continue taking pictures until they had driven off down the street, just in case I missed anything. Debbie left the party and I followed her out. She got in her limo and for some reason there was no one with her – and it made for a fabulous photograph. Although I have photographed Debbie loads of times over the years, this still remains my favourite picture.

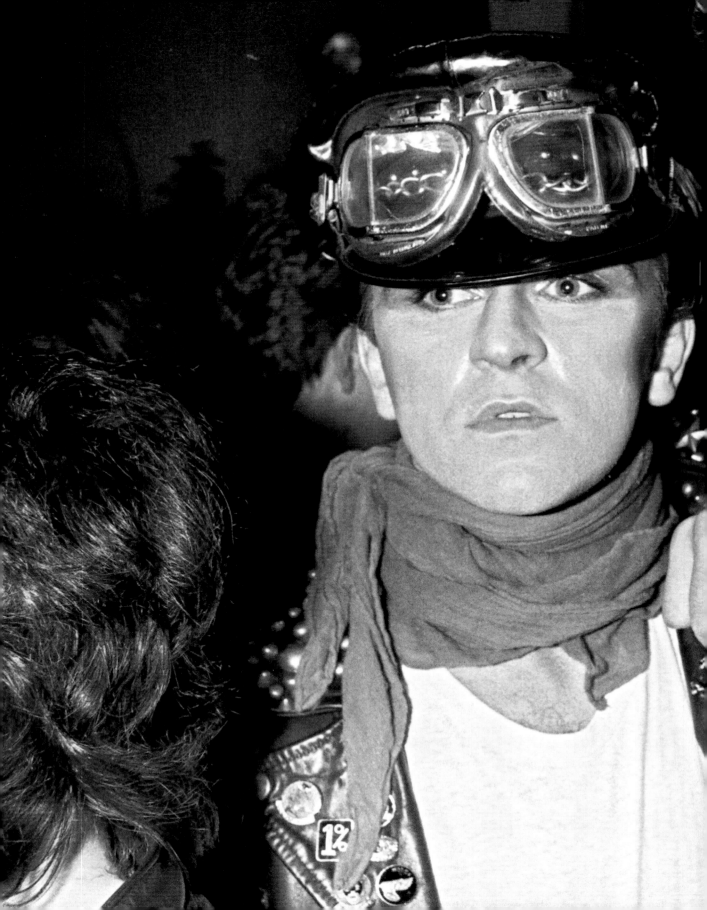

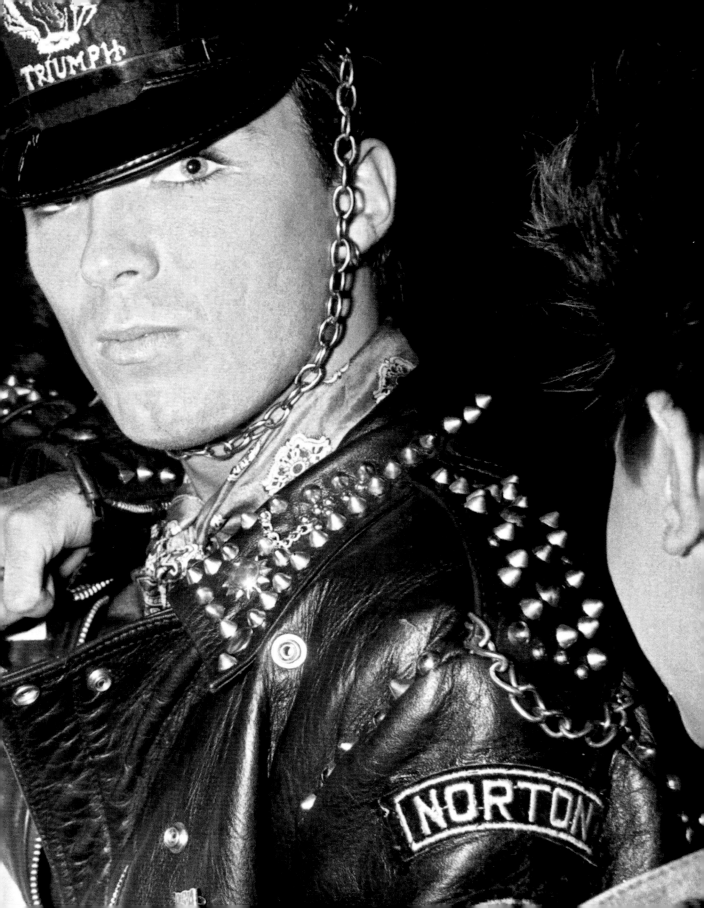

the dalai lama

euston road, london

THE THING I LOVE ABOUT MY JOB is that I get to photograph and meet a real cross section of people. I've taken pictures of rock stars, royals, actors, politicians, sportsmen, world leaders, religious leaders and various scallywags and rascals. Until I started researching this book I never realised what a diverse collection of people I have photographed over the last thirty years. There are a few personalities who have escaped my lens for one reason or another: John Lennon is someone I really regret never having photographed, as are Elvis and Jimi Hendrix. But, other than them, I've pretty much done the lot.

This was my first meeting with the Dalai Lama. I have always been interested in eastern philosophy, so I was really happy to meet him in person. He was giving a lecture for the Tibetan Society, of which I was a member at the time; I was asked to cover his talk, and I photographed his Holiness leaving. People love this photograph. I think it's because he's sitting in his car, which seems such an ordinary thing for an extraordinary man to be doing. I have met him on several occasions over the years and have had some very special conversations with him. He is such a warm, friendly and peaceful man, I feel very honoured every time I am in his presence.

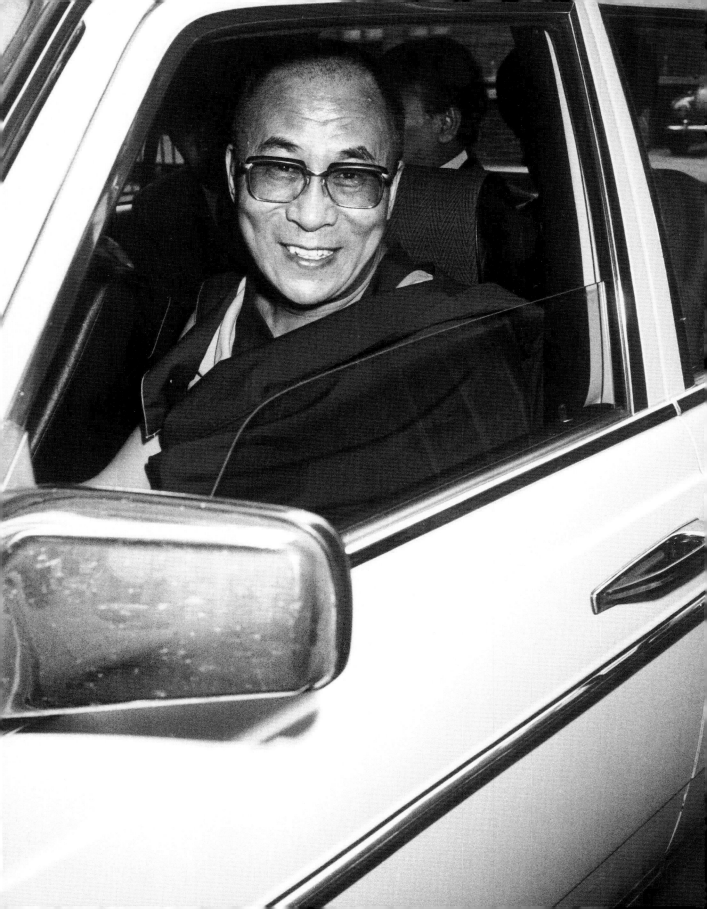

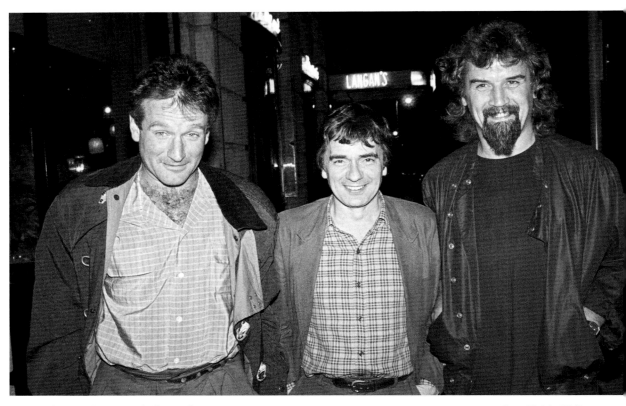

▲ Robin Williams, Dudley Moore and Billy Connolly

Happy birthday Mick! ▼

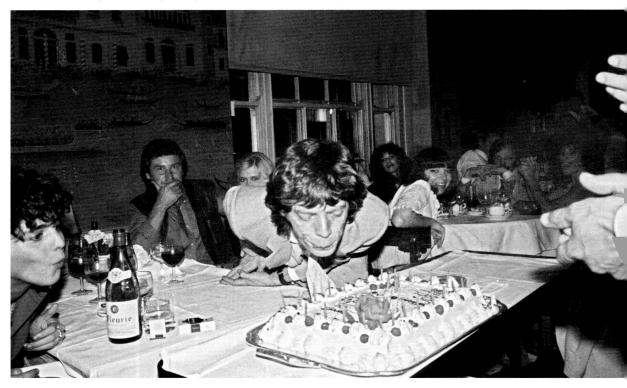

langan's brasserie

london

IN THE MID-SEVENTIES, *RITZ* MAGAZINE had a strong affiliation with Olympus cameras. Olympus had a gallery in the Ritz hotel, which is just around the corner from Langans Brasserie. Bailey and David Litchfield would hold court there every night along with Barry Taylor and Jeff Ash from Olympus. As I had started covering events for *Ritz* magazine, I would be invited to join them most nights at the bar. In the early days of Langans, every major celebrity would show up. The food was great and the room was interesting – it reminded me of La Coupole in Paris – and the walls were filled with amazing art. Moreover, the restaurant's partners Peter Langan, Michael Caine and Richard Shepherd would draw the best crowd in town.

Peter Langan was a lovable Irish drunk, who on occasion would offer free dinners and champagne to beautiful women if they would strip off in the bar and stand there naked. I only saw it happen once and I couldn't believe my eyes. I didn't have a camera on me – it was in the saddlebag of my Harley outside – so I had to make a split-second decision: stay and watch or go out, get the camera and miss the moment. So I stayed and watched!

Peter would crawl along the floor on his stomach biting ladies' ankles under the table, producing little yelps of surprise and pleasure. One day he got so drunk he fell off his chair on to the floor and a woman started screaming, 'He's had a heart attack!'

'Don't worry, dear,' I said. 'He's always falling over, and anyway he owns the joint!' Peter was always incredibly friendly to me; I would often sit with him late into the night, me drinking coffee, him drinking champagne. I could hardly understand what he was saying: he was always debating whether he should go home, spend the night at the Ritz or, as was often the case, sleep it off in an armchair in Langans, where the cleaning ladies would find him in the morning.

Peter once banned me for twenty-four hours because, being the cheeky fellow I was, I had snatched a photograph inside the restaurant of Anna Ford and Mark Boxer, who were hot news at the time. Anna complained bitterly to Peter, so Peter came over to me and said in a loud voice,

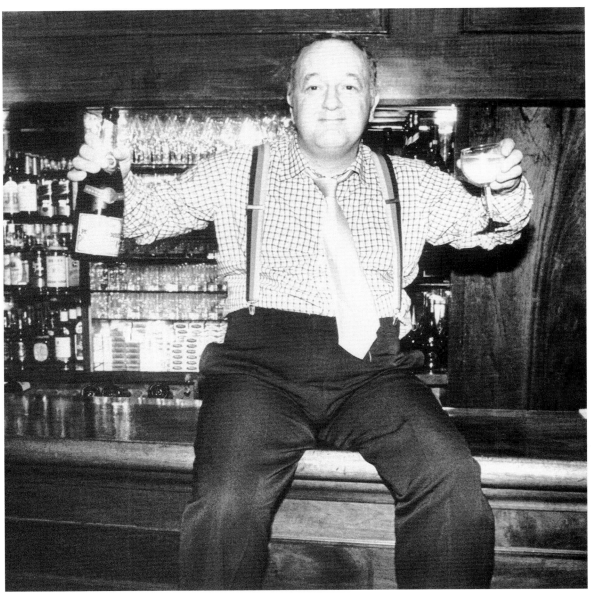

Peter Langan ▲

▼ Roger Moore, Michael Caine and Michael Winner

Marie Helvin and Jerry Hall ▲

'Richard, please go now!' and then behind his hand he whispered, 'But come back tomorrow!'

Richard Shepherd's patience was sorely tested on many occasions. Once he was so annoyed with Peter he decided to ban him from the restaurant. I came up Stratton Street to find Peter's table on the street outside the front door. Peter was sitting there, drink in hand, looking very sheepish.

Michael Caine would throw the most incredible summer parties during Wimbledon fortnight, when the major movers and shakers from the States were here. Because of my relationship with *Ritz* magazine, I was always on the inside as far as Langans was concerned. It became my second home for many years; in fact, I still go there two or three times a week to have a late-night coffee. It's great because many of the waiters and maître d's have been working there for thirty years as well; everyone is so friendly it feels like family.

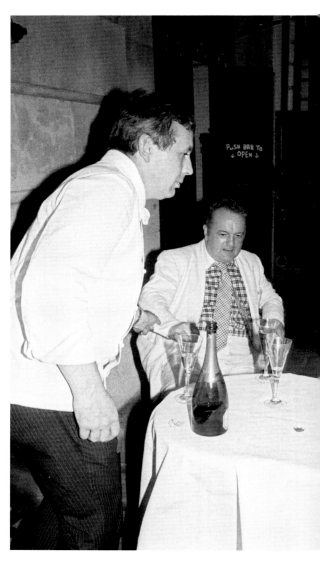

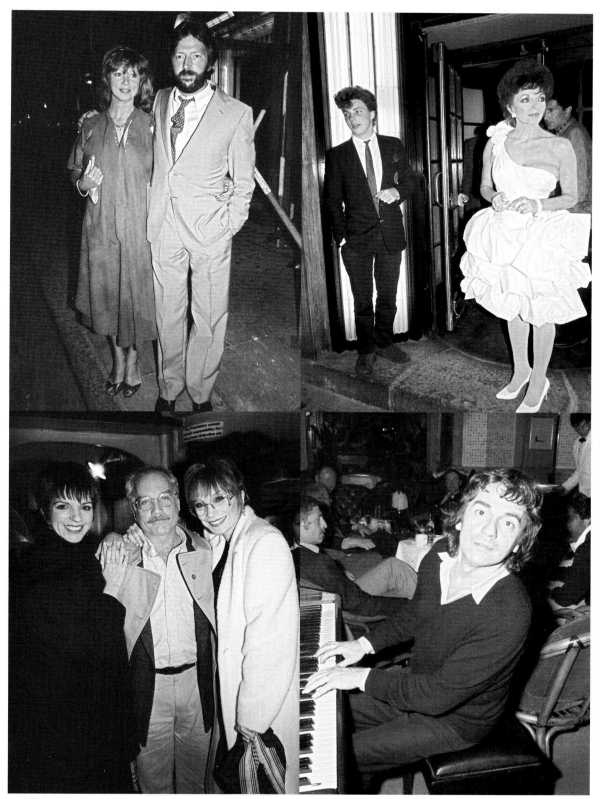

▲ *Clockwise from above left*: Eric and Pattie Clapton; Joan Collins;
Dudley Moore; Liza Minnelli, Richard Dreyfuss and Shirley McLaine

1981

richard burton

chelsea, london

IT WAS THE EVENING OF ELIZABETH TAYLOR'S fiftieth birthday and she had a big party at Legends nightclub to celebrate. Although she and Richard were no longer an item, he was there and at the end of the evening he escorted Elizabeth back to her friend Norma Heyman's house in Chelsea where she was staying. Although the main party was over at the club, I thought it might be worth hanging around to see if I could get a picture of the famous couple together at the after-party party in Chelsea.

I hung around outside and then, finally, at 5.45 a.m. Burton emerged from the house looking quite dishevelled and perhaps not a hundred per cent sober. As he came out, he looked at me, smiled and said, 'Would you like to come and have breakfast with me at the Dorchester?' That was certainly the best offer I'd had all night, so off I went with him in his limo. In his suite I ordered a full English breakfast – it was fantastic. Richard was drinking and talking, talking and drinking; he kept telling me how beautiful Elizabeth was and that we should all respect her because she was such a great woman.

Suddenly the door opened and Richard's manager stormed into the room, demanding to know who I was and what the hell I was doing. I told him I was there because Richard had invited me for breakfast. He wasn't interested in honouring that invitation any longer and asked me to leave in no uncertain terms. I thanked Richard for his hospitality, and left. It had been a long night and I was very happy to get home.

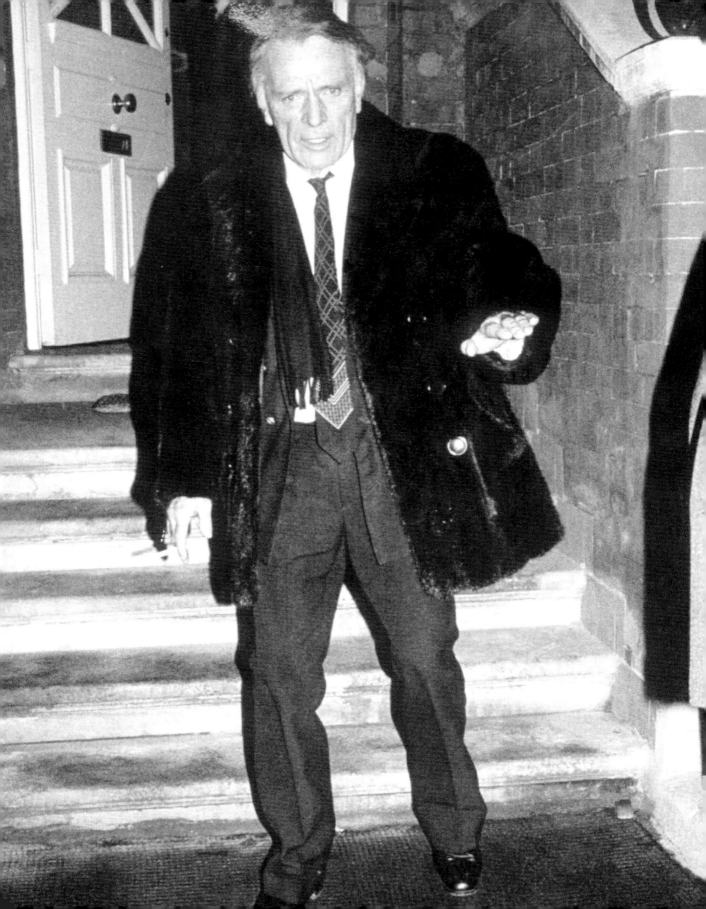

princess diana, prince charles and prince william

st mary's hospital, london

WHEN THE NEWS CAME THROUGH THAT Diana was about to give birth to her first child, I raced down to the hospital to get a good spot. As you can imagine, the whole world's press and media were camping outside, so it was imperative I got a good position. If you're stuck at the back you need a ladder; fortunately I was slap bang in the middle of the front line, opposite the front door. I quickly marked my place with a piece of masking tape on the barrier with Richard Young in bold letters. That is how photographers mark their spots for all big events. These days at film premières you have to put your name on a list with the publicist on a first-come first-served basis, so the lower your number the better your position. The fact that we all marked our spots meant there was no opportunity for disagreement, and people wouldn't try to improve their position.

I stayed there for six days awaiting the arrival of Prince William. I would arrive most mornings around eight o'clock and stay until ten at night. Most of us would go home late; only the newspaper night boys would stay on with the film crews. Between photographers and TV crews, someone would do a coffee and food run, and if we ran out of film we would help each other out. It can be quite boring once you have gone through all the jokes, relayed all your family news and any showbiz gossip. I am very happy not to be doorstepping any more – it really is hard work, especially when it's raining or cold.

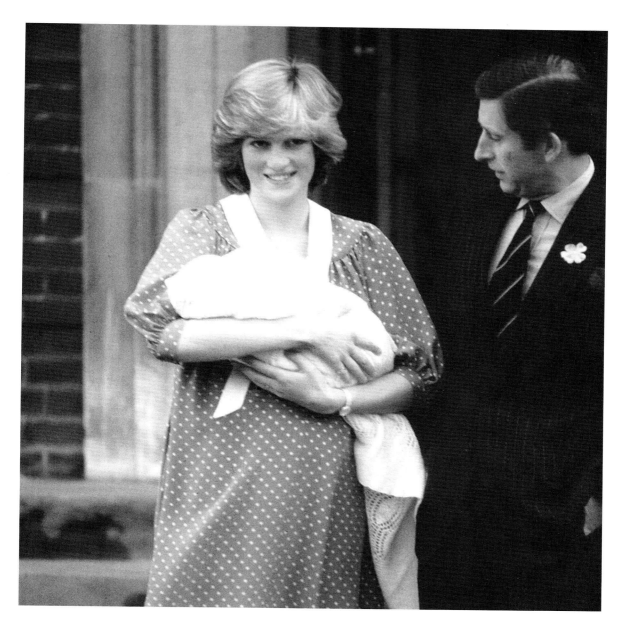

During the course of the six days, Diana had many visitors, which broke the tedium: the Queen popped by, Viscount Althorp and Charles were in and out. Finally Diana emerged with a beautiful baby boy, Prince William, and a proud Charles by her side. The reporters fired off a barrage of questions, and she answered them all. It couldn't have been easy coming out to that circus having just given birth. There were photographers and news crews all the way down the street, all desperate for that special shot. I raced back to the *Express* with my film, glad that that particular assignment was over. Now I could get on with some other work – six days is a really long doorstep.

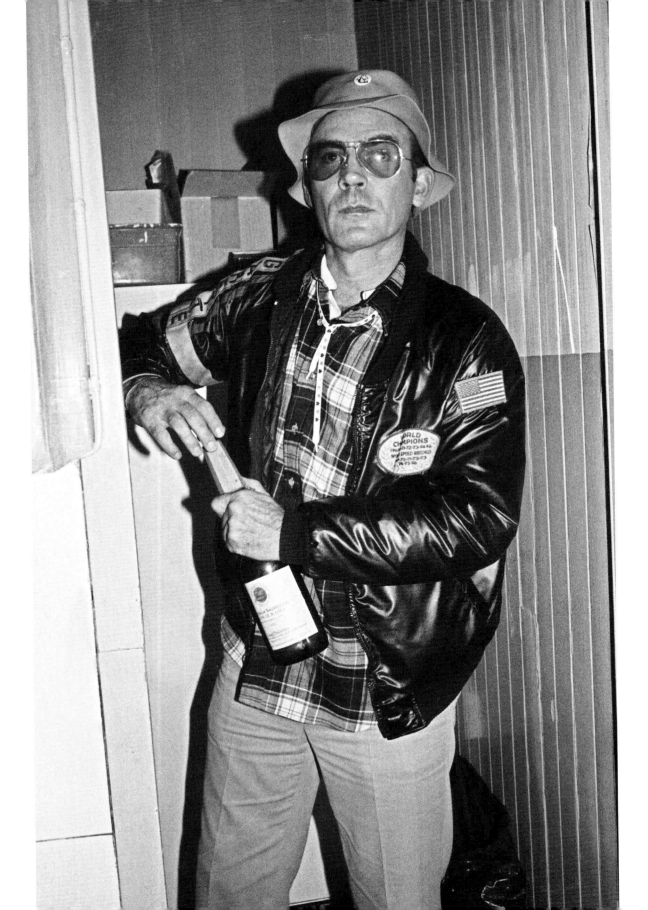

hunter s thompson

cheyne walk, london

I WAS HAVING A QUIET DRINK AT THE CHELSEA ARTS CLUB with some mates when in walked Hunter S Thompson. I knew him from his writing in *Rolling Stone* magazine, which I have been reading and collecting since 1968. In fact, I have every issue of *Rolling Stone* (it goes back to my trainspotting days – I just love collecting things, be they steam-train numbers, magazines, badges, back-stage passes or model Harley Davidsons). I was a great fan of his, so, when he walked into the club with an old girlfriend of mine, I invited them to join me for a drink. We had a few Jack Daniels and put the world to rights, the way you do. He was a great raconteur and kept us riveted to our seats. A few of us decided to carry on drinking at the flat in Cheyne Walk where he was staying. As we were walking down Cheyne Walk he decided he didn't like the For Sale signs outside the houses, so he took them down; don't ask me why – I suppose he thought they looked ridiculous.

We continued drinking until the early hours. Hunter became more and more drunk; I couldn't keep up, so I left them to it. I know I'm a lightweight, but it was still a very memorable evening. What a character.

new beginnings

PHOTOGRAPHICALLY, 1983 WAS A BARREN YEAR for me. Riitta sadly lost her battle with breast cancer in the February. I was devastated and suddenly found myself a widower. My sons Dan and Sam were five and three respectively, and I didn't quite know how to look after them: Riitta had brought them up because I was working so hard. After the funeral, I thought the best thing to do would be to jump on a train and take the boys for a holiday in Cornwall. We arrived in late February when it was raining and freezing cold; I wondered what the hell I was doing there – I wasn't thinking straight. So the next day we came straight back to London. It was difficult for me to cope on a practical level. I really needed to get back to work as the bills still had to be paid, so I decided that what I needed was a nanny.

A couple of days later I parked my Harley on the pavement outside Langan's, and a policewoman came over to give me a ticket. I begged her not to. I explained I had just lost my wife, that I had two little boys and needed a nanny. She told me she didn't want to be a policewoman any more and that she would become Dan and Sam's nanny. She started the following week.

Slowly I started to get some order back into our life. My main priority was to get the boys as settled as soon as possible. But it wasn't easy: my heart wasn't in my work, but somehow I managed to go through the motions.

For the rest of the year I battled on, slowly rebuilding my life. I listened closely to my father's advice: 'Life carries on, and you've got to get on with it. It *will* get easier.'

For much of the year I helped Vivienne Ventura with a book she was writing called *How to Social Climb*, and in late November she had the launch at the St James's Club. I was starting to feel a bit more like my old self, so, when she invited me to a private dinner at San Lorenzo after the launch, I was happy to join her.

I arrived late and there was only one space left on one table. On one side was my old mate Peter (the DJ at Richard Burton's fiftieth birthday party), and on the other side was a beautiful, dark-haired, half-Iranian girl who introduced herself to me. Her name was Susan. I was immediately smitten, and became rather concerned when I noticed that Peter was trying to chat her up. I suggested that we go somewhere else for a drink; as we left San Lorenzo I explained that she would have to get a taxi on her own, as I had arrived on my Harley Davidson without a spare helmet. She didn't seem put off by this, even though she told me later that she was more used to Mercedes and Rolls Royces. So it was that Susan came into my life and took Dan, Sam and me under her wing. Slowly we started to rebuild our lives. We married in 1985 and have now been together for twenty-one years.

isaac hayes

chelsea hotel, london

THE *DAILY EXPRESS* WAS DOING A SPECIAL FEATURE on Isaac Hayes the photographer. Isaac is a multi-talented man: not only is he a brilliant singer-songwriter and actor, he has a great talent with the camera as well.

I went over to the Chelsea Hotel and was asked to go up to his room. It was great to meet him, as I have always loved his music, particularly *Hot Buttered Soul*. As soon as I walked in he was really friendly. He had three metal suitcases full of the best cameras and lenses; I had never seen such a collection. Everywhere he goes he takes pictures. I told him we should swap jobs, and he laughed.

As the years have passed, I have had to adapt to modern technology in a big way. I have always been loyal to Nikon because they make good solid cameras without too many plastic bits that can fall off; if you drop a Nikon (which happens in this business) you can pick it straight up and continue working with it. Most importantly, the quality of their lenses is second to none.

In 1991 the *Daily Express* loaned me an Apple computer to play around with. It came with a separate modem and scanner and they asked me to scan my negatives in. They didn't want to work from hard copy any more; instead they wanted to view all the images up on their computer screens. I realised early on that things were going to change drastically for me, and I needed to learn to be competent with

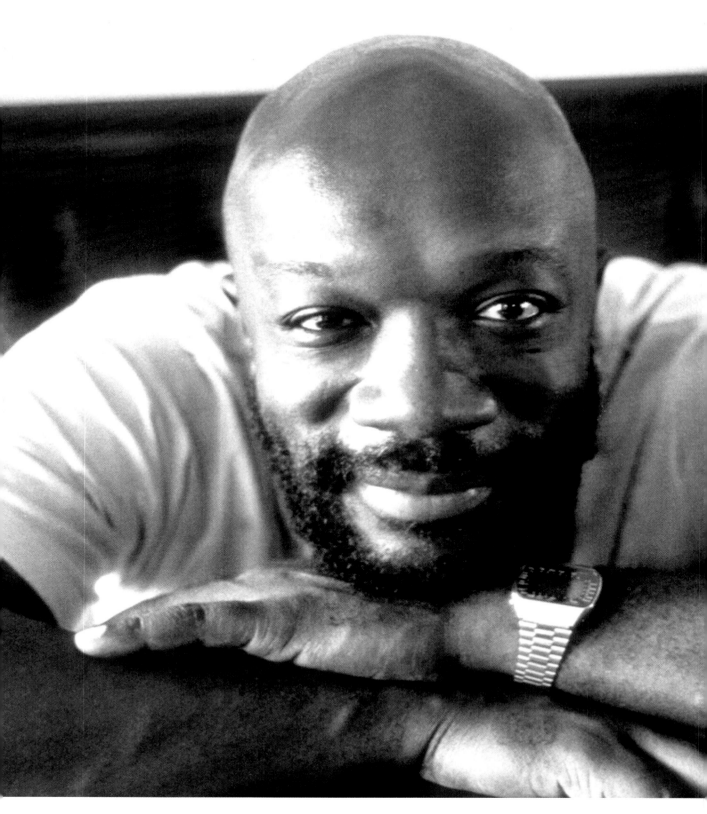

computer technology. Initially I was scared stiff: I'd never used a keyboard before, and had no knowledge of the computer world, but as the years progressed I gained confidence. The next step was to learn how to use a digital camera, and again Nikon saved the day.

Digital photography has revolutionised my life. Firstly, you can see your images the second you have taken them, and that is great, especially, for example, if someone has closed their eyes. (May I say for the record that I do not manipulate any of my images: everything you see in this book is exactly how it happened, so, if it's fuzzy, that's my fault!) Secondly, I can select and download and send my images from anywhere in the world using the Internet. I now use the Nikon D1X and D2H, which are perfect for my needs. I shoot at high resolution, and I get superb results every time.

These days all the top photographers take along their own technicians, especially at big events when it is impossible to shoot the job and download at the same time. Time is of the essence: if my images are not sent immediately to the newspapers or my agency, I will miss the deadline. However, one of the best things about my life now is that, after a hard night's work, I can go straight home and do everything there. In fact the only time I need to go out these days is actually to take the pictures. Everything is done in-house, including our photographic printing.

1
9
8
3

ava gardner, stevie wonder and lena horne

downes wine bar, london

SADLY I HAVE NO RECOLLECTION of taking this picture. Over the years I have found it increasingly difficult to remember exactly where and when every image was taken. Sometimes I even find myself surprised that a particular picture is mine! Digging deep in the archives I found this wonderful picture of Stevie entertaining Ava and Lena, and it did jog my memory of a wonderful time I had with Stevie in New York in 1972.

At that time I was working at Electric Lady Studio in New York City as a general dogsbody. Electric Lady was a recording studio in Greenwich Village owned by Jimi Hendrix. All the major artists would come down to record their albums there: Paul Stanley and Gene Simmons who later became Kiss, Led Zeppelin, Steven Stills, Jeff Beck and Stevie Wonder. I had managed to get the job through Jimi Hendrix's producer Eddie Kramer, who I knew from my days working for John Michael in Old Compton Street. I had told Eddie I hoped to move to New York, and he told me to call him when I got there and he would get me a job. He was true to his word.

I started work at six in the evening and finished at whatever time the last artist left the studio – usually around three to four in the morning. It was quite a wild time: American women just loved that good old British accent and there weren't that many English boys out in New York at that time.

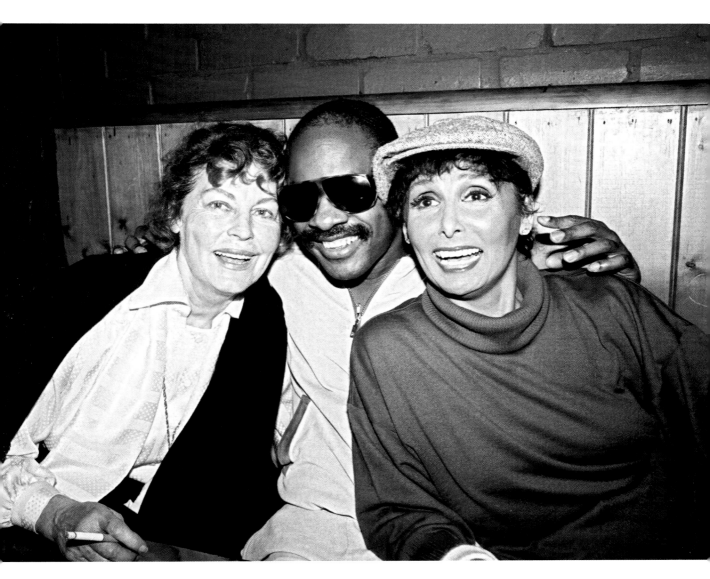

The world was my oyster, so to speak. We were all still stuck in the sixties, and I did my bit to support the cause of sex, drugs and rock and roll.

Late one afternoon, Stevie Wonder's people needed someone to take him to Washington DC as he was opening the Rolling Stones' American tour. I was asked if I would accompany him and I jumped at the opportunity. Stevie was already in the studio doing some mixes and at about four o'clock the limo arrived. We closed up the studio

and drove off to LaGuardia airport, just Stevie and me. I took him through departures and we flew business class to Washington. That was the first time I had flown club. It was fantastic. We chatted on the way – mainly about women. He was talking about relationships and life, and it was fascinating.

When we arrived we walked through the arrivals and two gentlemen approached us. One of them gave Stevie a big hug and I realised it

was Smokey Robinson, one of my heroes. I was so happy to meet him. We got into our limo, which took us straight into the underground VIP artist area in the RFK Stadium. I led Stevie to the backstage area and into his dressing room where the rest of his band were waiting.

My next job was to lead him on to the stage and place him by his microphone. As I led him out on stage about 40,000 fans roared for Stevie. It was incredible. All I could see was a sea of people, and it was a tremendous feeling. I waited in the wings until he finished his set, and then took him back to his dressing room. He wanted to return to New York that night, so we caught a plane straight back and I dropped him off at his hotel.

It was about midnight when I eventually walked back to my apartment, trying to absorb all that had happened to me that day. It was one of the most incredible moments in time; I knew from that point on that I wanted to be part of the showbusiness world, but I wasn't sure how I would get into it. Deep down, though, I knew I would be involved one day.

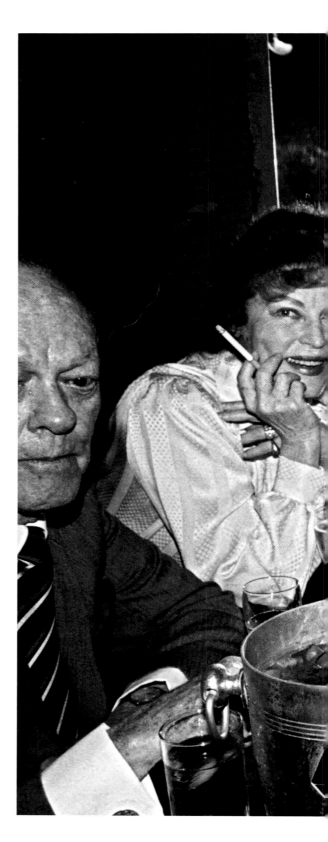

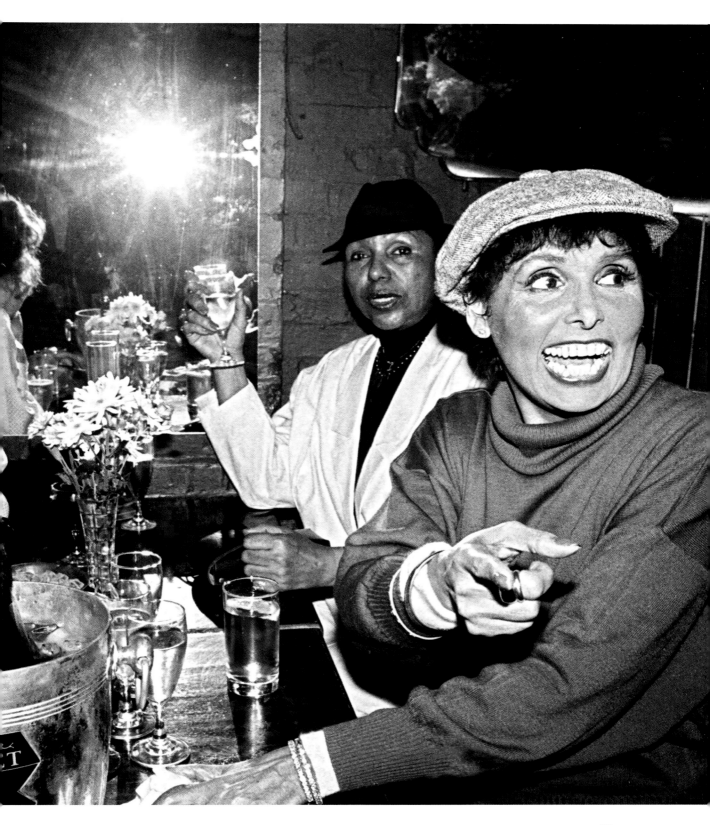

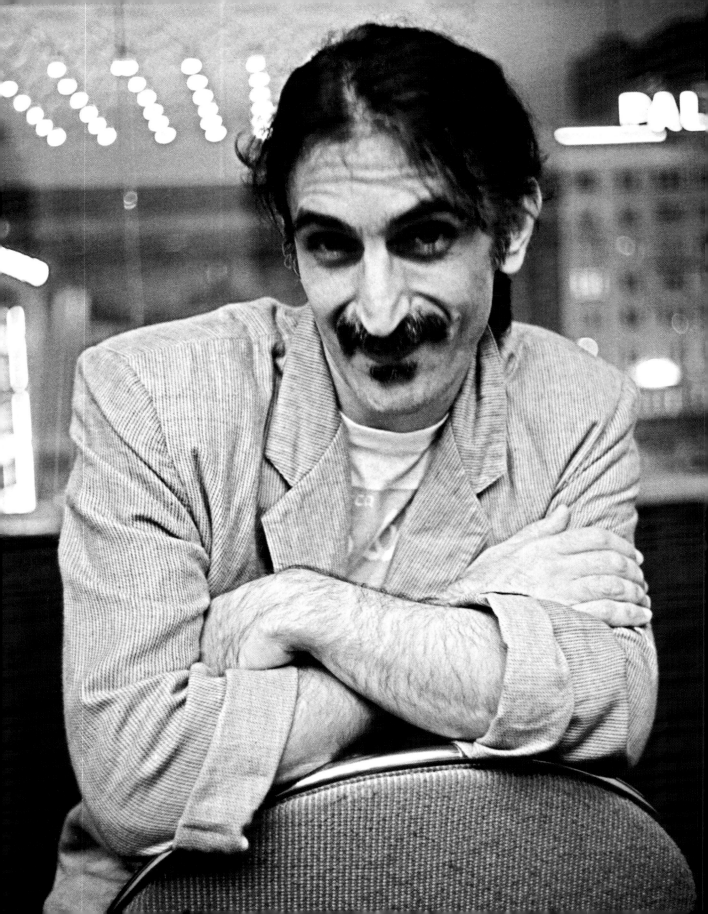

frank zappa

brussels

EARLY IN 1984 I HAD MET FRANK ZAPPA in Maunkberry's on one of those late nights; we started chatting about music, cars and girls, in that order – the usual boys' stuff. We got on so well that he invited me to cover his next concert in Brussels.

On the day I flew out, I had to meet Frank's PR guy at the airport; he turned up an hour and a half late. There I was, sitting all bright eyed and bushy tailed and waiting to get on a plane and go off on my assignment, when eventually this dishevelled guy turned up. He tried to reschedule our flights, but it was a while before he could get himself organised enough to do this! We eventually left London later on that afternoon. I wanted to go straight to the concert, but now this PR guy was ravenously hungry and wouldn't go anywhere until he had eaten steak and chips.

Of course, we arrived so late that we missed the concert. Frank had just come off stage and was in his dressing room. 'Where were you, man?' he asked. 'I didn't see you in the photographers' pit.' I told him I'd been shooting from the back of the stadium on a long lens. I didn't want to get the PR into trouble: he wasn't a bad bloke, he'd just had a bad day!.

I took a few frames of Frank in his dressing room, and when everyone had left we went back out on to the stage. I photographed him there, which was all I had wanted to do in the first place.

raquel welch and tony hadley

the hippodrome, london

PETER STRINGFELLOW OPENED UP STRINGFELLOWS in 1980. It was an upmarket, glamorous club, always full of beautiful people. For the first three years of its life, I would often be found there late at night. Peter always offered me and a couple of the other photographers breakfast on a regular basis. I must say that Peter is one of the nicest and most generous people that I know in this business and genuine too.

I always had full access to the club, and his office would often call me up to let me know who they were expecting that night; they were never short of a celebrity turnout. I remember one evening in particular. It was about two in the morning and I was sitting in the restaurant eating my breakfast. Marvin Gaye was sitting a couple of tables away from me with some friends, and there was a buzz going around that Stevie Wonder was going to pop by. Sure enough he did. Marvin got up from his table and went to the front door to greet his old mate and, as they walked back through the bar area, Marvin noticed that to the left was a grand piano. The two of them sat down and for the next hour played some of their greatest hits: it was a magical moment. I listened to these two giants of Motown jamming and believe it or not there were only about fifty other people left in the club.

A few years later, Peter opened up the Hippodrome, which was in the old Talk of The Town on Leicester Square.

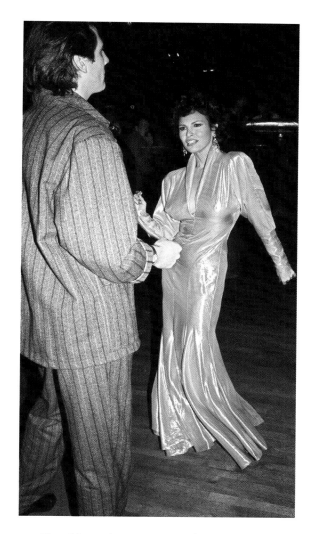

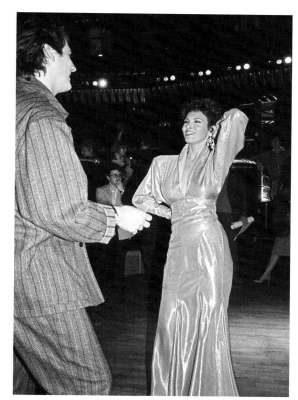

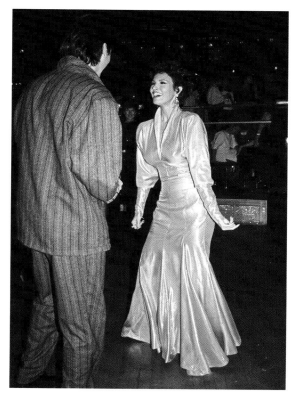

The Hippodrome was a huge venue and Peter turned it into one of the biggest nightclubs in Europe. For some time that was *the* venue to hold showbiz parties – I remember going to a party one night and even Princess Diana showed up.

I love my dancing shots. This was taken at the Hippodrome, and I think Raquel looks great in this picture. In case you're wondering, she's dancing with Tony Hadley: don't forget he was a very big name in those days as he was in Spandau Ballet. I hope you dumped the jacket, Tony!

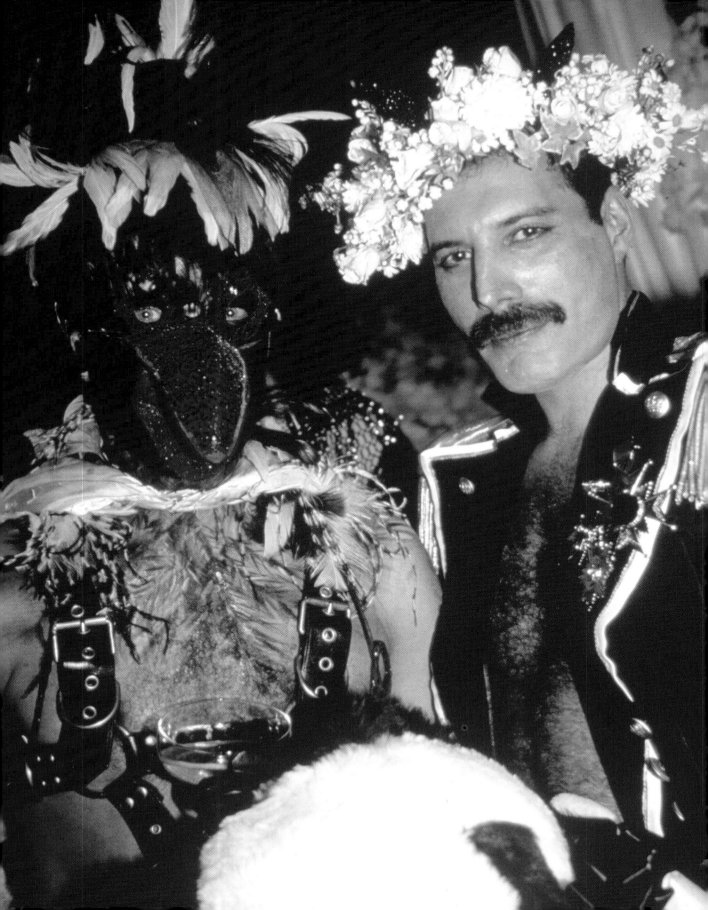

freddie mercury's birthday party

the hilton, munich

OVER THE YEARS I WORKED WITH FREDDIE on a regular basis. I covered all his parties and video shoots, and at his request I travelled all over the world with him to some fabulous places, often in private jets. I enjoyed all of the work I did with Freddie, as he and his friends were enormous fun. Everyone who worked with him had a nickname, and his nickname for me was Muriel, after Muriel Young, the children's TV presenter from the fifties. I didn't mind being Muriel; it made me feel I was part of the team. So I wasn't surprised when I got a call from Freddie's publicist Phil Symes, inviting me to Freddie's birthday party in Munich. 'Love to be there,' I said.

'Great,' he replied. 'Just remember it's drag, and that includes you!'

Susan and I had a root through her wardrobe and found the perfect dress, a baggy, black, new-romantic-style number. I loved it! I just felt it needed a little something extra, so Susan suggested a wig. Off she went to Selfridges' wig department where she was accosted by an assistant. 'Can I help you, dear?'

'Yes, I'm looking for a wig. Well, actually, it's not for me, it's for my husband.'

'Don't worry, dear,' replied the assistant. 'We get a lot in here like you.'

Off I went, dress and wig in hand, to the Munich Hilton, where a whole bunch of us was staying. As we walked through the lobby we noticed there was a fashion shoot in progress, so Phil Symes persuaded one of the make-up artists to make

us all up. There was enormous merriment – as we got ready, I accidentally ripped the bum of my tights and had to send out for a new pair. Make-up done – I went for blue eyeshadow, mascara and lipstick – I didn't recognise myself. I had such lovely eyes!

We all gathered in the bar downstairs for drinks before heading off to the party. What a bunch we were, hobbling and teetering through the lobby in our finery (although I had gone the sensible route and wore penny loafers, not heels – I didn't want to trip). I have never laughed so much. We arrived at the party and I realised I had to get working, but I was terrified my wig would get caught in my camera. Freddie arrived, his

girlfriend Mary was there and everyone was in drag; there were some great outfits and mad characters. I can't remember all of the evening – as there weren't too many celebrities there, I decided to join in the party and have a drink or two. As I'm not a great drinker, it was an exceptional night.

The party was still in full swing when I decided to make my way back to the hotel. It was three in the morning and I was a little the worse for wear. A girl approached me and said in a husky German accent, 'Darling, your shoes give you away.'

'My shoes?' I answered. 'What about my beard?'

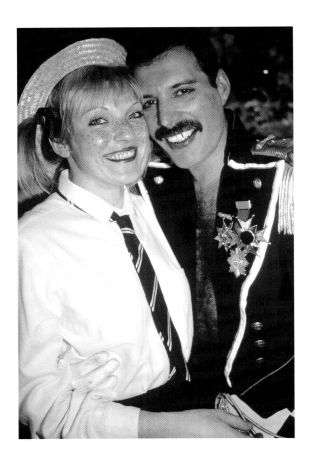

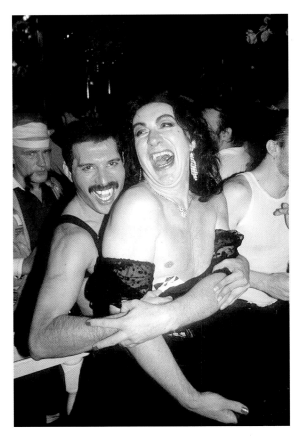

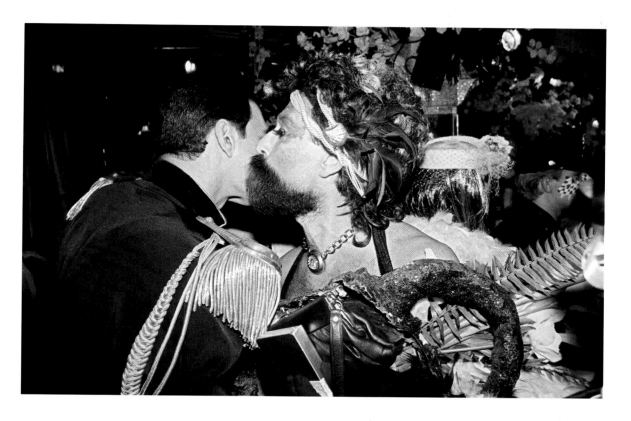

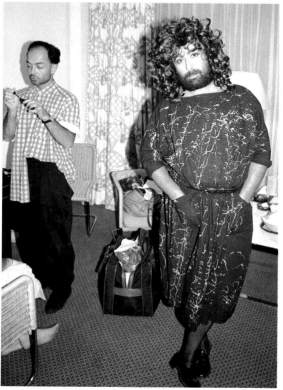

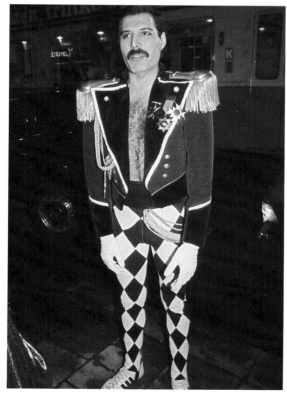

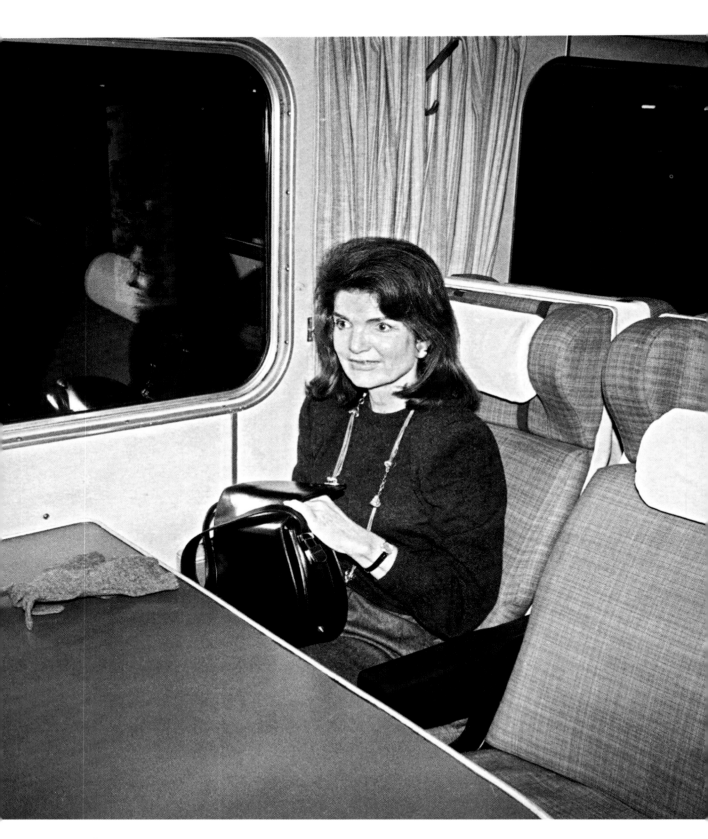

jackie onassis and teddy kennedy

euston station, london

JACKIE ONASSIS WAS IN LONDON for the funeral of her good friend Lord Harlech. Teddy Kennedy had accompanied her and they were staying at the Ritz. I had a tip-off from the doorman that they were leaving the Ritz at about lunchtime to catch a train up to Bangor for the funeral.

I rode over on my Harley, only to discover that they had already left for Euston station. I raced over there, parked on the pavement and found the platform for the express train to north Wales. I walked along the platform looking in all the windows, but I could not see either Jackie or Teddy. I walked back and coming towards me were the two of them and another woman. I fired off a few shots, no problems. They got on the train and settled in the first-class restaurant car. I decided to jump on the train to get a last picture of them, as it wasn't very often that you got to photograph Jackie O on a British Rail train.

As I was photographing them, the train began to move. I couldn't believe it. I turned to Jackie and said, 'Oh my God, the next stop is Crewe, two hundred miles away!'

They laughed their heads off. Teddy turned to me and said, 'Well, you'd better sit down and have a cup of tea, but please don't take any more photographs.'

It took two hours to get to Crewe and I had to wait forty-five minutes for the next train back. I finally got back at about eight o'clock. As there were no mobiles I'd been unable to contact anyone, so, when I got back to the office, they thought I'd been kidnapped!

live aid

wembley, london

THE SUMMER OF '85 HAD A REAL BUZZ about it. Bob Geldof and Midge Ure had previously written 'Do They Know It's Christmas?' to raise money for the famine in Ethiopia. It had been an enormous success and they decided to follow it up with a major worldwide concert with live acts in London and Philadelphia. There were only a few photographers who had Access All Areas passes including me, Dave Benett, Dave Hogan, Brian Aris and Bailey. We had to be at Wembley at ten o'clock in the morning as the concert started at noon. I didn't realise the importance of this event until I arrived and saw the amazing set-up. Harvey Goldsmith did a great job organising such a vast event. Backstage were different compounds for various artists: it was like a little village and the atmosphere was buzzing. Elton was there cooking hamburgers on his barbeque, Bowie and Paul McCartney were joking around, and there was this band called U2, who I'd never heard of. (Dave Benett told me who they were – as he often does. Thanks, Dave!) Freddie, Roger, Brian and John of Queen were partying in their compound. I spent quite a lot of time there as I always enjoyed Freddie's company, and his friends were always such good fun and extremely hospitable. Bob was flitting around, compèring and presenting on stage.

There were 100,000 people crammed into Wembley to watch the show which went live worldwide and had a live link-up to JFK Stadium in Philadelphia.

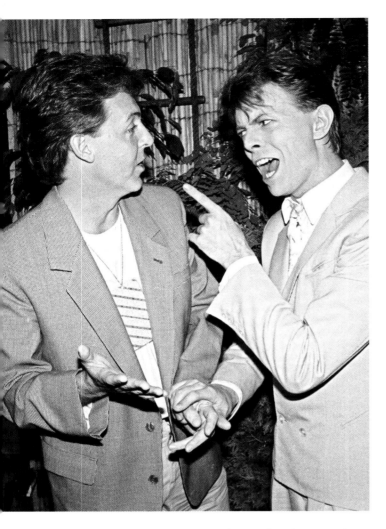

I can remember standing in the photographers' pit in front of the stage and looking behind me at this mass of people: to my right, out of the corner of my eye in the royal box I could see Diana and Charles dancing, as were Bob and Paula. It was a really joyous occasion, and I felt I was part of a historical event. Huge credit is due to Bob Geldof; he is a rare and special man.

When Queen came on everyone went mad. I think they probably gave one of their best live performances ever.

Everyone came on stage for the finale; it was a very emotional moment. Backstage after the show was indescribable. Everyone was thrilled that it had all gone so well. I hung around mopping up any odd pictures I might have missed. It was about midnight by then, and I was so tired; I had very sore feet and was extremely hungry as I hadn't had a chance to eat all day – not even one of Elton's burgers. This is when I noticed an exhausted Bob slumped against a box next to his wife Paula Yates; it was a serene moment after a manic day.

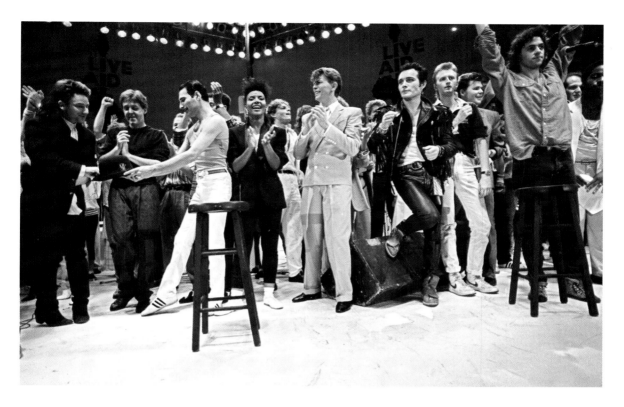

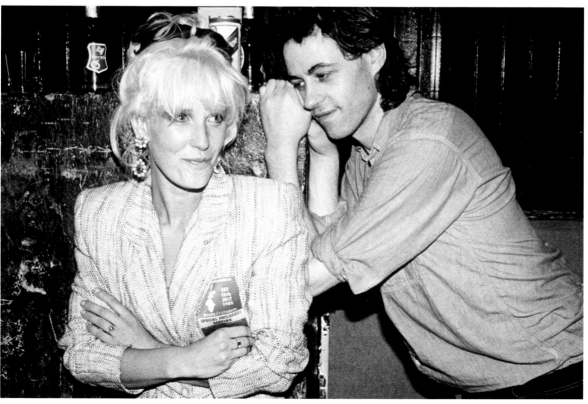

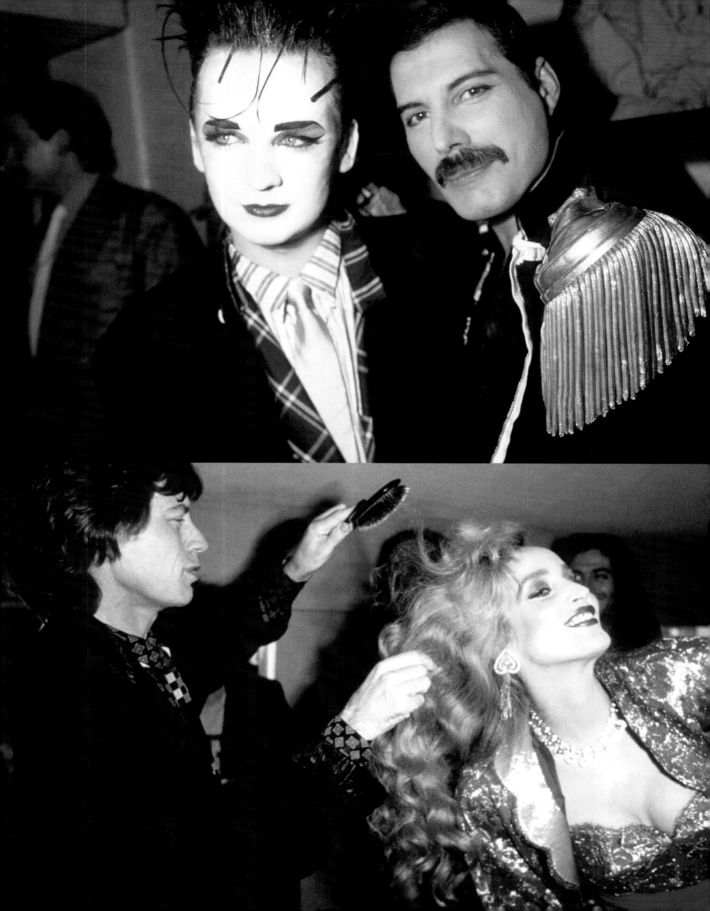

fashion aid

royal albert hall, london

AFTER LIVE AID, THE FASHION WORLD became involved in raising money and promoting awareness of famine in Africa. As I had been involved in Live Aid, I was asked to cover this event as well. Anyone who was anyone from the world of film, fashion and music was there: Jane Seymour, Mick Jagger, Jerry Hall, Freddie Mercury, Annie Lennox, Dave Stewart, Grace Jones. There were so many great photographs to be had, I just didn't know where to start. The atmosphere was so up and buzzy it made my job easy; everyone seemed happy just to be there and taking part. It was a real pleasure to be involved.

This is one of the best pictures of Mick and Jerry I have taken. He was in a great mood, and they both seemed really happy.

'If there is a photographer who captures not only the moment, the times we live in, it is Richard Young. Long after the champs are drunk and the tarts packed away for the night, we are left with Mr Young's record.'

STEVEN BERKOFF

mohamed, salam and dodi al fayed

fashion show, harrods, london

OVER THE YEARS, I HAVE HAD A GOOD relationship with Mr Al Fayed; he has always been kind and generous. There was a time when I urgently needed a room at the Ritz in Paris as I was covering the Versace show. There was no availability, so I rang his office and asked Michael Cole, his press officer whom I knew quite well, to see if he could help. He in turn asked Mr Al Fayed if there was any way they could get me into the Ritz. He actually came back and offered me one of his private apartments just off the Champs Elysées. I was so surprised. Dave Benett and I flew off to Paris; we collected the keys from the Ritz and they chauffeured us to the apartment.

We opened the door, entered a very luxurious duplex apartment and, having been told to help ourselves to anything we wanted, we started exploring the kitchen. To our delight, we found the fridge full of Beluga caviar, smoked salmon, fois gras and other delicious bits and pieces. Dave and I looked at each other and said in unison, 'They did say we could help ourselves!' And so we did. We polished off everything in the fridge. It was delicious.

Sadly we had to rush off to the show and didn't return until late – the fridge hadn't been replenished when we got back. Oh well, never mind! We left early next morning, having thoroughly enjoyed our stay.

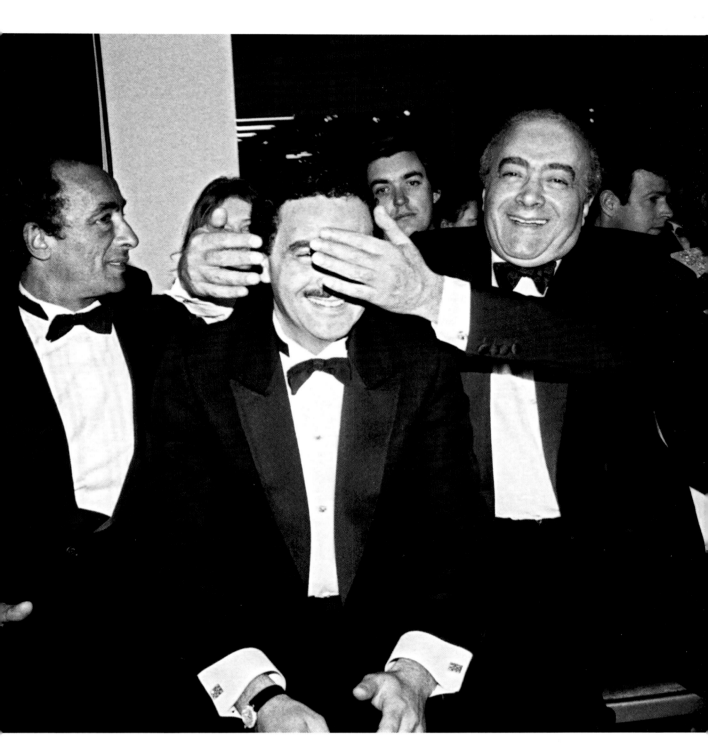

I have photographed Mohamed and his son Dodi many times over the years, and since Dodi's untimely death with Princess Diana I can't help feeling terribly sad about Mr Al Fayed's great loss. I can't imagine how you would get over the death of your child.

miles davis

royal festival hall, london

HAD I NOT BEEN A PHOTOGRAPHER, I would love to have been in the music business, either as a musician or on the production side. My love of music started at an early age: my father would play his old records to me on Sunday afternoons – Johnny Rae, Frank Sinatra, Sammy Davis Jr, John Coltrane, Lester Young, Stan Getz and Roland Kirk. I loved the romance of jazz music.

I was eleven years old when my elder sister Rochelle took me to a dance for the first time. It was at a Jewish youth club in Stamford Hill, and it was there that she introduced me to blues and soul music. I had never heard anything like it before and it set me on fire: it had such a powerful effect on me that since then my whole life has been full of music. I had an enormous vinyl collection which I sadly had to sell in 1970 in order to pay for my trip to New York, and since then I have amassed a large collection of CDs, many of them replacing what I sold in the seventies. I'm still listening to a lot of the same stuff I listened to back then – Bob Dylan, Neil Young, Leonard Cohen, Love, the Doors, Jefferson Airplane, Grateful Dead and Bruce Springsteen – but, in fact, I listen to anything. My son Sam has inherited my love of music and has become an extremely accomplished DJ who is making waves on the London club scene. His knowledge and understanding of music is phenomenal.

When I heard that Miles Davis was appearing at the Royal Festival Hall, I was

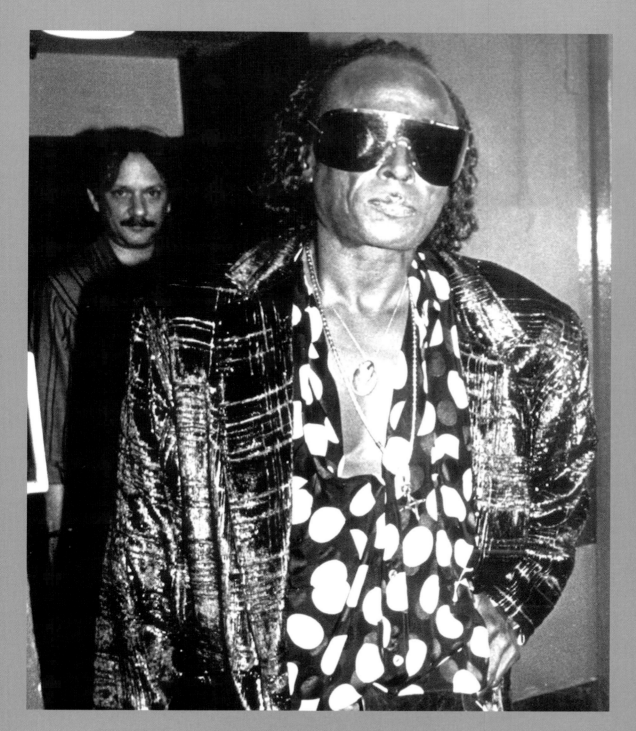

determined to get backstage and try to get a shot of him. I hadn't seen that many backstage pictures of him. I managed to get a photo pass from the promoter, and once I was there I persuaded his people to let me take a couple of quick pictures just before the gig started.

And then I went and watched the show, which was fantastic.

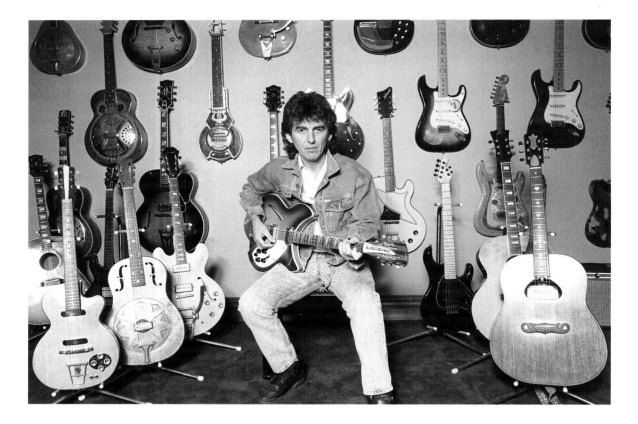

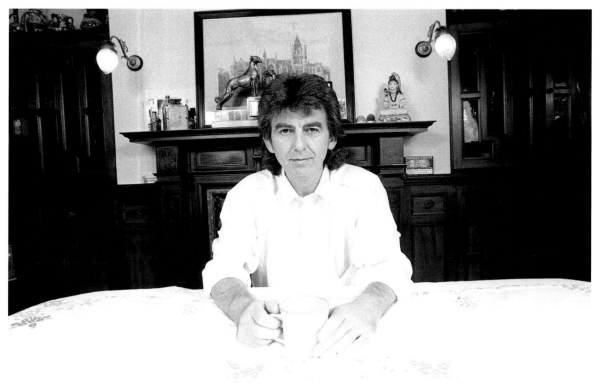

george harrison

at home, berkshire

I HAD JUST LEARNED TO DRIVE A CAR (I'm a bit of a late starter) and was racing around town in my battered-up old Golf with one of the first generation of mobile phones in my hand. They weighed a ton and the battery only lasted fifteen minutes, but I felt really cool. My career was going well, Susan had just given birth to our beautiful daughter Hannah, and everything was back on track – I felt on top of the world. My heavy mobile rang. I pulled over to lift it up and all I could hear was this Liverpudlian accent saying, 'Hello, how are you? It's George.'

'George who?' I asked. Well, it's not every day a Beatle calls.

'George Harrison!' He wanted to know what I was doing on the Saturday, and would I drive down to his house in Berkshire and take a few pictures of him and his family. I was absolutely gobsmacked, and of course I accepted.

I drove down in the Golf, arrived at the gates and rang the bell. Two school kids walked past me and said, 'You'll never get in there, mate!' at which point the gates opened and I drove up the long driveway to the front of the house and parked outside. The front door was opened, and George's wife Olivia invited me into the kitchen for breakfast. George had just got up.

After breakfast George and I decided to walk around the grounds: the gardens were his pride and joy, and they were very beautiful.

He pointed out certain locations where he wanted to be photographed. We spent most of the morning and early afternoon doing the pictures, and after a light lunch I photographed him with Olivia and their son Dhani. Then George showed me around the house where I photographed him in his guitar room. He explained the history of each instrument and who had given it to him. I really loved the guitar that Roger McGuinn of the Byrds had given him; it meant a lot to me seeing that guitar as I am a great fan of the Byrds. Later that afternoon we went into his recording studio where he played me some tracks from his new album, *Cloud Nine*.

I felt so thrilled to be in George's company. He was a very warm and interesting man and it was a special day for me that I shall always cherish.

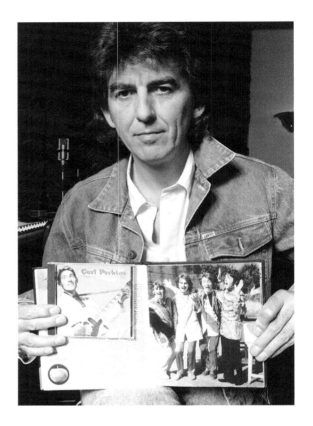

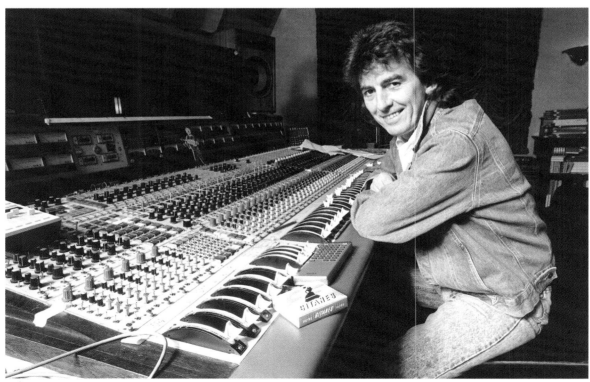

▲ Michael Brandon and Bill Wyman

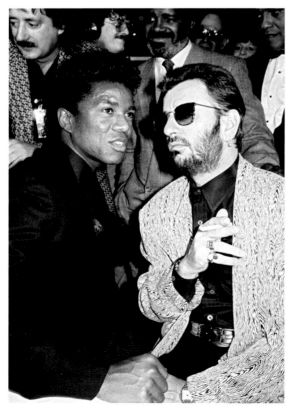

Ringo Starr and Germaine Jackson ▲

Jerry Lee Lewis ▲

opening of the london brasserie

atlanta, georgia

PRESS JUNKETS CAN BE A LOT OF FUN as long as you are travelling as part of the entourage. Sometimes PRs can be quite disrespectful to the press and will not necessarily give them the same benefits as other people on the trip. But, when Bill Wyman's people called me up and asked me if I'd like to go to the opening of Bill's new restaurant in Atlanta, it was clear this wasn't going to be one of those trips. They were chartering a flight for press and guests only, so it was first class all the way. We flew out with Bill Wyman, Ringo Starr and Michael Brandon and spent the journey playing blackjack and poker. We were picked up by a double-decker bus and had a police escort to our hotel; we were treated like visiting royalty.

The next day we went sightseeing and shopping, and that night was the opening. It seemed like the whole of Atlanta had congregated outside the restaurant – fans, policemen and film crews all added to the mayhem. I was the only photographer inside, just the way I like it.

Everyone arrived, we had dinner and there was a stage set up for a jam session later. Germaine Jackson was singing, as was Jerry Lee Lewis. Ringo played drums, Bill played guitar, Kenny Everett was camping it up and my old mate Isaac Hayes was playing keyboards and singing. It was amazing. After the party we all went back to the hotel and, as is usually the way with these trips, straight back to London in the morning.

bette davis

grosvenor house hotel, london

IN GENERAL, I TEND NOT TO COVER PHOTOCALLS. Firstly, they are often very early in the morning so you have to be there at the crack of dawn to get a good position, and secondly, there are usually so many photographers invited, it's just not worth it. In the early days I would make the effort because there weren't so many photographers and I was more hungry for work. Nowadays it has to be a very special person for me to attend a photocall. The last one I did was at Selfridges in 2003 for Victoria Beckham's launch of Damon Dash's Rocawear. I had to be there at half-past eight in the morning and I was twenty-fifth in line. I wasn't too happy until the press officer came over to me and Dave Benett and said, 'You don't need to worry, we've marked your position up right at the front and dead centre.' That took the pain out of the job! Victoria turned up thirty minutes late (which wasn't too bad – I've waited up to four hours in the past for other celebrities), stood on the stage for no more than one minute and was then swept away.

Some years earlier I was offered the opportunity to photograph a great Hollywood legend: Bette Davis. I was not going to say no as we don't get to see too many legends in London. It was an opportunity not to be missed. Bette was in London to promote her book. It was a great photocall because they limited the number of photographers. I don't think she wanted to make a big song and dance about it, as she was a little fragile at this time. What style this woman had – I think the picture speaks for itself.

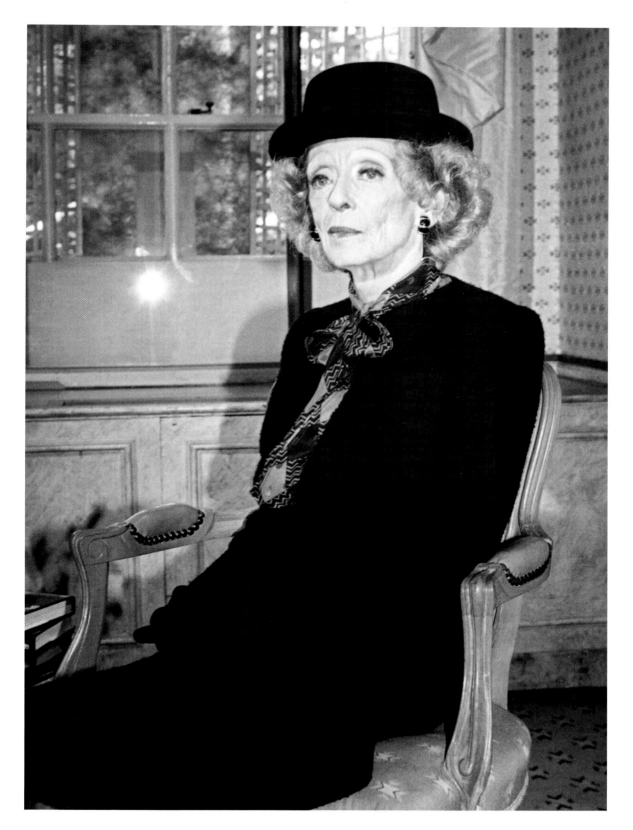

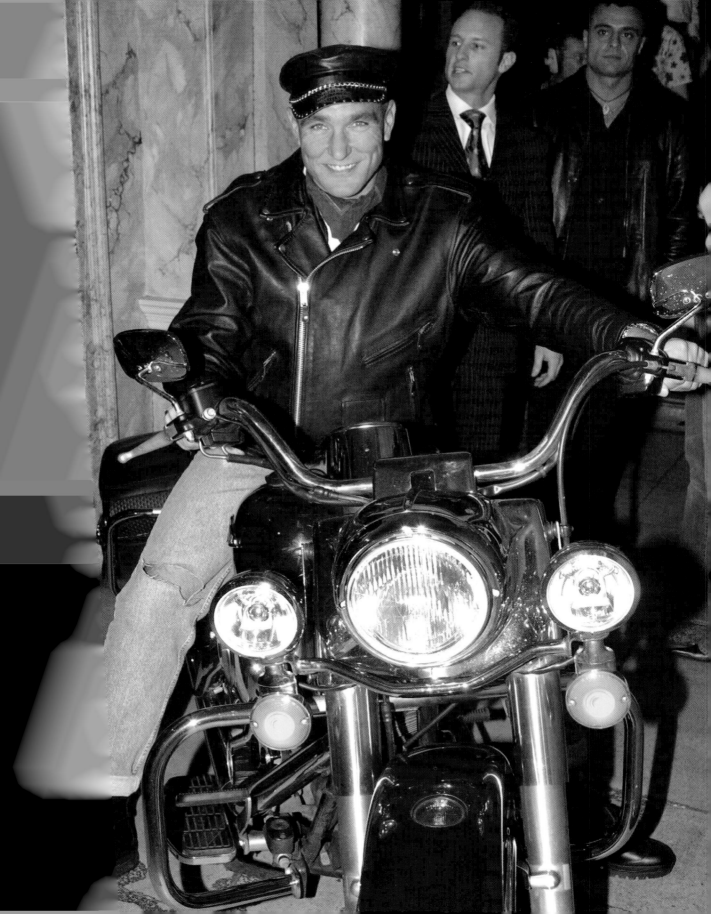

happy harley days

IN THE MID-SIXTIES I WAS WALKING down Kings Road when I saw a beautiful blonde girl in a white leather catsuit riding a white Harley Davidson Electra Glide. It was love at first sight. This vision has stayed in my mind to this day and from that moment on I wanted one of those machines. I discovered Fred Warr, the main Harley Davidson dealer in London, and he became an important part of my life. I would go into his little shop at World's End and collect leaflets on bikes. At the time, buying a bike seemed an impossible dream.

Finally in 1982, the day after I passed my motorcycle test, I saw an advert in a bike magazine and purchased my first Harley for £900. It was a sportster. I had problems with it from the day I bought it, and after three months I sold it to Fred Warr for £1,500 (don't ask me how) and got myself a decent bike, a beautiful black Electra Glide. That was it. I was on my way. It meant I was finally mobile after all those years.

I started turning up at all the parties and premières on my bike, my cameras tucked away in the top box. I soon became quite well known as the paparazzo on the Harley; it became part of my image, and I loved it. As the years progressed I became more and more addicted to the Harley lifestyle. I became a lifetime HOG (Harley Owners' Group) member. I'd hang around with other Harley riders and we'd go off on long runs, and then I started going to Harley rallies. A group of us would go to Yorkshire or Brighton – on a couple of occasions I even took my own tent. I soon gave that up for a five-star hotel.

◄ Vinnie Jones

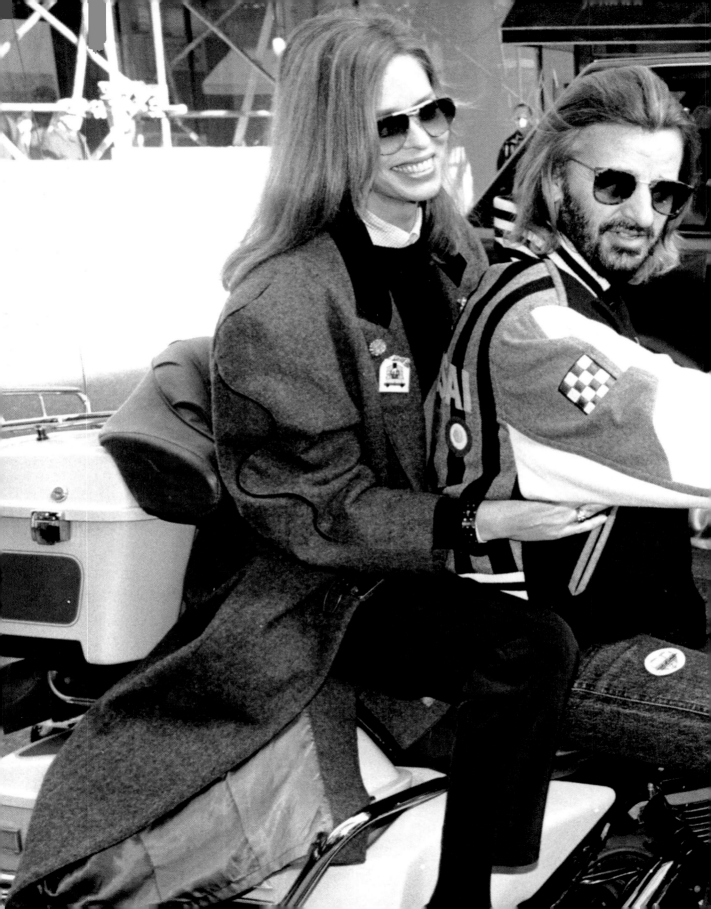

I didn't like roughing it that much! Later on I started travelling further afield, making memorable trips to Daytona and Sturgis for the Harley Davidson rallies. I became friendly with all the top executives at Harley, which enabled me to have good access to all their events. I've made many great friends through my love of Harleys and they are not all RUBS (rich urban bikers). I love all the characters at the rallies, the camaraderie and friendship is wonderful. I remember going on a solo run to Brighton once and on the way back I had to stop a couple of times as nature called. Every time I stopped, at least two or three bikes pulled over to ask if I was OK. You would never get that with car drivers.

I've always made a point of photographing famous people either sitting on my bike or on their own. The list is endless: Lou Reed, Ringo Starr, Mick Jagger, Neil Diamond, Peter Fonda, Mickey Rourke, Paul Young, Terrence Trent D'Arby. A couple of years ago I was invited by the London Hell's Angels to their club house in the East End to photograph the most famous Hell's Angel of all, Sonny Barger. He was here to promote his book, and I wasn't sure what to expect.

Susan and I turned up looking very chic as we were off to a party later. We looked a little out of place, but were still warmly welcomed. Sonny turned up later with all his people and was happy to pose up for some pictures. I was surprised at the kind of people who were Hell's Angels; they didn't conform at all to the image we generally have of them, but they all seemed really nice people.

To this day, people come up to me and say, 'How's your bike?' In fact, I stopped riding on a daily basis back in 1997, but I still have a Harley at my house in Suffolk. And I still love the freedom of being in the saddle, cruising along the sea front. I still haven't lost the easy rider in me.

Opposite: Sonny Barger (right) ▶

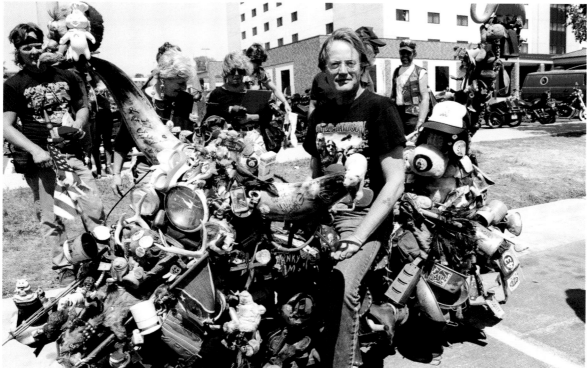

▲ Peter Fonda

sammy davis jr

london

IN 1958, WHEN I WAS ELEVEN YEARS OLD, my dad arranged a special treat for me: a visit to the London Palladium to see Sammy Davis Jr. Just the two of us went and we had a brilliant evening. My dad loved Sammy very much, so I was really happy to have the opportunity to photograph him many years later.

Sammy was often in London with his wife Altovise, and I have photographed them on a number of occasions. I used to love seeing him because he was always laughing and having a good time.

When he died in 1990 I happened to be in Los Angeles and was invited to attend the funeral by my old friend Joyce Blair (Lionel's sister) who was a good friend of Sammy's. After the funeral Joyce asked me if I would like to join everyone back at Sammy's house for drinks, but I had to decline as I had a job on. The next day I heard that Frank Sinatra had turned up and had sung some of the songs he used to sing with Sammy. I really regretted that I wasn't able to be there – it would have been an incredible evening.

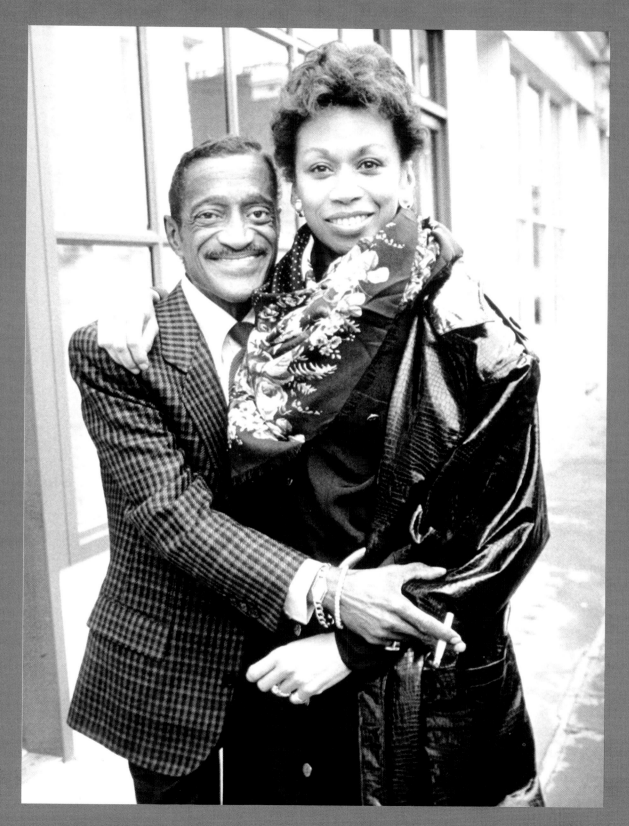

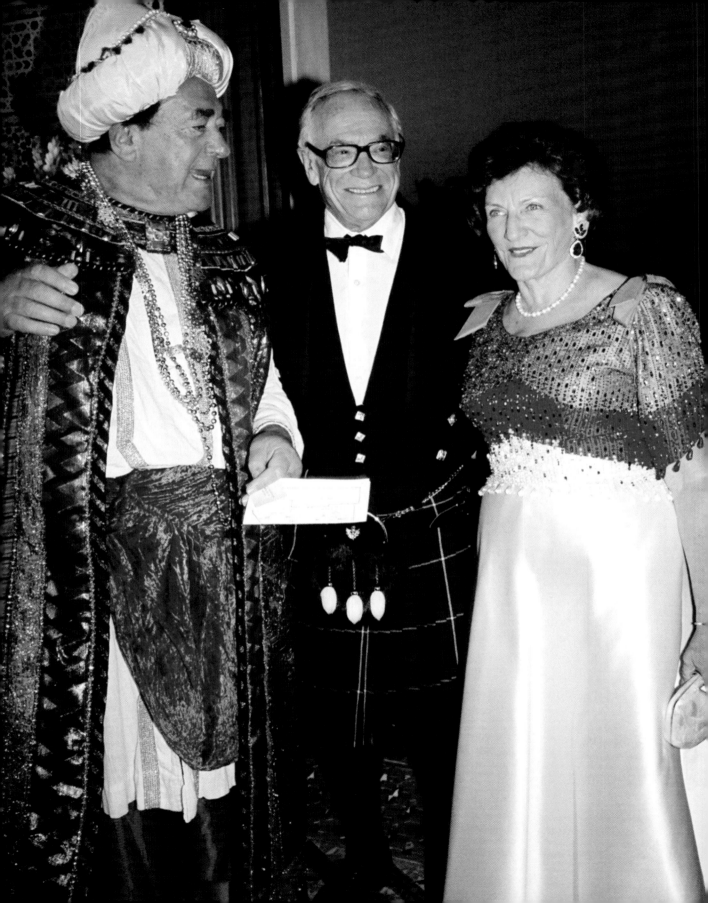

malcolm forbes's party

tangiers, morocco

IN JANUARY 1989 I WAS IN NEW YORK for the Rock and Roll Hall of Fame awards. While I was there I was invited to a big charity antiques fair at the 7th Regiment Armory on Park Avenue. The tickets were sold at two price levels. Tea from four till six was $1,000, and if you arrived for drinks between six and eight it was $500. So the earlier you arrived, the richer you were. I arrived at the early slot, which was when all the most interesting people turned up. Paul Newman was there with his wife Joanne Woodward, as were all of New York's high society.

I noticed that Malcolm Forbes had arrived and made a beeline for him; I knew he was a fellow Harley rider, so I wanted to have a chat about bikes. I introduced myself and explained I was interested in joining him on one of his tours that he and a group of his friends used to organise. About twenty of them would put their bikes on to Malcolm's private plane *The Capitalist Tool*, and fly to a third world country where they would ride through and donate aid and money to children's charities. Malcolm gave me his card and told me to call his office, which I did, giving them all my details. About five months later I got a call from *Forbes* magazine's press office asking if I would like to go to Tangiers to cover Malcolm Forbes's seventieth birthday party at his palace? Of course I would – no question!

I arrived in Tangiers and was put up in a fabulous hotel; people were jetting in from

◀ Robert and Betty Maxwell, with party host Malcolm Forbes

all over the world, but mainly America. On the Friday I went to the airport to photograph everyone arriving: Calvin Klein turned up, Barry Diller, Diane von Furstenberg, James Goldsmith, Gordon and Anne Getty, Henry Kissinger, Robert Maxwell and Elizabeth Taylor. Some stayed at Malcolm's palace, others stayed in the same hotel as me. On the Saturday morning there was a photocall at the palace with Elizabeth and Malcolm, and while I was there I heard Rupert Murdoch was hosting a lunch on his boat in the harbour. So I jumped in a cab, went down to the harbour and waited for the guests to arrive for the lunch party. I didn't notice any *Sun* photographers around (the *Sun* is Murdoch's

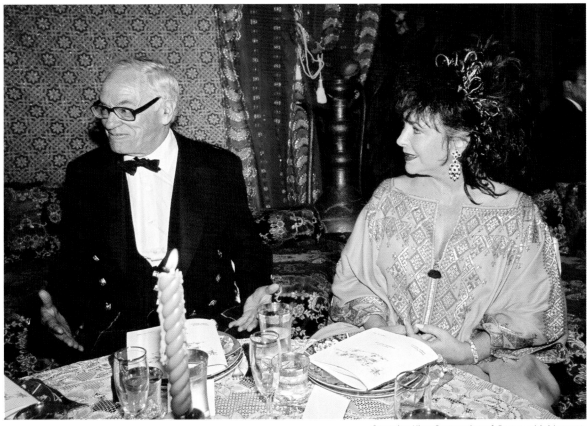

Opposite: King Constantine of Greece with his sons ▶
Prince Nikolaos (*left*) and Crown Prince Pavlos (*right*)

paper), so I went up to the security on the boat and told them I was the photographer from the *Sun* in London and was here to cover the lunch; they went and checked if it was OK and then came back and invited me on board – even though I actually was with their rival paper the *Express*. It was a beautiful boat. I photographed everyone having a great time, and no one asked me any questions.

That evening was the main party at Malcolm's palace, and it was amazing. The dress code was either black tie, Moroccan or traditional Scottish. Robert Maxwell turned up in Moroccan attire. It was an opulent affair: the entire place was decorated like a Bedouin tent, and there were whole lambs roasting, Moroccan tagines, amazing fruits and desserts, music and dancing till the early hours.

The following morning I arrived at the airport only to find there was a delay on my flight back to London. Out of the corner of my eye I noticed King Constantine of Greece walking across the tarmac to his private plane. 'Good morning, sir,' I called out. 'Any chance of a lift back to London? I'm delayed.' He waved back and kept walking. A few moments later the captain of his plane came back to me and said, 'King Constantine would love to give you a lift back to London, but sadly he is flying to Austria!' Oh well, maybe next time!

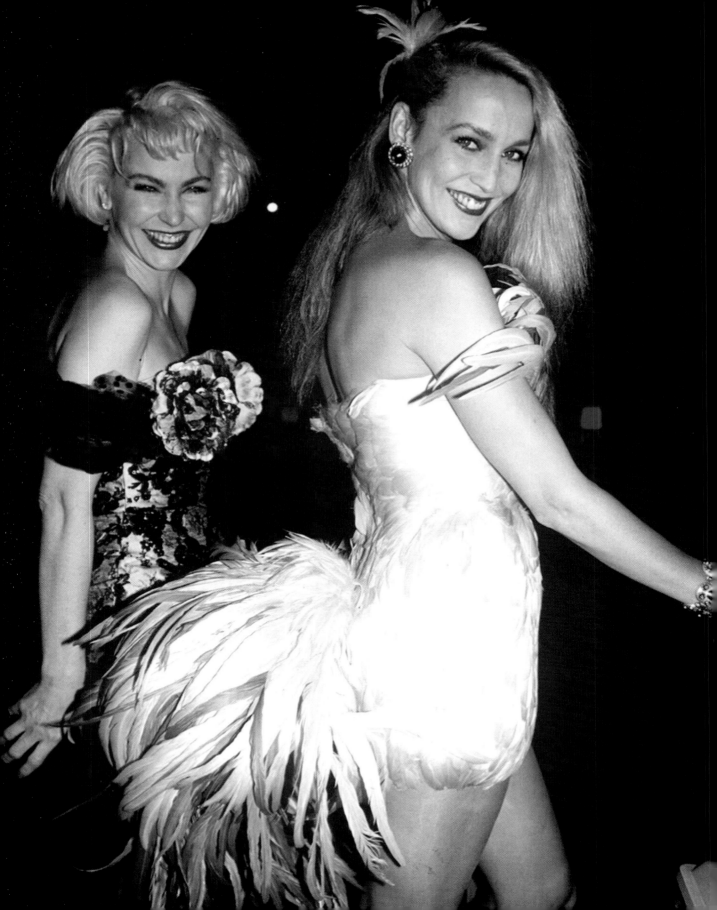

jerry and rosie hall

notting hill, london

I HAVE KNOWN JERRY FOR OVER TWENTY YEARS. I first photographed her when she started dating Mick Jagger in the early eighties. In my view she is one of the all-time great models, along with Jean Shrimpton, Twiggy, Christie Turlington, Linda Evangelista and, of course, Kate Moss and Naomi Campbell. These have been the girls I have enjoyed photographing the most over the years.

Jerry is a rare character. I have never seen her in a bad mood, and she is always charming and has a smile for everyone. Considering the difficult times she must have been through over the years, which were often chronicled in the press, I find it admirable that she has always managed to be cheerful. That must take some doing.

I have photographed Jerry with all her children since they were born, and now it is Elizabeth, her eldest daughter, that everyone wants to capture on the catwalk. I just don't know where the years have gone – I took my first picture of Elizabeth when she was two weeks old.

This picture of Jerry and her sister Rosie is a favourite of mine because I know that the two of them are really close. Rosie is also a very nice woman. And it's not often I get to photograph Jerry dressed as a chicken!

nelson mandela

wembley stadium, london

NELSON MANDELA HAD FINALLY BEEN RELEASED from prison on Robben Island in February 1990; later that year Harvey Goldsmith organised a huge concert at Wembley Stadium to celebrate. Obviously I had never photographed him before, so I was very pleased to be able to cover such an event. The line-up was impressive: Neil Young, Lou Reed, Peter Gabriel, Terence Trent D'Arby and Steve Van Zandt.

Since 1990 I have had the good fortune to work with Mr Mandela on at least four or five occasions. Most recently I was flown out to Cape Town to cover 46664. Dave Stewart and Bono had organised a massive concert to bring AIDS awareness to the world, and the number 46664 was Mr Mandela's prison number on Robben Island. I always feel very humbled when I meet a man of his calibre; he is truly a remarkable human being.

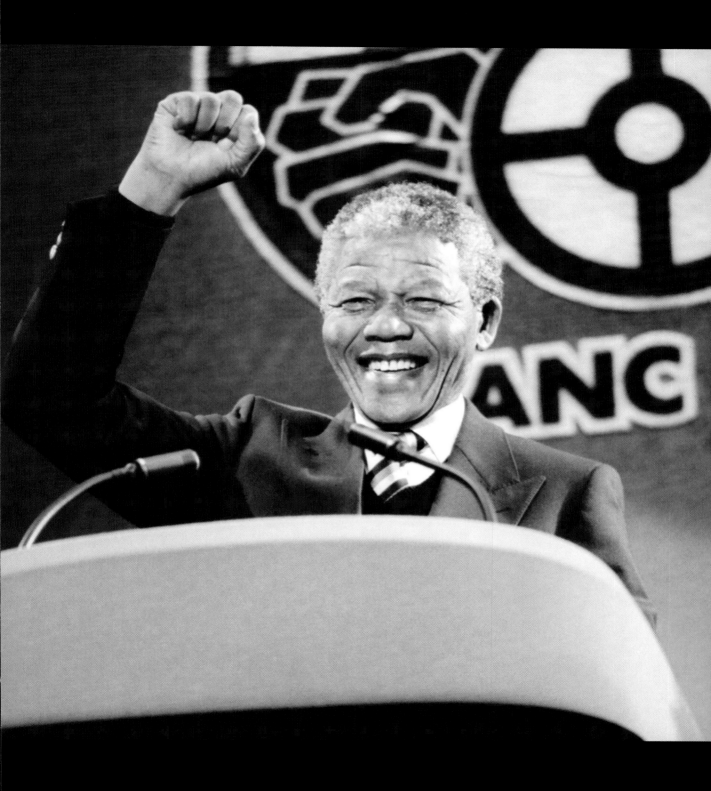

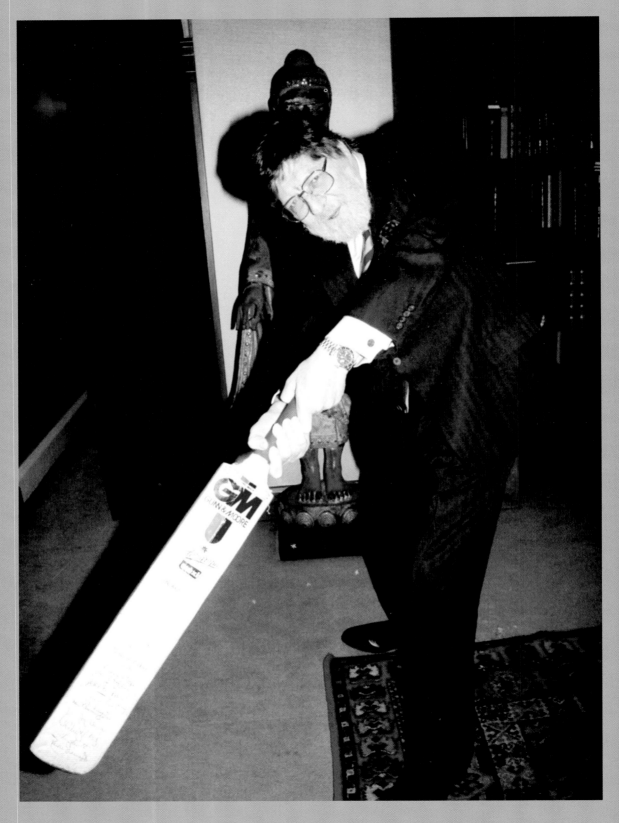

sir john paul getty

st james's, london

AS I HAD A LONG-STANDING FRIENDSHIP with the Getty family, word got to me that Paul would like me to take some pictures of him at home. I went to his apartment in St James's and was told by him that I only had half an hour, which was perfect as I work quickly. Three hours later we were still at it! We had a good old chat, talking about the old days when I used to come up and see him with his son Paul, and somehow the time just flew by. I took various pictures of him in most of the rooms of his apartment, and he showed me his cricket technique, a gesture I found quite charming. He loved his cricket, and also his books and music. Towards the end of the session Victoria arrived. Paul insisted that she came and sat next to him and instructed me to take some pictures of them together.

I think the reason I get invited into people's homes so often to photograph them is because I don't make a song and dance about it. I don't use lights or make-up or assistants. I walk in, camera in hand, and it's all very spontaneous and natural. Keeping it simple takes a lot of the pressure off.

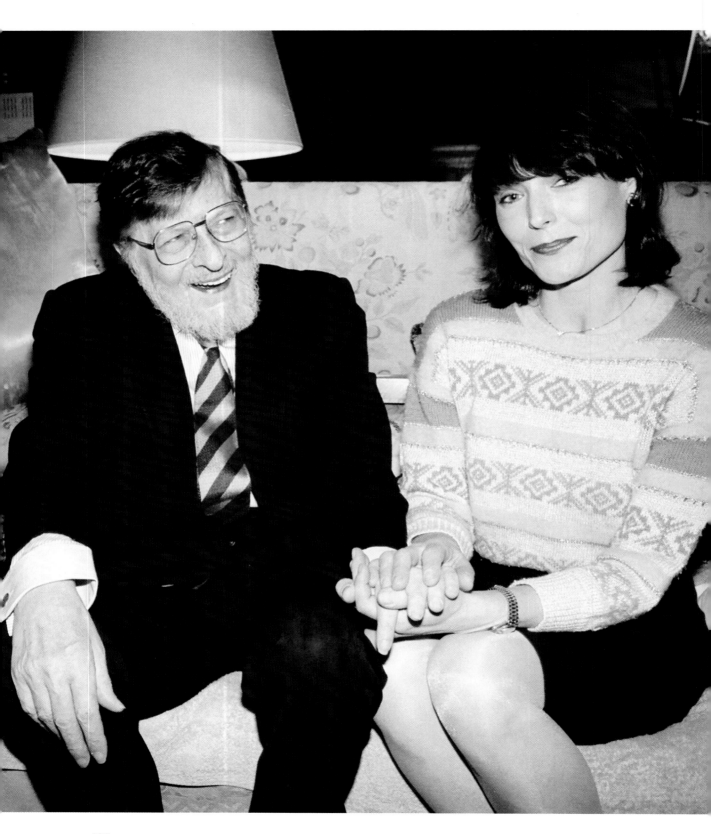

frank sinatra

langan's brasserie, london

AS USUAL, MICHAEL CAINE HAD HIS summer party during Wimbledon fortnight. He invited a lot of American showbiz pals, took over the Venetian room upstairs, and as usual I was invited in.

I had heard that Frank Sinatra was going to turn up that night. It was very rare to see him in public places, so I knew it would be worth waiting for that exclusive shot if he did turn up. I knew that he would be surrounded by his own bodyguards – I reckon he was better protected than the Royal Family! I had also heard that his people would even do dummy runs through Heathrow, just to test security – definitely a team not to be messed with!

As he walked through the main door into the restaurant, everyone stood up and applauded him. He was friendly and happy and even chatted to a few people before making his way upstairs to Michael's party. In the thirty years I've been photographing celebrities, I have never seen people in a restaurant react in that way. Sinatra commanded huge respect.

opening of planet hollywood

new york city

FREUD COMMUNICATIONS WAS HANDLING THE opening of a new chain of restaurants owned by Robert Earl called Planet Hollywood. They were Hollywood-themed restaurants based around movie memorabilia. Stars involved included Sylvester Stallone, Arnold Schwarzenegger, Bruce Willis and Demi Moore, and the opening was one of the biggest showbusiness events at that time. I was the only photographer from London allowed in, and I even had access to the VIP room which is a rare treat these days. There were so many stars I didn't know where to start. I managed to get a fantastic number of different combinations of people including Glenn Close, Don Johnson, Melanie Griffith, Stevie Wonder and Eddie Murphy; Caroline Kennedy arrived, as did Elton John. It was fabulous to have such access to a party like this, and as you can see from the pictures it made a great spread for the newspapers and magazines.

A year later, Planet Hollywood opened in London and then all around the world. I covered all their openings, and they were always fantastic.

1991

◄ Richard Harris

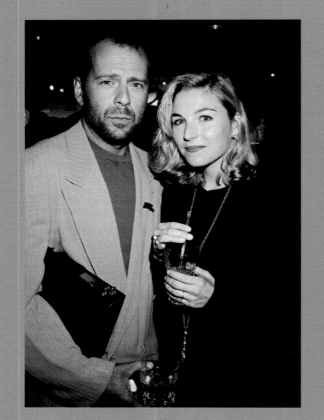

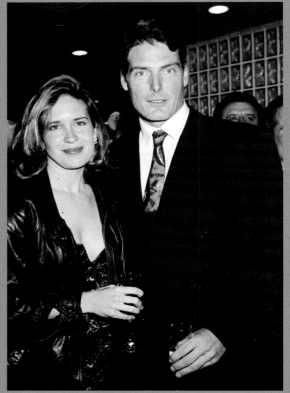

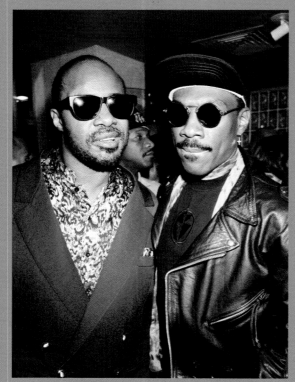

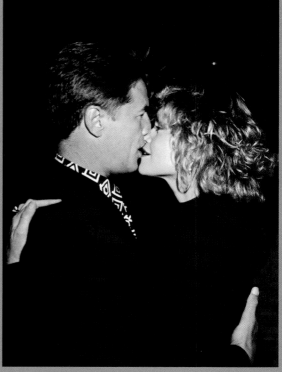

Clockwise from above left: Bruce Willis and Tatum O'Neal; Christopher and Dana Reeve; ▲
Don Johnson and Melanie Griffith; Stevie Wonder and Eddie Murphy

Opposite: Glenn Close ▶

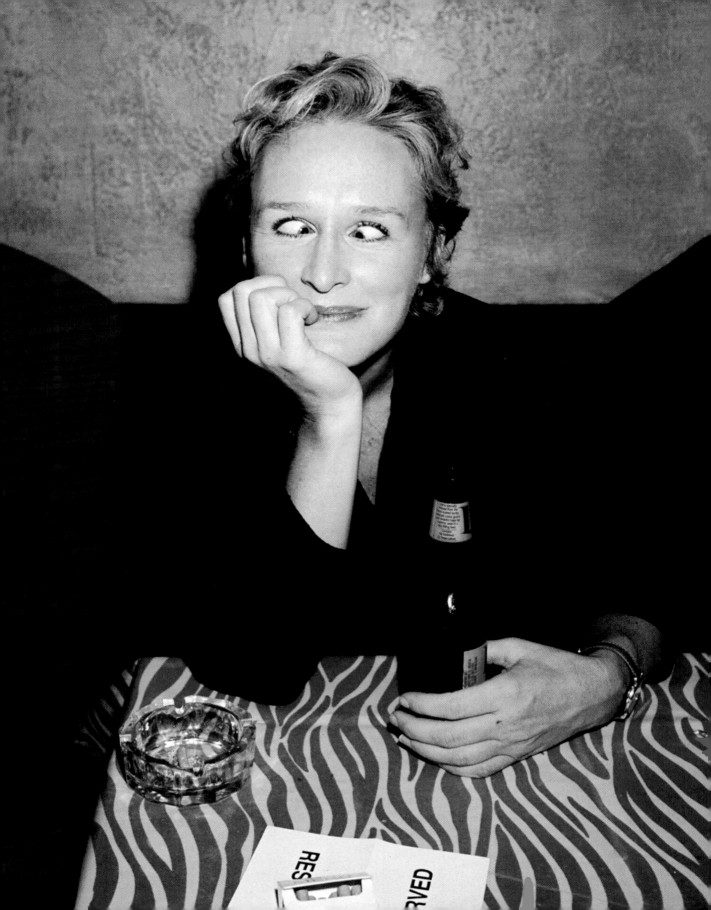

prince charles and susan george

smith's lawn, windsor

I HAVE BEEN A MEMBER OF THE GUARDS POLO CLUB at Smith's Lawn for over twenty years. I started going initially because there was a lot of royal activity happening there. Prince Charles was playing there on a regular basis and used to take his then girlfriend, Lady Diana Spencer. As you can imagine, polo became a very popular sport around that time. But, away from all that madness, I absolutely love the surroundings – only thirty minutes from London and you are in some of the most beautiful parkland in England. There is nothing more pleasurable than spending a summer afternoon watching a game of polo, sipping a Pimm's and nibbling on a smoked-salmon sandwich. So civilised!

Once, after I had been to the first day of Royal Ascot, I decided to pass by Smith's Lawn for a cup of coffee. I was sitting in the members lounge, minding my own business and eating a rather messy chocolate cornflake cake, when suddenly behind me I hear, 'Hello, Mr Young. How are you? May I join you?' I looked around and to my surprise it was Princess Diana. I had first met Diana when she was a nursery-school teacher, and had photographed her ever since, which is why she recognised me.

She came and sat down opposite me and asked what I was eating. I explained it was a delicious chocolate cornflake cake. 'I'll have one of those,' she said.

I was a bit surprised because she was in a pale yellow suit and hat and I was worried

she would get chocolate all over herself. My camera was sitting next to me on the floor and I felt it would have been inappropriate to take pictures of her with chocolate all round her mouth, so we just sat and had a nice chat.

This photograph of Prince Charles and his old friend – and reportedly old flame – Susan George was taken at another event at Smith's Lawn. Charles's good friend Lady Dale Tryon had organised a lunch in aid of the mental health charity SANE, which was close to Charles's heart. I was invited to the lunch and Charles popped in to say hello to the guests before they sat down. As he moved around the tent, he came across his old friend Susan George. I just captured this in a split second. I love the spontaneity and the chemistry of this image; it shows such warm feelings between them.

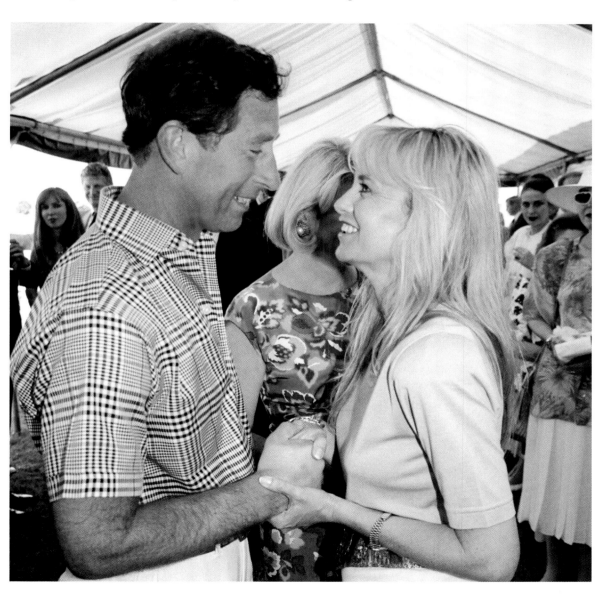

1991

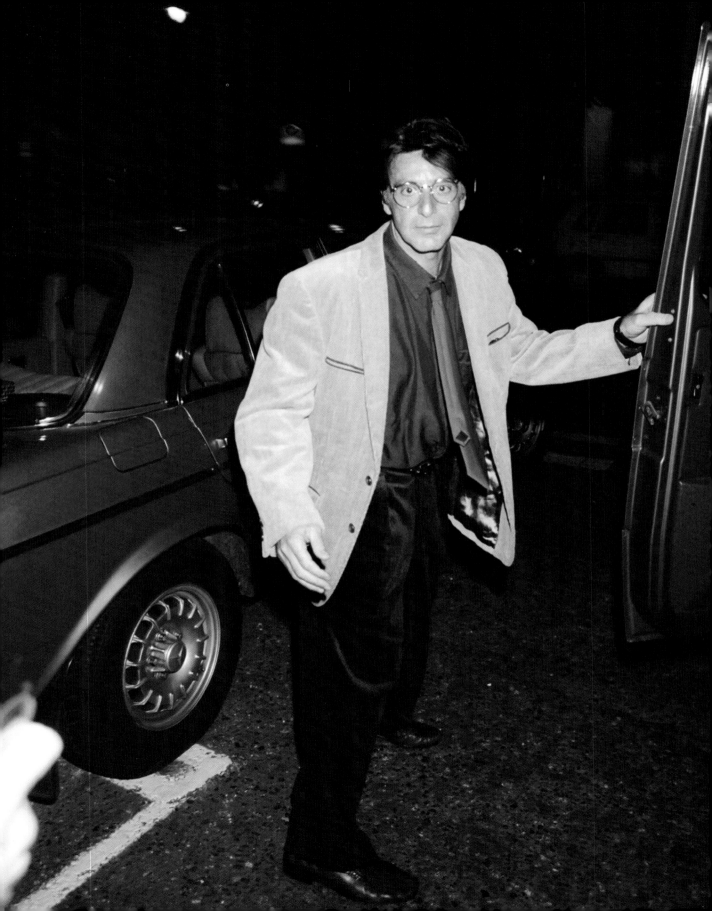

al pacino

harry's bar, london

H ARRY'S BAR HAS ALWAYS BEEN AN IMPORTANT location for me. It is one of the most private of private restaurant clubs in London. Only the *crème de la crème* can pass through its hallowed doors. It is owned by Mark Birley, an extremely charming man who is also proprietor of Annabel's, Mark's Club and George, all equally exclusive. On any given night, you will find a fleet of Bentleys, Rolls Royces and Range Rovers with tinted windows parked outside, their drivers patiently waiting for their VIPs to leave what I have heard is one of the best restaurants in London.

In the early days Dave Benett and I would hang around on the off chance that there would be someone of interest inside. Sometimes the drivers would let us know who was there, and if it was someone interesting we'd stick around. On this particular night, we had heard that Al Pacino was having dinner at Harry's Bar with his then girlfriend, Lyndall Hobbs, an old mate of mine from the days when she was dating the impresario Michael White. At around half-past eleven Al and Lyndall emerged. Al recognised me from some previous encounters, and was very friendly. 'Hi, how are you guys?' he asked.

We photographed them together and, as they got into their car, everyone stopped in their tracks as I turned to Al and said, 'Thank you for all your great movies.' I knew as I was saying it that everyone was thinking, What an idiot, but I couldn't help myself. I admire Al Pacino and sometimes I just get carried away. I'm a fan – what can I say?

143

michael jackson

romanian orphanage, bucharest

MICHAEL JACKSON HAD SET UP A CHARITY called the Heal the World Foundation to raise money for kids throughout the world. I took a call from a PR guy called Julian Henry, who wanted to know if I would like to travel with Michael to record his visit to an orphanage in Bucharest. In 1992 Michael was really hot, the biggest star in the world. I felt very honoured to be asked, and packed my bags immediately.

I flew from Stansted on Romania Airlines, and it was certainly not the kind of business-class travel to which I was accustomed: the plane was falling apart, the fold-down tables were rusty, the overhead compartments were jammed shut and pieces of metal were hanging from different parts of the plane. The flight took about three hours and I was very happy when we landed in one piece. When I went through immigration I was relieved of all my small change: the customs officer said I couldn't bring it in, and he pocketed the lot!

I was driven to the Intercontinental hotel where I awaited instructions. Some time later I was picked up by bus and taken to the orphanage where I was to meet Michael. He turned up in the only limousine in Bucharest and we went into the orphanage together. The smell was overpowering. The children, many of them crying, were in rows and rows of metal cots; some were newborn and had been abandoned.

Michael and I travelled through the wards, and as we passed the cots he would lean

over to coo and gurgle at the kids. I asked him to pick up two babies so he had one in each arm. 'That's a good idea,' he said. His voice was perfectly normal, not at all high pitched, and he seemed very charming, caring and genuine.

After two hours we went out into the park area where the older children were waiting for him. There was a carnival atmosphere – the kids were thrilled to see him and it felt like being with the Pied Piper. That evening, after I had processed all my film, I was resting in my room when one of Michael's aides come by to look at the contact sheets. He was very happy with the images, but then told me I could not use any of the pictures. I was absolutely shocked. Why bring me all the

way out here to record the event and then tell me the photographs can't be used? I was told that Michael had simply decided he didn't want them used; it didn't ring true to me.

I arrived back in London with a heavy heart. It is so maddening when you're asked to cover a great event like that only to be told you can't use the material. Fortunately it doesn't happen too often. After much discussion and persuasion I was given the OK to use the pictures and they were syndicated throughout the world. I used the picture of Michael for my Christmas card and was inundated with calls – everyone wanted to purchase the cards, as they loved the shot.

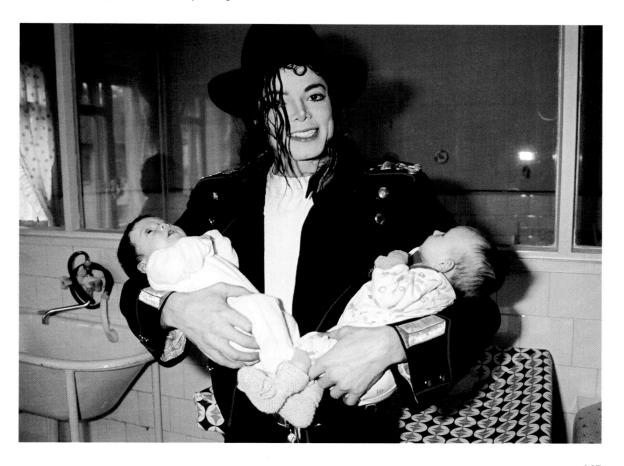

madonna

hyde park hotel, london

IN THE EARLY NINETIES I FOUND I WAS BEING ASKED to cover more and more A-list events, and was often the only photographer to be invited. All my hard work was beginning to pay off. Publicists were beginning to realise the value of a Richard Young photograph: my agents Rex Features were often able to place the images in newspapers and magazines around the world, and that kind of publicity is very valuable to certain stars.

Madonna was doing a TV interview with Jonathan Ross. I was asked to come and take a few stills of the two of them together for pre-publicity for the show. I was the only photographer allowed on the set. When I saw Madonna looking very Marlene Dietrich in her beret, suit and tie, I thought, What a great image. They had just finished filming and it was my turn to do the stills, so I posed them both up and took a few shots. To be honest it wasn't that interesting, and I think Madonna realised that the shoot needed something extra. She grabbed Jonathan's cigar out of his top pocket and put it in her mouth (with the wrapping on!); she immediately turned the whole thing into a much more interesting situation. I tried to angle the shot of her and Jonathan so that I could crop him out later (sorry, Jonathan!) which was what I did and I think this is now an iconic shot. To this day, this is one of my favourite Madonna images.

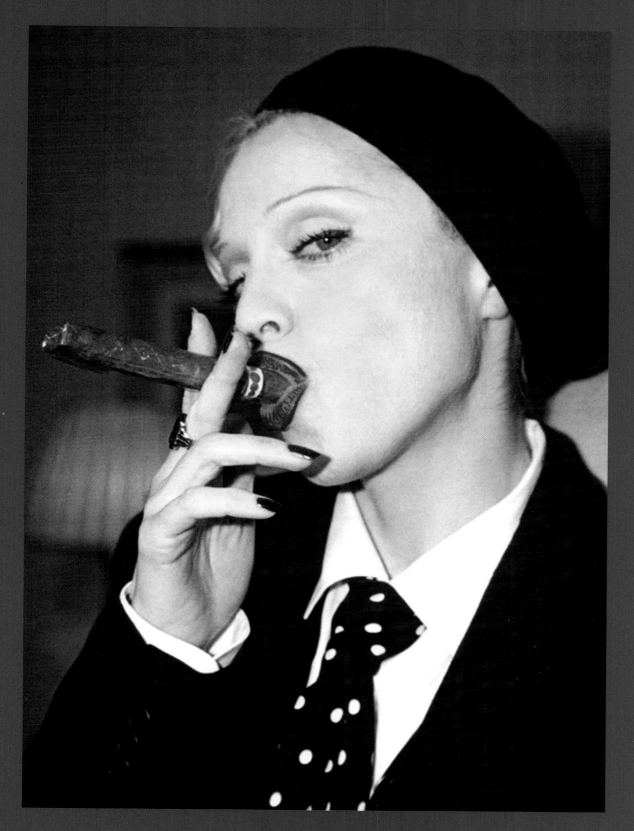

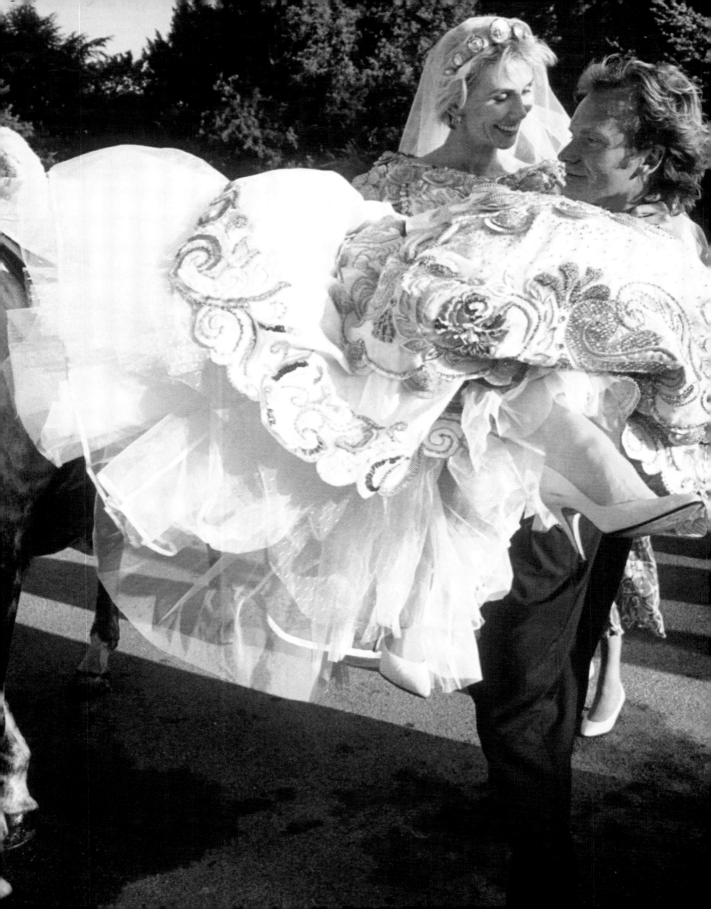

sting and trudie's wedding

wiltshire

I HAVE BEEN WORKING WITH STING SINCE the early eighties when the Police were still together. I went up to Newcastle to photograph them in his old neighbourhood, and then a concert in the evening, and since then we've always had a good relationship.

His publicist asked if I'd like to be one of the official photographers to cover his wedding to Trudie. That meant it would bring me together with my old mate photographer Brian Aris. Brian and I have been friends for over forty years. We used to hang out in the mid-sixties; we'd go off to Brighton together in his Hillman Minx on a Saturday afternoon when I'd finished work at Sportique. If we had enough money we would stay in a bed and breakfast; and, if not, we would try and find some local girls to put us up. If all else failed, it was the Hillman parked outside the Starlight Bar! Brian was a photographer for the *Kilburn Times* at that time; it would be another ten years before I followed in his footsteps.

And now here we both were covering the wedding of the year. Versace had specially designed a magnificent dress for Trudie, and he also dressed Sting. It was a fairy-tale wedding, full of family and friends. Often you go to a celebrity event and it's only full of other celebrities. This was a real family affair.

After the ceremony Sting swept Trudie off her feet and carried her off on a horse – it was very romantic.

rod stewart and ron wood

san lorenzo, london

I HAVE BEEN A CUSTOMER OF SAN LORENZO since 1968, and it is one of my favourite restaurants in the world. I was first taken there by a girlfriend of mine at that time called Marie Claire. She was a hairdresser and used to cut Mara's hair, who owns and runs the restaurant along with her husband Lorenzo. When I entered the restaurant that first time, it was a small, narrow room, very cosy with wicker tables and chairs, lots of plants, and a huge tree growing in the middle. Sitting at the end of the room I saw – to my sheer amazement – John and Yoko having dinner. It was exciting to have been invited to such a place and I vowed I would be back.

There are few restaurants in London which consistently still attract the A-list, but it is a very rare night that you will not find a famous person enjoying Mara's excellent fried calamari, fantastic truffle risottos and legendary hospitality. I go back a long way with Mara and Lorenzo and consider them very good friends. We have celebrated every major family occasion at San Lorenzo, from both my weddings to all of our children's birthdays, and they have always been so generous and kind to us. I have never taken photographs inside unless invited to do so. Up until about 1993 I would take pictures outside, and this image of Rod and Ron was one of the last.

In the mid-eighties, Dave Benett and I would often drive around town to various restaurants to see who was around, chatting to doormen and limo drivers, listening

out for any little tips that were on offer. On one particular night, we pulled up outside San Lorenzo to have a nightcap with Lorenzo and to share some football gossip. As we arrived it was obvious to us that Princess Diana was inside having a bite to eat – we recognised her car which was parked outside. At that moment, Diana's protection officer Ken Wharfe strolled over to our car and popped his head in the window. He said there was a very sensitive situation going on in San Lorenzo, and very politely asked us, as he knew we had such a good relationship with Diana and the restaurant, not to come in. 'OK,' I said, 'we won't take any pictures, but we will stay here to see what happens.'

By now we were extremely curious, and there was no way we were going anywhere without finding out what was going on. 'Fine,' said Ken. 'I owe you one.' About twenty minutes later Diana emerged with James Hewitt. Dave and I looked at each other as we saw our pension funds shrink before our eyes. If we had got that picture it would have been worth a fortune.

About a month or so later I happened to be at the Royal Opera House for a very special night. Pavarotti was performing, and most of the senior royals were present. I was backstage in Pavarotti's dressing room taking a few shots, and as I left I bumped into Ken Wharfe. 'Hello,' he said. 'Good to see you, and thank you very much for your co-operation a couple of weeks ago.'

'No problem,' I replied, a bit ruefully.

'Do you have an invitation to the party upstairs this evening?' he asked.

'No.'

'Well, you do now. Wait for me and I'll take you up.'

I then found myself upstairs in the Crush Room of the Opera House with the Queen, the Queen Mum, Princess Diana and various other aristocrats. There is a great deal of give and take in this business. Ken had been a gentleman and true to his word.

'Although we didn't plan them, our encounters over the years have produced many treasures due to Richard's work. My wife and family agree!'

RON WOOD

153

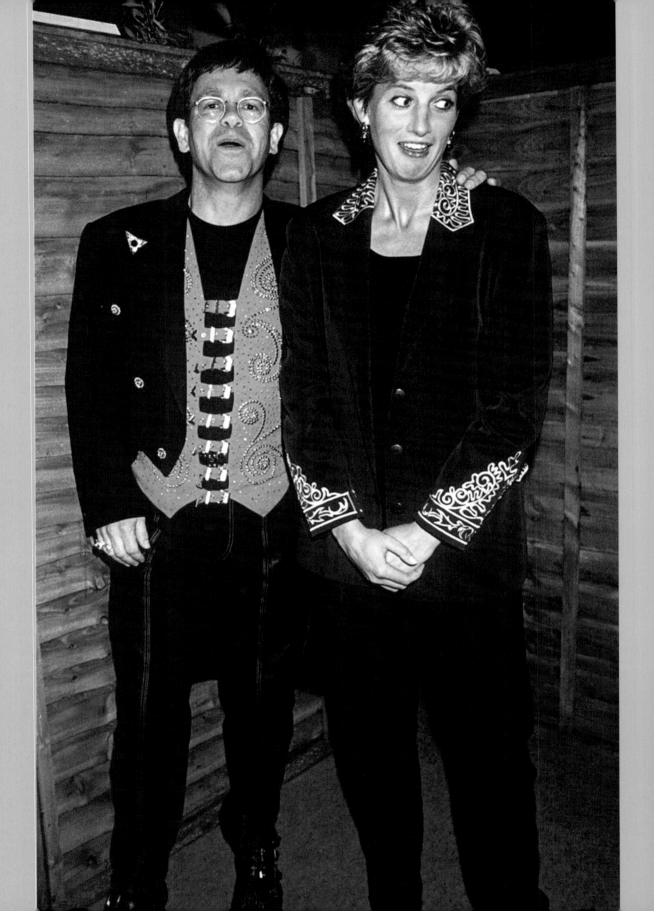

1993

elton john and
princess diana

earl's court, london

ELTON WAS APPEARING AT EARL'S COURT and he had invited me to photograph him backstage. Elton and I have been friends for 25 years. I have always enjoyed taking pictures of him – he is a consummate professional and we have had some great laughs and enormous fun over the years. He was incredibly kind and supportive when I lost my first wife, Riita, and I really appreciated that. In the mid-eighties, he asked me to shoot an album cover for him, so I hired a studio and lights, and got some snacks in. Elton arrived bang on time and I did a couple of Polaroids which he inspected, chose one of them and he was off! It took no longer than thirty minutes.

I have been invited to his fabulous house in the South of France to cover his Cannes film Festival parties – always A list events. I was invited to his fancy dress 50th birthday party and I went as John Shaft, once again donning a wig – this time an afro. During the evening, my camera jammed and I got into a panic until I discovered that the reason why was that a bit of my wig had got stuck in the mechanism!

I knew Elton was friendly with Diana but was surprised when her car swept into the backstage area. I was called into Elton's private enclosure to take a picture of him and Diana. The first shot I took was quite posed and staid, so I asked them to get a bit closer. As Elton nudged in, he put his arm around her and took her by surprise, hence the funny expression. That's what I loved about Diana; she was spontaneous and great fun.

kate moss and naomi campbell

london and paris

THIS IS A FAIRLY EARLY SHOT OF KATE AND NAOMI. Kate was twenty years old here and her career was really taking off; Naomi was already quite well established. I love this picture because Kate looks so fresh and innocent. I must say, you'd have to be a really useless photographer to take a bad picture of her: she always looks so interesting and you never tire of seeing her on the front covers, unlike some models who seem to date after a few years. In fact, she often reminds me of a young Marianne Faithfull. More importantly, Kate has an innate sense of style. She can just throw together an outfit which creates a certain funky, casual elegance; in this respect she is at the cutting edge, in my opinion.

The modelling business is a tough world, and the girls can soon get burned out. We've all seen the images of anorexic girls and the horror stories that go with them. I have been backstage for thirty years at all the big fashion shows, and I've seen many girls come and go. It is hard to stay on top and not fall prey to the temptations which are always at hand; if you want any longevity in this business, you need your head screwed on tight.

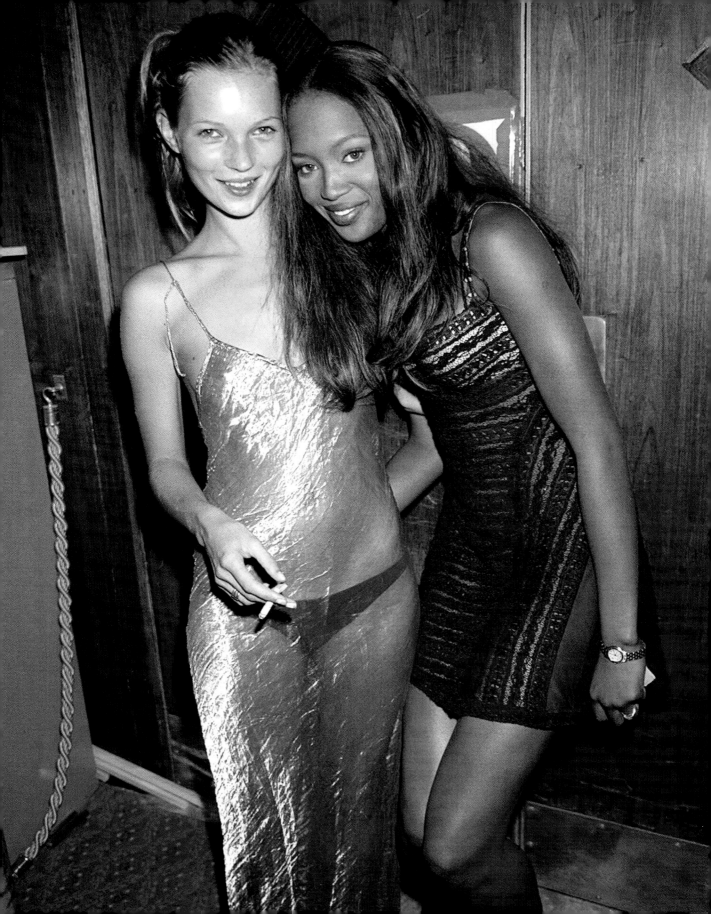

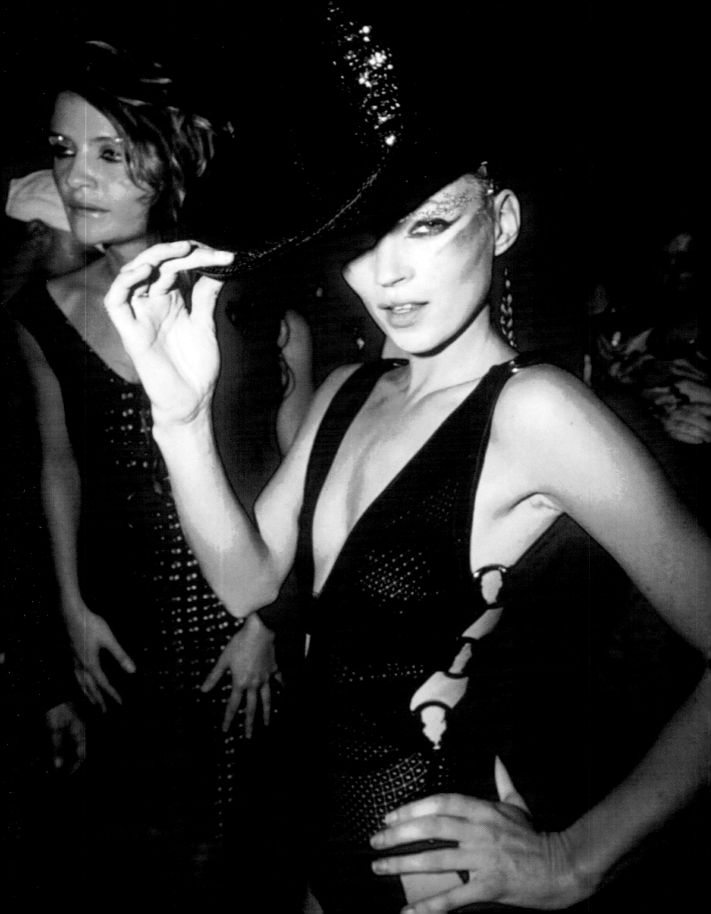

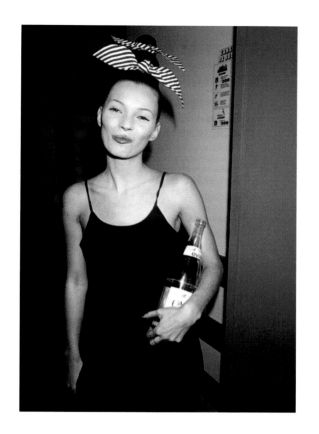

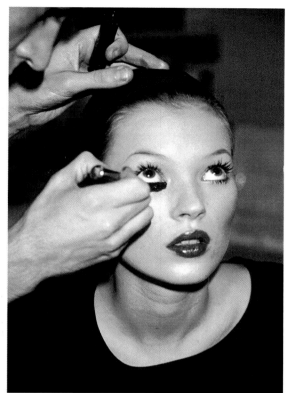

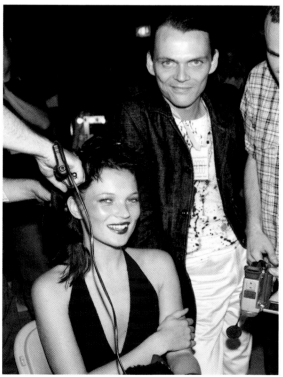

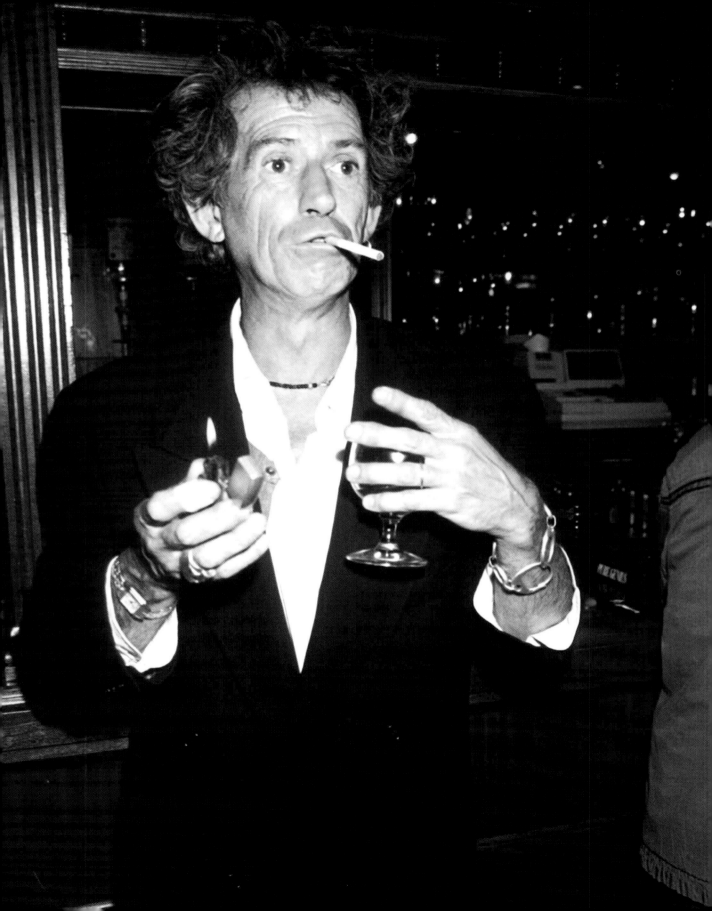

keith richards

cobden working men's club, london

PETER COOK AND DUDLEY MOORE were having a party to celebrate the release of their Derek and Clive video. I went along with no expectations – it looked like it was going to be a pretty low-key affair at the Cobden Club, a private venue above Cobden Working Men's Club. I turned up more as a fan of Pete and Dud than anything else, and was quite surprised when Keith Richards and Ron Wood arrived. That's the great thing about my work – you never know what might happen or who might turn up. They hung around the party for a while and then decided that they fancied a Guinness; as there was none at the party they went down to the actual working men's drinking club which was underneath the rather smart club the party was being held in. They propped themselves up at the bar and had a couple of pints with chasers.

Keith started chatting with the locals. One bloke said to him, 'So, what do you do then?'

'I'm in a band,' replied Keith.

'Which one?'

'The Rolling Stones.'

'Oh yeah,' replied the bloke. 'I think I've heard of them.'

ivana trump and
shirley bassey

royal albert hall, london

I HAD BEEN ASKED BY OLYMPUS CAMERAS to shoot an advertising campaign for them. The idea of the campaign was that the camera was waterproof and could withstand people throwing champagne over it. Ivana had recently split up from Donald Trump and was quite big news at that time, which is why they decided to use her in the advert. We did the shoot at the Hyde Park Hotel and Ivana had to keep throwing glasses of champagne over me so that we could have a final shot of the champagne in full flight. I was covered head to toe in bubbly. The ad was a great success, and I really enjoyed shooting it.

A few weeks later I was backstage at the Royal Festival Hall. Ivana was sitting in Shirley Bassey's dressing room having a drink. She and Shirley both leaped up when they saw me and just couldn't resist re-enacting the scene. Luckily I had my wits about me and managed to get the shot perfectly. I think that technically this picture is spot on.

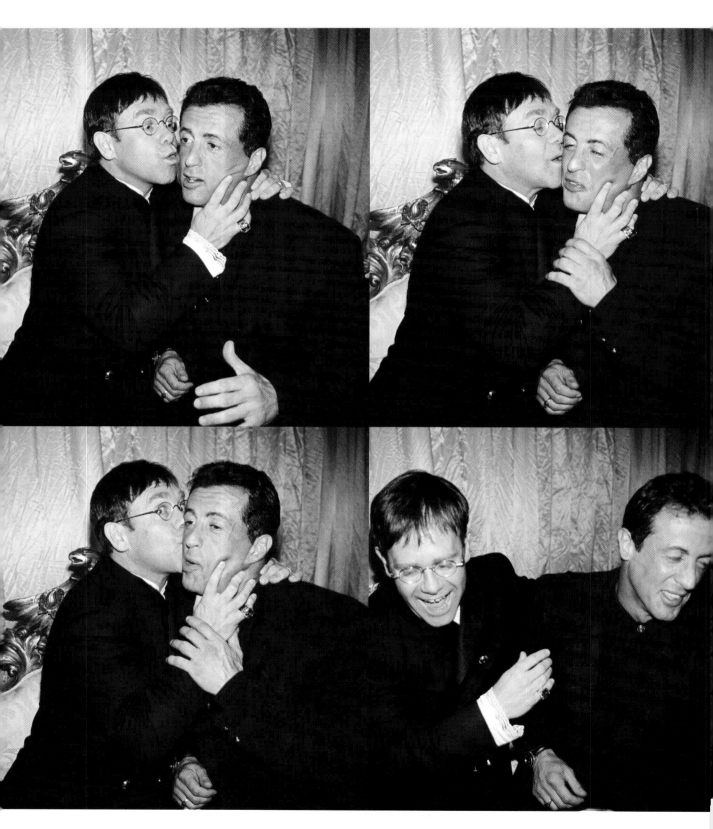

elton john and sylvester stallone

lion king première, london

ALWAYS ENJOY PHOTOGRAPHING ODD combinations of people. I like to try and put different types together to create an interesting and unusual situation; you'll probably have noticed some other unusual combinations in this book.

At this particular première I didn't really have to try too hard as Elton and Sylvester were already larking around. You can always guarantee Elton will play up to the camera, and I think Sylvester's expressions are classic.

'Richard is always a treat to see at a party, always with a smile and a kind word. I try to watch photographers like him because they succeed in capturing that instant moment that I then try and recreate in my photos. Cheers to you, Richard and to many, many more years.'

MARIO TESTINO

rupert everett and
janice dickinson

versace after-show party,
the ritz club, paris

THE VERSACE AFTER-SHOW PARTIES are always very glamorous affairs and I try to be there if I can. I know there will always be something memorable to photograph, and this one was no exception.

I had spotted Rupert Everett dancing with a friend out of the corner of my eye; they were having fun like everyone else. Then I noticed that Janice Dickinson (ex of Sylvester Stallone and supposed mother of his child until a DNA sample proved otherwise) joining them. They were dancing up a storm and as I was making my way across the dance floor to photograph them, my film ran out. As I was reloading I noticed that the strap had broken on Janice's dress. I couldn't get the film wound on quick enough, so I only had a split second in which to get the shot – hence the red exposure line along the top of the picture. It still makes me smile when I see it – I just love Rupert's expression.

Sometimes I forget I've taken a particular photograph, and the picture of Johnny Depp and Kate Moss overleaf is one of those. I knew who Kate was, but Johnny wasn't such a big name, so it wasn't that important at the time. Often it takes a few years for a picture to mature; suddenly you find that you've got a classic or iconic shot. I like to photograph young up-and-coming actors, singers and artists as you never know who is going to make it big a few years on. It's always a good feeling when you look through the archives and think, Wow, I photographed them at the beginning of their careers.

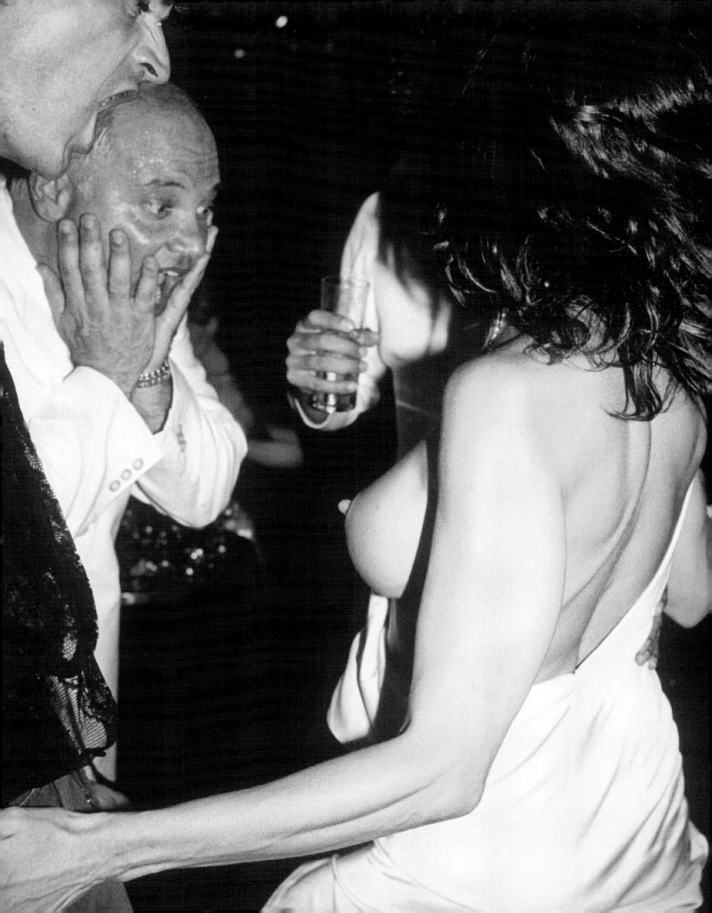

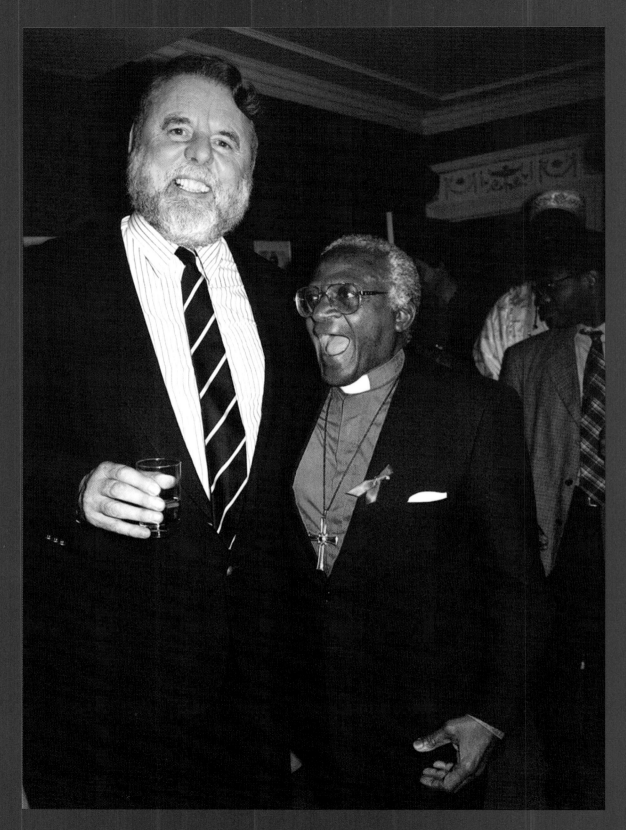

terry waite and archbishop desmond tutu

theatre royal, london

THE MEMORIAL SERVICE FOR AFRICAN DISSIDENT Ken Saro-Wiwa was being held at the Theatre Royal, Haymarket. Terry Waite was there, as was Archbishop Desmond Tutu. At the other end of the political scale, Anita Pallenberg turned up. During the interval, my son Dan (who has followed in my footsteps to become a photographer working out of Los Angeles) and I went to have drinks in the green room. Dan and I stood there chatting when suddenly Terry Waite came charging over to me. As you might know, Terry is very tall, well over six feet, and as I looked up at him he said to me, 'How wonderful it is to meet you. I have read all your books and I'd love to have lunch with you to discuss further projects!'

As I looked up at this very imposing man, I said, 'Terry, I'm not him!'

At that precise moment Archbishop Tutu, who was standing very close to us, and who is *not* a very tall man, turned on his heels, grabbed my hand and said, 'I've been waiting to meet you too!'

'No!' I replied. 'I'm not him!' We all burst out laughing. I know I look a *bit* like Salman Rushdie, but I am *definitely not him*!

president mitterand

boulevard st germain, paris

EUROSTAR HAD RECENTLY BEEN LAUNCHED and I decided to whisk Susan off to Paris for the day. It was wonderful, so civilised; I always use the train now, and I never fly. Within three hours you are in the centre of Paris, and it's so comfortable.

That day, we jumped into a cab at Gare du Nord and went straight to my favourite café in Paris, Café de Flore on Boulevard St Germain. I have been sipping espressos there since my first trip to Paris with Brian Aris in 1964, and I always make it my first port of call.

Susan and I sat down and ordered our coffees when out of the corner of my eye I saw a gentleman walking down the street whom I recognised. It was President Mitterand. Now it's not every day you get to see someone like that strolling down the street, and even though my paparazzo days were behind me I just couldn't resist taking a couple of pictures. As usual, my trusty camera was by my side – it's very rare for me not to have one somewhere nearby.

He was strolling down the street, and I took a couple of quick photographs. I then introduced myself and asked him if I could do a nice posed shot. He said 'non' in no uncertain terms, and suddenly four burly bodyguards came into the picture. I quickly took another two shots and called it a day.

When you are doing my kind of photography, you really need to practise your 'walking-backwards-taking-a-picturetechnique'.

I have come a cropper on a couple of occasions: once I fell down a flight of stairs backwards whilst photographing Elizabeth Taylor and Richard Burton – Richard kindly picked me up off the pavement; and another time I fell down a hill in Tuscany – that was when I was restaging the Getty wedding.

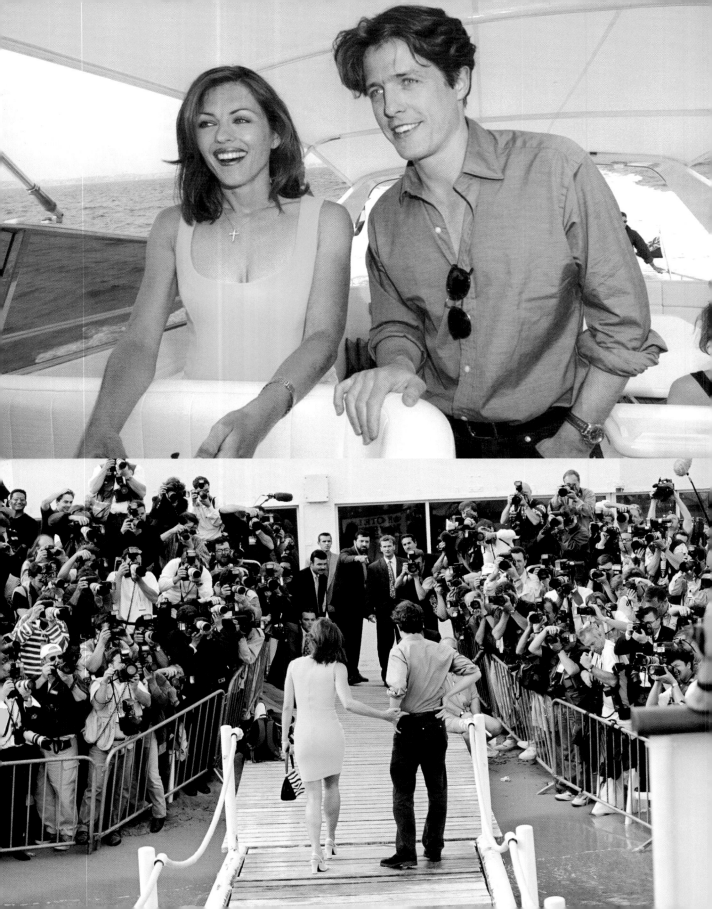

elizabeth hurley and hugh grant

cannes film festival

ELIZABETH AND I HAVE BEEN GOOD FRIENDS since I photographed her in 'that' dress. She is always charming and friendly; Hugh on the other hand can be offhand and irritable, and not just with me, thankfully.

I was already in Cannes covering the festival, which I always enjoy, and I had been commissioned by a magazine to do an exclusive photo shoot with Hugh and Elizabeth. I was told we would do the shoot on a boat, so I met up with them at the Hôtel du Cap in Antibes and travelled with them to the Majestic pier in Cannes. Elizabeth's career was really taking off, and Hugh was very big as well: they were the golden couple and everyone was interested in them. Elizabeth seemed happy to see me and even Hugh was in a cheerful mood, which made my job a lot easier. I spent about an hour on the boat with them, and by the time we arrived in Cannes the Majestic pier had been besieged by about 200 photographers and film crews. It was mayhem. Elizabeth and Hugh got off the boat and I walked behind them, as I wanted to get a shot of the scene with all the photographers in front.

Later I joined them for drinks at the Majestic hotel where they were holding a small party. All in all, a fun day.

iggy pop

recording the white room,
ealing studios, london

DON'T VERY OFTEN GET TO WORK ON TV OR FILM SETS. In fact, I'm not very interested in doing film work as I can't bear all the hanging around. I was once asked by Michael Winner to shoot some stills on a film he was making. We agreed a fee, and I was supposed to be on the set for the whole day. I arrived early, it was freezing cold and everything seemed to be dragging on forever. I took a few shots here and there, and after lunch I'd had enough so I sneaked off, hoping no one would notice. I was so bored. I sent my invoice to Michael's office, and a few days later received a very sharp letter from Michael along the lines of, You left early, and you didn't do enough pictures. The letter ended with 'Call yourself a photographer?' I had to laugh – Michael is a wily old fox. He insisted I reissue the invoice with a reduction for the hours I bunked off. I haven't done much film stuff since.

I do get asked to cover a lot of advertising shoots, though, which I really enjoy. They are faster and much more fun. I've covered some of the Renault 'Nicole? Papa!' adverts, including 'Va va voom' with Thierry Henri. I've also worked on the Argos adverts with Richard E Grant, and done things for Harvey Nichols. It is beneficial for the advertising agencies to get me on board because it means they get some good pre-publicity, and as I know most of the stars it makes everything much easier.

I was asked to cover a series of programmes called *The White Room*, which was one

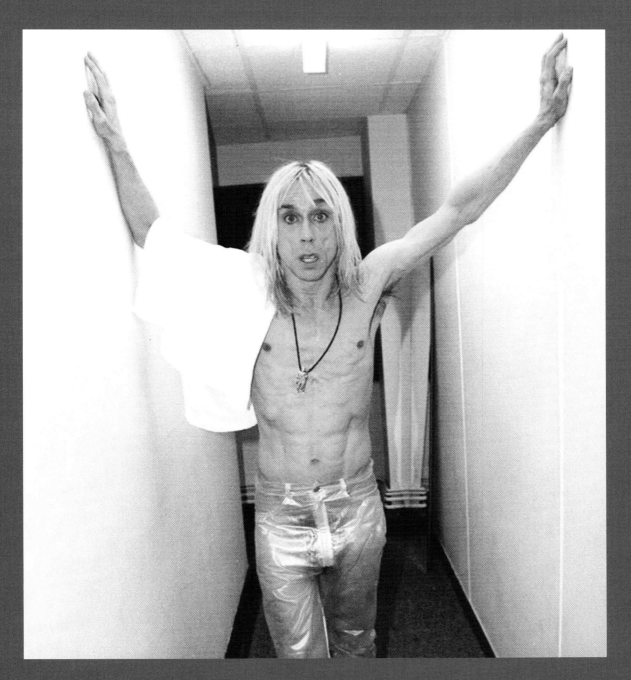

of the best music programmes of the mid-nineties. It featured the kind of music I really liked: Little Richard, PJ Harvey, Nick Cave and REM. When I heard Iggy Pop was performing I knew it would be a great show, and he didn't let me down. He turned up wearing clear plastic trousers with no underwear. I tried to avert my eyes but it was a full-on show – he really is an exhibitionist. During the performance, his flies came undone. I did have to chuckle to myself – I don't half get to see some sights in this job!

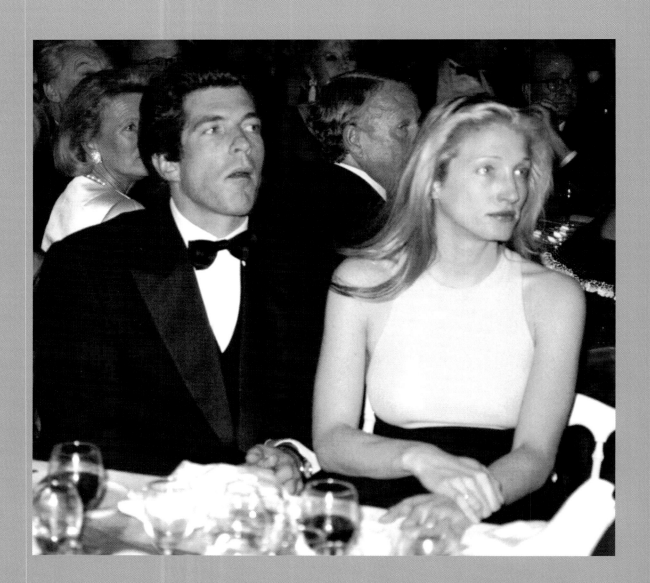

carolyne bessette and john kennedy

cartier launch, geneva

OVER THE YEARS I HAVE ALWAYS ENJOYED working with Pilar Boxford who was the head of press at Cartier. I have covered the Cartier international polo day at Smith's Lawn, Windsor for many years. It is a very glamorous A-list affair, and there is always a royal presence. So I wasn't surprised when Pilar asked me to cover the launch of Cartier's new Santos watch in Geneva. I was told there would be lots of celebrities there so off I went, camera in hand, for what promised to be an outstanding evening. It was a black-tie event; the women were all dressed up in haute couture dresses and dripping in diamonds and pearls.

As soon as we arrived there seemed to be a bit of a problem. It turned out I was not allowed to take photographs after all. Apparently there had been some miscommunication: Cartier's French office had a deal with a French photo agency for the exclusive rights to photograph the event. Pilar was very upset: she had dragged me all the way out there and I couldn't work. I decided to sit down and have dinner, wait for everything to calm down, and I would discreetly do my own thing later. The guests of honour were Carolyne Bessette and her husband John Kennedy Jr. I had never photographed them before, and I certainly wasn't going to miss this opportunity.

The evening progressed. Dinner was over and the presentation of the watch was beginning. I calmly walked over to the table and took about six pictures.

I then walked away, stood nearby and took a couple more shots. That was going to be the best I could do under the circumstances. I was lucky: all the other photographers were in a pen on the other side of the room, whereas I was sitting down for dinner. I had the freedom of the room but I didn't want to take too many liberties, so I just left it at that and called it a day.

These were the only pictures I took all evening. They were used everywhere.

A few weeks later Pilar called me and asked me to pop by because she wanted to discuss next year's Cartier polo. She told me she wanted a couple of photographers to dress up as waiters and discreetly take pictures of the guests – or did I think it would be better if they cut holes in the marquee through which we could photograph them? How crazy, I thought, why on earth would she want me to do that? I was trying to envisage myself poking my lens through a hole in the tent, and I just couldn't get my head around it. It was so off the wall I felt it must be some kind of wind-up. Suddenly Arnaud Bamberger, managing director of Cartier, walked in carrying a large red box. I looked at him and thought, What's going on? 'This gift is for you,' he said, 'for being so understanding about the fiasco in Geneva.' I opened it up and inside was a beautiful Cartier Santos watch. What a fantastic surprise – and what a wind-up! That was the first Cartier I had ever owned, and I still enjoy wearing it to this day.

1
9
9
6

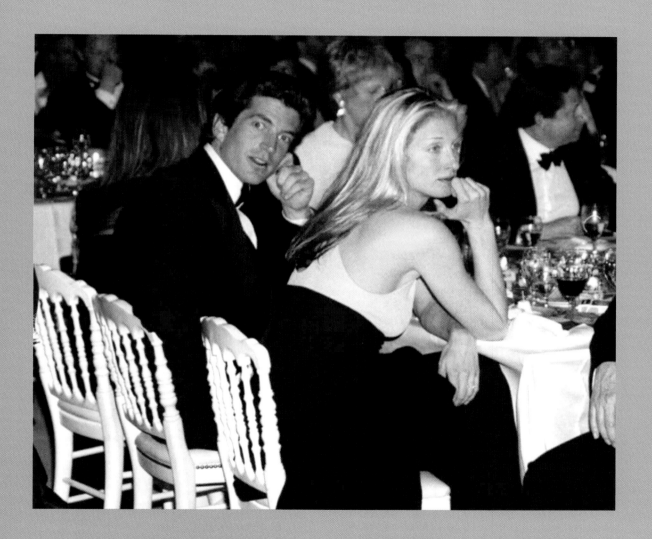

princess diana

tate gallery, london

IT WAS A GLORIOUS SUMMER EVENING. Chanel and *Vogue* were hosting a party at the Tate, and I knew it was going to be a great night as Princess Diana was the guest of honour. When Diana was around you were always guaranteed a memorable evening, but tonight would be particularly special as it was her birthday. Her romance with Dodi was in full bloom and that night she was absolutely radiant.

I was the only photographer allowed in to photograph the private dinner after the show. As Diana sat down, I went over to wish her happy birthday. She shook my hand and said, 'Thank you. Please give my regards to your family.' She was, as always, charming and warm and giving. I never could have imagined at that moment the horror that would occur only a couple of months later.

Her death was an enormous blow to me: she was, without a doubt, one of the most remarkable people I have ever worked with. This was her last official engagement before her death, and I feel very honoured to have been there.

'Richard is always discreet, never "in your face"
and backs off whenever you ask him to. Above all, when
Richard is there, you know you are where it's at.'

ROSA MONCKTON, *PRINCESS DIANA'S BEST FRIEND*

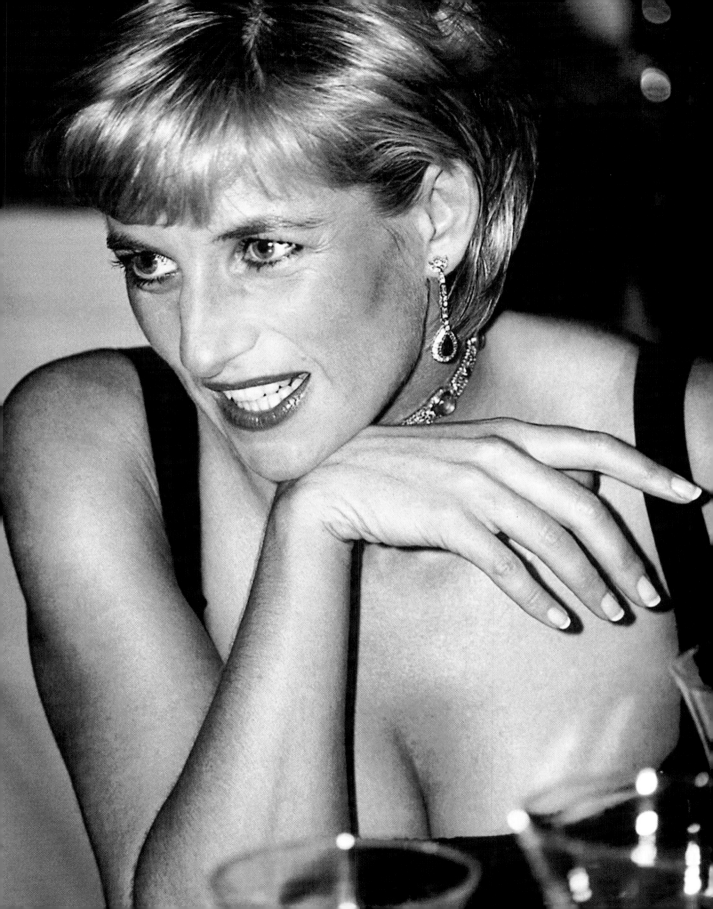

naomi campbell, janet jackson and lisa marie presley

janet jackson party, the chrysler building, new york

PRINCESS DIANA DIED IN PARIS with Dodi Al Fayed in August. I was devastated. My phone did not stop ringing – everyone wanted a comment or quote. For my part, I felt there was absolutely nothing I could say, as at the time the photographers were to blame for the events of that terrible night. I took the phone off the hook and decided to take up the offer of a job in New York to cover the MTV Awards; I just felt I wanted to be away from all the madness in London.

With a very heavy heart I flew to New York where the atmosphere was just the same: shock and sadness. I was staying at the Four Seasons hotel and received a call from PR Alan Edwards inviting me to Janet Jackson's party which was being held a couple of days before the awards at the Chrysler Building. I arrived knowing I had access all areas, and there was only myself and another photographer – my good friend Kevin Mazur – covering the party. As we stood side by side in the lobby, Janet Jackson arrived with her entourage. Kevin posed Janet up with another girl; I tried to move the girl out of the shot because I thought she was in the way. 'What are you doing?' asked Kevin. 'That's Lisa Marie Presley!'

I suddenly recognised her, and rather swiftly moved her back into the shot. She must have thought I was mad.

There have been a few occasions when I have not recognised a celebrity, or even

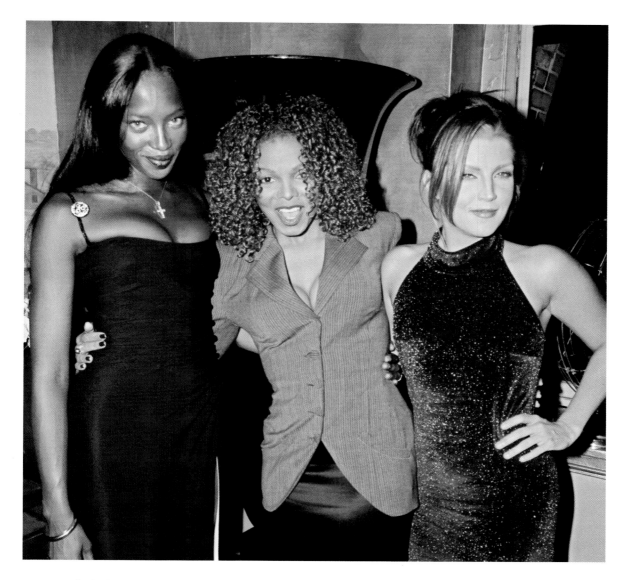

worse called them by the wrong name – very embarrassing, as you can imagine.

Later on, in the VIP area upstairs, I sat down with Lisa Marie and we had a long chat. She was very interested in knowing if the death of Diana had been as big an event as her father's death. I told her I thought Diana's death had affected the world in a much more significant way, but I did also mention that I actually happened to be in Memphis in 1977 when Elvis had died. I took

photographs of his funeral but sadly, due to my lack of organisation in the early days, the negatives are now lost.

In 2003 I bumped into Lisa Marie again, in London this time for the launch of her solo album. After she finished her soundcheck, she came over to me and said, 'I remember you – we had a lovely conversation in New York in 1997.' I was so happy she remembered.

geri halliwell

the brits, london

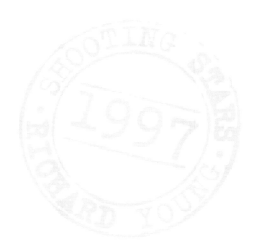

I HAVE COVERED EVERY BRITS CEREMONY since the early eighties. At the beginning it was quite a small event over which not too much fuss was made, but over the years it has mushroomed into an international event, attracting major stars from around the world. Nowadays it's a bit like the Oscars: you need accreditation and special passes to be part of the exclusive group of about six photographers who get access to the dress rehearsals and actual show. The rehearsals are very important for us: we need to be able to get an early picture transmitted to our various agencies and newspapers to be used that night. We have to move very quickly or we miss the deadlines.

This was Spice Girl year: Geri, Victoria, Mel C, Mel B and Emma were at the pinnacle of their careers, and they were headlining the show. I knew the girls would be the main picture of the event. They looked fantastic, particularly Geri, who stole the show in her Union Jack dress. This picture made all the magazines and newspapers worldwide; I even got the front cover of *Playboy*. That was a first.

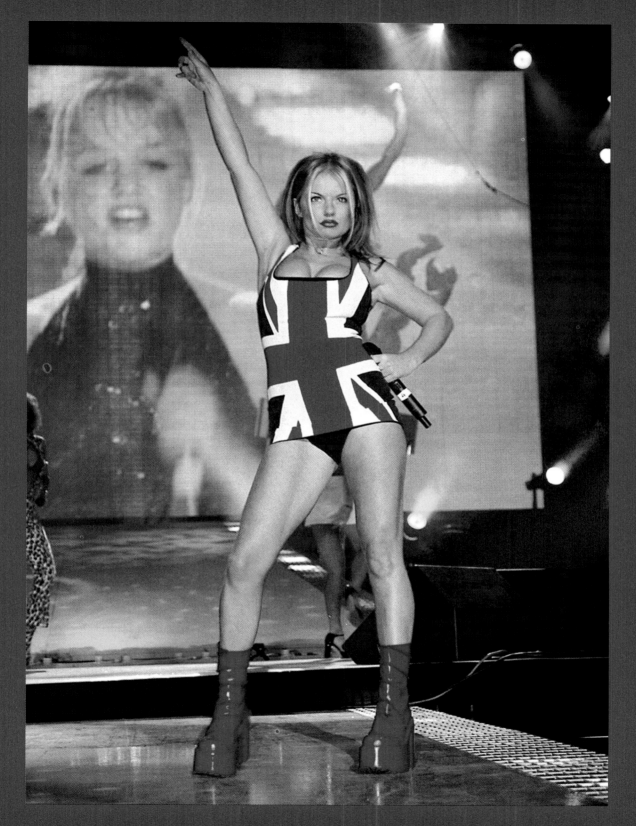

ron wood

fiftieth birthday party, london

LOVE FANCY-DRESS PARTIES. People can use their imagination and become whoever they want to be. I have seen some amazing outfits over the years – some people really put their heart and soul into creating a look.

I was particularly pleased when Ron and Jo invited me to cover his fiftieth birthday, especially as it was a cowboys and Indians party. It was held at his house in west London. Ron and Jo had really gone to town: the whole place looked like the Wild West, with teepees and bucking broncos; there was a great barbeque; and a stage had been set up for a jam session later. Ron was dressed up as a bandito, and there were lots of pretty cowgirls including Kate Moss, Jerry Hall, Elizabeth Jagger, Anita Pallenberg, Marianne Faithfull and Meg Matthews. Jo Wood looked great. She wore two different outfits that night – I think it is so glamorous to change mid-evening. Mick Jagger went as a cowboy, but as usual he said, 'No photographs please, Richard.' So I only took a couple. Sorry, Mick.

Ron and some of his mates had a jam later in the evening. Everyone was having such a great time I decided to down cameras and join in the fun.

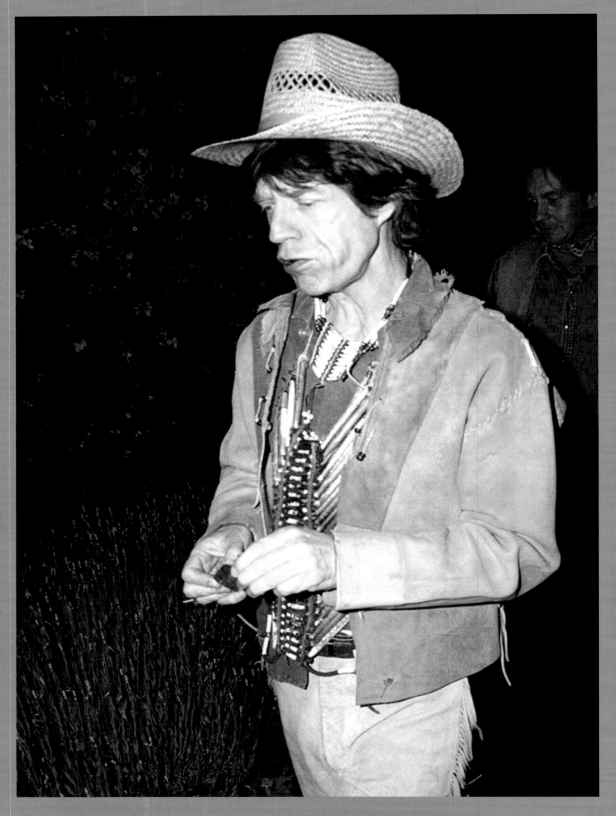

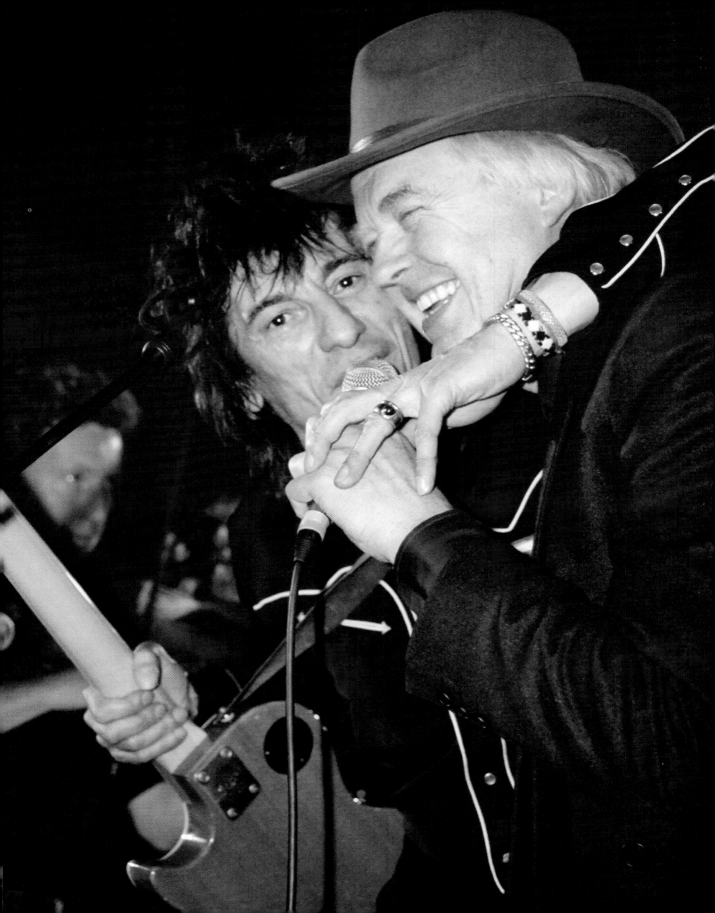

Kate Moss with Jo Wood ▲

▲ Jerry Hall

1
9
9
7

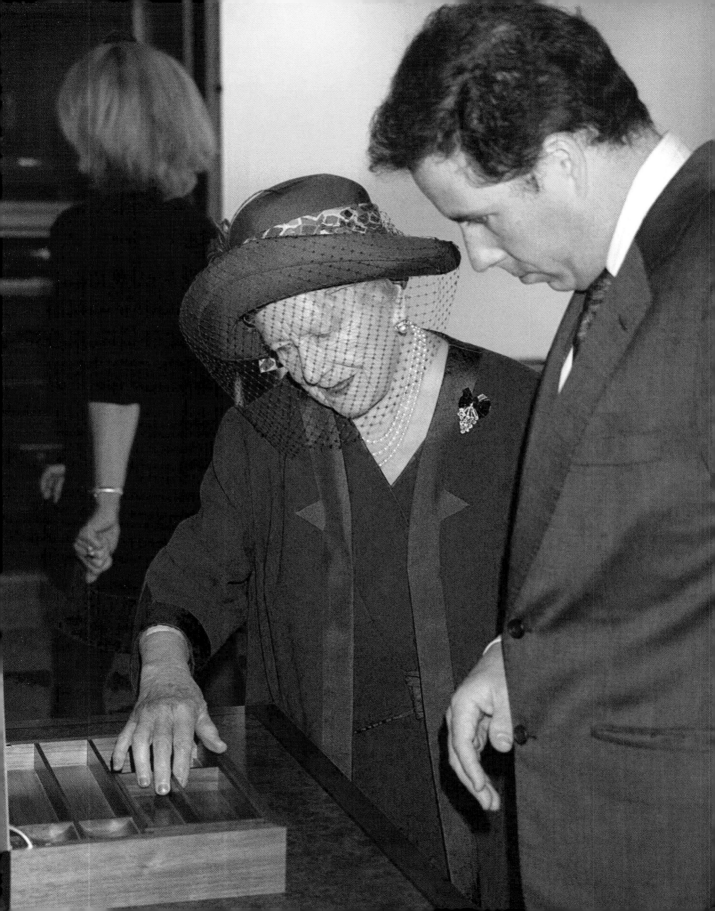

the queen mother

linley, london

DAVID LINLEY'S OFFICE CALLED AND ASKED if I would pop by and take some pictures of David and his grandmother. I didn't think too much about it – I know David quite well and was happy to do it – but I hadn't really registered who his grandmother was. I know it might sound mad, but it wasn't until the Queen Mum walked in that the penny dropped. She seemed very fragile as David gently helped her around his shop. She was interested in the various set-ups: as she entered the bedroom showroom she stopped for a second and remarked, 'David, this is very *Hello!*.'

I have photographed her many times over the years; once, I was covering a photocall for the Queen and Ronald Reagan at Windsor, horse riding together. Afterwards I tried to work out how Reagan was going to get back to Westminster in time to give a speech that afternoon. I thought he might take a helicopter back to London, so I went to Smith's Lawn to see if I could get a shot of him which might be a little different from the one that we had done at the photocall – I knew there was a helicopter landing area there, so it was worth a look. I could see a helicopter hovering, and it landed in the far corner of the field. People got out carrying shoes and a handbag, and they were followed by the Queen Mum. They started walking in my direction, and as they got close the Queen Mum said, 'What are you doing here?' I explained and she said, 'Oh, no, no. The only reason the helicopter is here is because the damn thing has a fault. I was supposed to be on my way to Margate.'

k d lang and girlfriend

thirtieth anniversary of mr chow, los angeles

MICHAEL AND TINA CHOW PLAYED a very important part in my career in the early days. They would have wonderful parties at Mr Chow in London, and there would always be an interesting, bohemian crowd with aristocrats, models, film stars, artists, writers and various rogues and ragamuffins – and of course the food has always been excellent.

The *Ritz* magazine people, Bailey, Litchfield, Frances Lynn and various others, used to cover a lot of parties there. In fact, *Ritz* magazine pretty much exclusively covered any event there from the mid-seventies to early eighties. The London restaurant was buzzing every night with great people, and Tina Chow was always around. She was so elegant and beautiful, an extremely gracious host, full of life and fun. Her untimely death was a great loss.

Michael Chow invited me to celebrate his thirtieth anniversary in Los Angeles; he held an art exhibition and dinner at his restaurant there. Michael still manages to draw a very interesting mix of people: Quincy Jones was there, Dennis Hopper (a big favourite of mine), Joe Pesci, and K D Lang and her girlfriend.

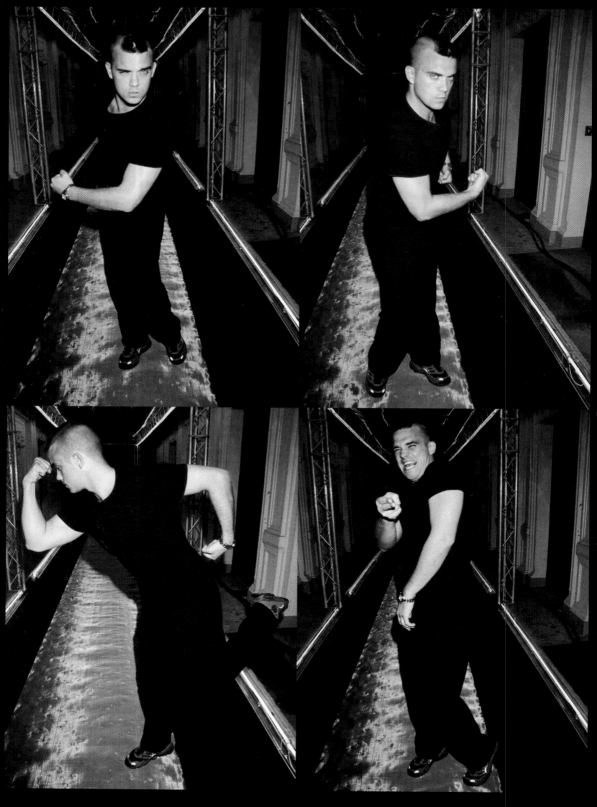

robbie williams

versace after-show party, paris

AFTER THE TRAGIC MURDER OF GIANNI VERSACE in Miami in 1997, Donatella took over the designing at their fashion house and this was one of her first collections on her own. There was a lot of speculation as to whether or not she could keep the Versace name going. I flew out to Paris to cover the show and the after-show party at the Ritz. The show was a huge success and the clothes were fabulous. Donatella had done a great job; it couldn't have been easy for her after losing her brother in that way.

Versace was one of the first designers to set the trend of having really famous rock stars and actresses in the front row of the show, thereby guaranteeing maximum publicity. Versace always managed to get a good mix of people, and this particular year they had Puff Daddy, Melanie Griffith, Jon Bon Jovi, Matt Dillon and a not very well-known Jennifer Lopez.

Robbie Williams gave a solo performance at the party and was brilliant. He certainly knows how to turn it on. It was just like the old days; Gianni would have been proud.

julian mcdonald
fashion show

the roundhouse, london

FASHION WEEK, WHETHER IT'S LONDON OR PARIS, is one of my favourite times of the year. There is so much going on – so many parties, so many faces, so many invitations – it's very exciting but also very tiring. I tend to pick and choose what I want to do when it comes to the shows, but mostly I like being backstage where I can shoot all the hair and make-up and goings on.

I like covering new British designers, as they can often throw up surprises. Julian McDonald's people called me and said that his show was going to be electrifying, and that one of the Spice Girls was going to model. Well, PRs have a habit of promising the world, and often nobody turns up. On this occasion, though, I couldn't leave anything to chance as the Spice Girls were still very big at the time.

I have never liked standing with the bank of fashion photographers on the catwalk. I always try to find my own unique position so I can get something different from everyone else. I found a seat on the front row at the side of the catwalk, facing the photographers – one of my favourite positions. On this particular occasion all the Spices were in a prime location waiting for Mel B to make her appearance. When she made her entrance, everyone went wild. I leaped out of my seat, stood close to the catwalk and fired off four shots. It was perfect. I caught all the expressions just so. I think this is a perfect image – even though I say so myself!

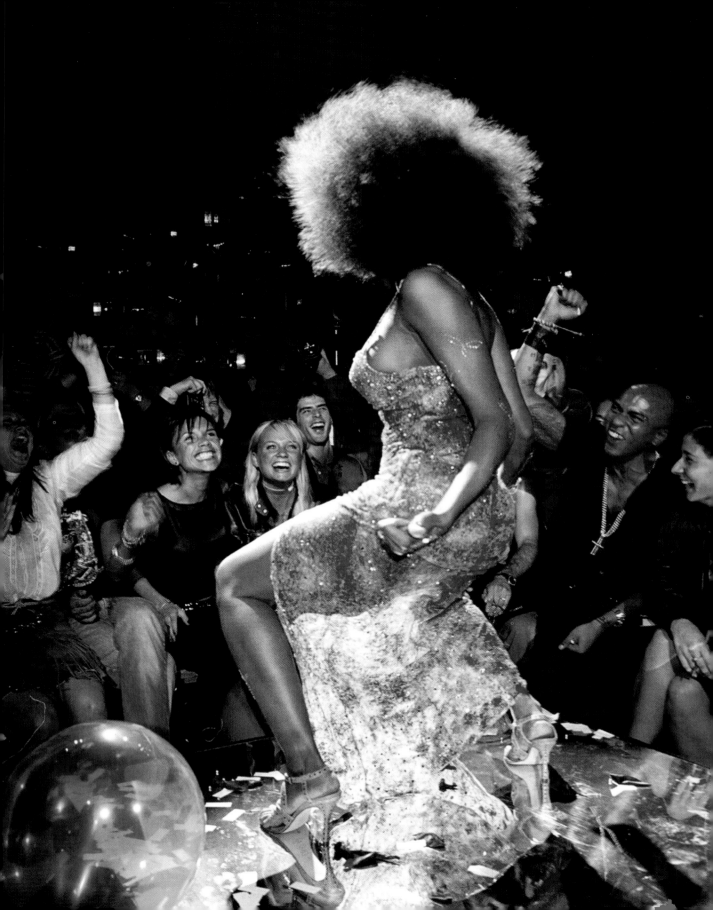

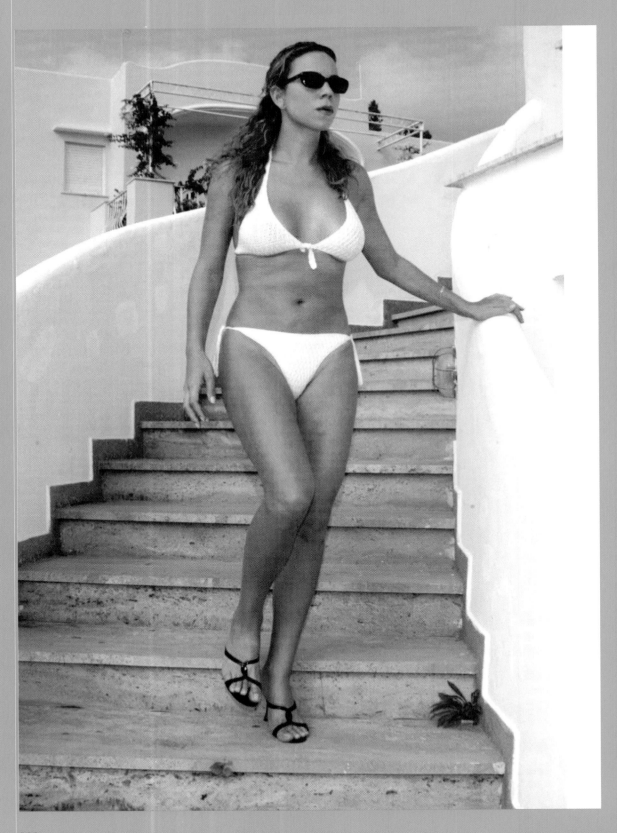

mariah carey

grand hotel quisisana, capri

'TWAS ON THE ISLE OF CAPRI THAT I MET HER … MARIAH, THAT IS!
I was on holiday in Cornwall where I couldn't get a telephone line. My mobile scarcely worked, and the only call that managed to come through was from my old mate Connie Filipello who was looking after Mariah Carey. She wanted to know if I would fly out to Capri to photograph Mariah. They needed pictures for the launch of her new album, and they wanted me to pretend that I just happened to be in the area and taken some pictures of her from behind the bushes, paparazzo style. I laughed my head off. I had pretty much left paparazzo photography behind me some years ago; moreover I didn't think it seemed plausible that I should just happen to be in Capri at seven o'clock in the morning by a swimming pool. I said we should do this properly, to which they agreed. I agreed on picture approval, and within twenty-four hours I was winging my way to Capri.

I was put up in the Grand Hotel Quisisana. I always insist that when I travel on location I'm put up in great hotels. I do like my creature comforts. Mariah was staying at the same hotel and at seven o'clock I wandered around the pool checking for the best location. Mariah walked down to the pool in this little crocheted bikini. We chatted about how we were going to do the shoot: I suggested a few splashing-in-the-pool pictures, and a few full-length of her walking around.

She wanted the images to be relaxed and casual, not too posed, which was a little difficult given the circumstances. We spent about forty-five minutes shooting and then I went back to Mariah's suite to download the images for her to make her a selection. She and I were lying down together on her bed, selecting the images she liked the best – it was a very distracting half hour as she was still in her skimpy white bikini. Hey, it's a hell of a job, but someone has to do it …

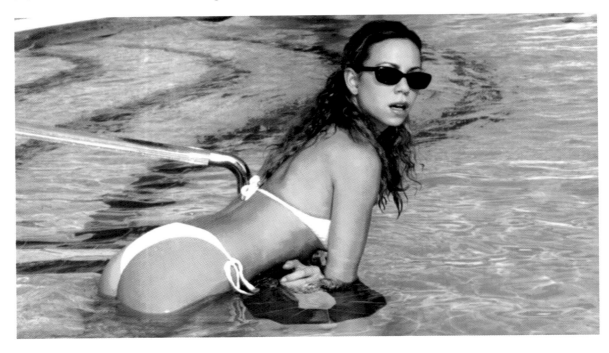

madonna and puff daddy

versace party, man ray, paris

VERSACE WOULD USUALLY KICK OFF the couture shows in Paris. Donatella Versace decided to hold a party for Madonna at Man Ray, Johnny Depp and Mick Hucknall's restaurant on the Champs Elysées. I was asked to take some pictures. As I've mentioned previously, I have always covered Versace's parties. They are great fun and there is always good turnout of A-listers. This party was no exception. Madonna was there with her entourage as was Puffy (as he was known in those days).

As you know, I love taking dancing shots. My technique is to stand as close as possible, but to try and get a full-length shot; I kind of do a little dance as well, which camouflages me. Well, sort of. It's important to work quickly and quietly as the minute people see you photographing them they become inhibited. As I was edging around the dance floor I noticed Madonna out of the corner of my eye. She was really, really getting into the groove with Donatella. Madonna noticed Puffy and edged over to him – he is a really mesmerising character and everyone was trying to get close. As you can see by the images, Madonna did not notice that I had taken any pictures – until the last shot. There were a couple of other photographers at the party, but they missed this one. It's a good feeling when you get an exclusive! This picture always makes me giggle – it's so playful.

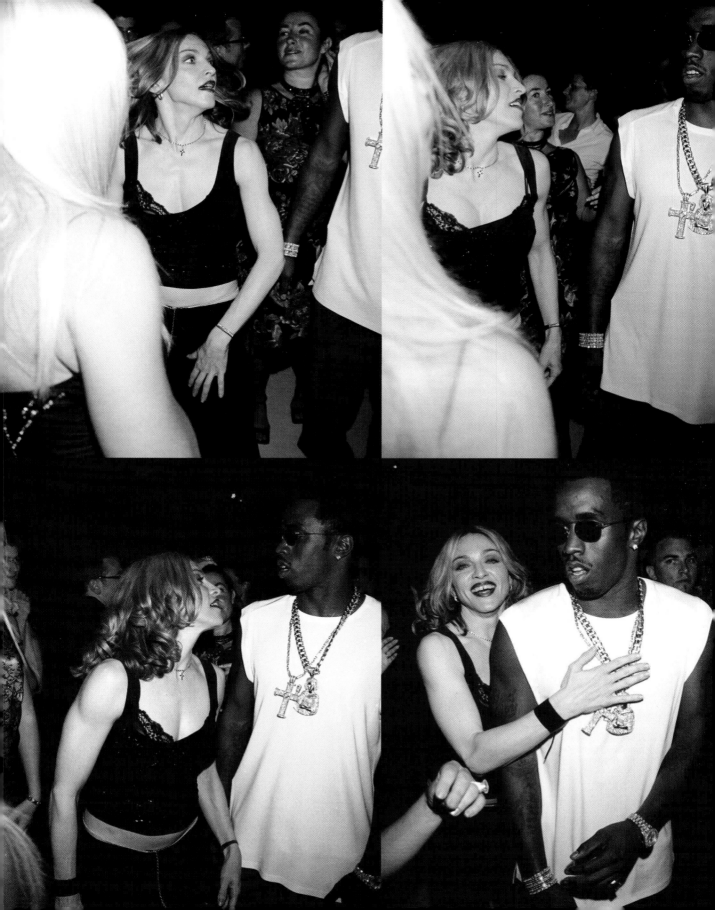

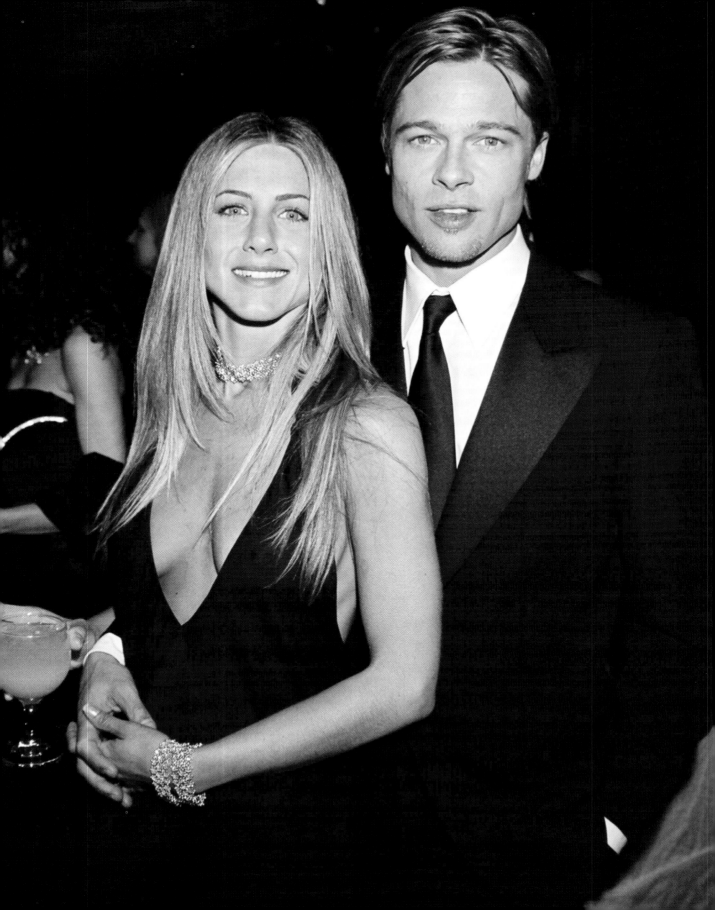

vanity fair oscar party

los angeles

IN THE LATE NINETIES I DECIDED THAT IT WAS TIME I got involved with the Oscar party scene in LA. I flew out with no invitation, no credentials and very few contacts. I put myself up in a hotel and started ringing around the few people I knew to see if I could get myself an invite to any of the parties. I managed to get into Elton John's AIDS Foundation party which was a lot of fun, and I covered it for the first couple of years of going to the Oscars. However, this particular year I had been invited by Sara Marks of *Vanity Fair* to cover their party, which of course I was delighted to do.

I got myself out to LA, checked into the Mondrian on Sunset Boulevard, and set about getting myself ready. At this time digital technology was in its infancy. I was mainly using film at that time, which meant that, once I had finished the job, the film had to be processed, then scanned into my computer so that I could send it by telephone to London. It took forever. Nowadays I use a Nikon D1Xs D2H and can download directly from the camera in minutes.

I got there at about five o'clock in the evening and all the photographers and film crews were already in position. I went up to the security guy at the main entrance and told him I was one of the two photographers allowed inside. He asked me my name, I told him and he said, 'Yes, you're in.'

I was so relieved because I didn't have an invitation or pass, and there is always a

part of me which says they might not let me in or not have my name on the list – then I would have had real problems.

That year Kevin Spacey received an Oscar, Charlize Theron turned up looking magnificent, Keanu Reeves – someone I rarely get to photograph – was there, as were Arnie, Jack Lemmon and his wife, Tom and Nicole. Uma Thurman looked stunning, as did Jane Fonda, and Cher looked, well, interesting …

At the *Vanity Fair* party there were a lot of English actors: my good friend Vinnie Jones was there, as were Jude Law, Sadie Frost and Minnie Driver, so I felt at home. It was a brilliant evening. Around three in the morning I knew I was in trouble. I was running very late, the film hadn't been processed and I was going to miss my deadlines.

I left the party and was standing on Melrose trying to get a taxi back to my hotel. Suddenly a limo pulled up next to me, the window opened, and a familiar voice said, 'Do you want a lift, mate?' It was Vinnie. I fell into the car with all my photographic equipment, squeezed myself in – and found myself sitting next to Brad Pitt and Jennifer Aniston. I got the giggles! Vinnie asked me to come and join them for a drink at the Peninsula, but I just had to say no: I still had this film to download and get back to London. I was gutted – it would have been so much fun to have joined them but instead they let me out at the Mondrian where I proceeded to sit by my computer all night sending the pictures to London.

And would you believe it? I missed the deadline – I should have gone for that drink after all.

Below left: Keanu Reeves. *Below right*: Uma Thurman ▲
Opposite: Charlize Theron ▶

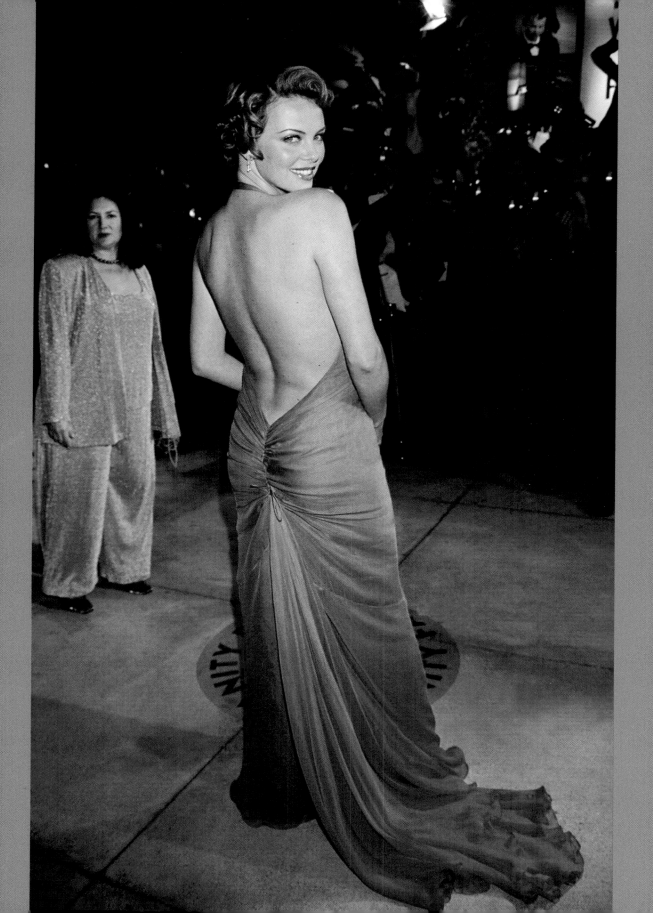

2000

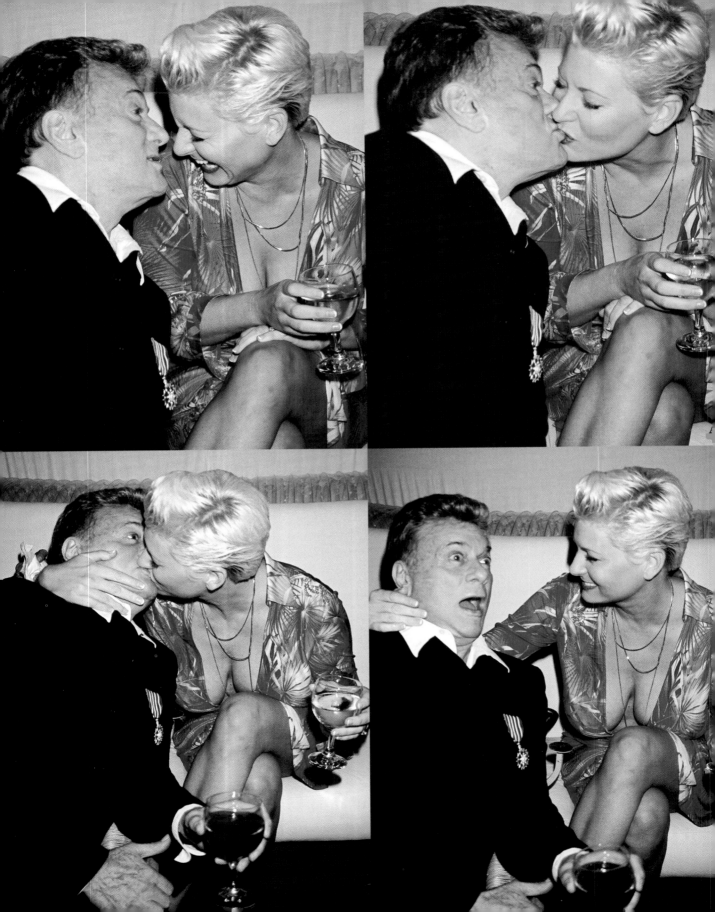

◀ *Opposite:* Tony Curtis with his wife

▲ *Above:* Tom Cruise and Nicole Kidman *Below left:* Cher *Below right:* Arnold Schwarzenegger

annabelle rothschild, meg matthews and naomi campbell

laureus world sports awards, monte carlo

IN CELEBRATION OF THE EIGHTIETH BIRTHDAY of that great photographer Helmut Newton, Italian *Vogue* and Laureus threw an extremely lavish party at the Monte Carlo Beach Club. It was a very glamorous evening, and everyone seemed to be there – wall-to-wall celebrities from the world of film, fashion and sport including Prince Albert of Monaco, Boris Becker, Stella McCartney, Sophie Dahl and Catherine Bailey.

It was a beautiful hot Mediterranean evening, and as the party progressed it became wilder and wilder. Everyone seemed to be determined to live *la dolce vita*, if only for one night, and they were all loosening up and enjoying the party. I knew something wild was going to happen (I was around a lot of wild parties in the seventies, and I've developed a nose for these things). John Galliano's table included Annabelle, Meg and Naomi. Just after I took this picture they all decided they needed to cool off: Annabelle, Meg and John jumped into the pool, pulling a few friends including Alexander McQueen with them. It was a lot of fun, and reminded me of some of those outrageous parties I attended early on in my career.

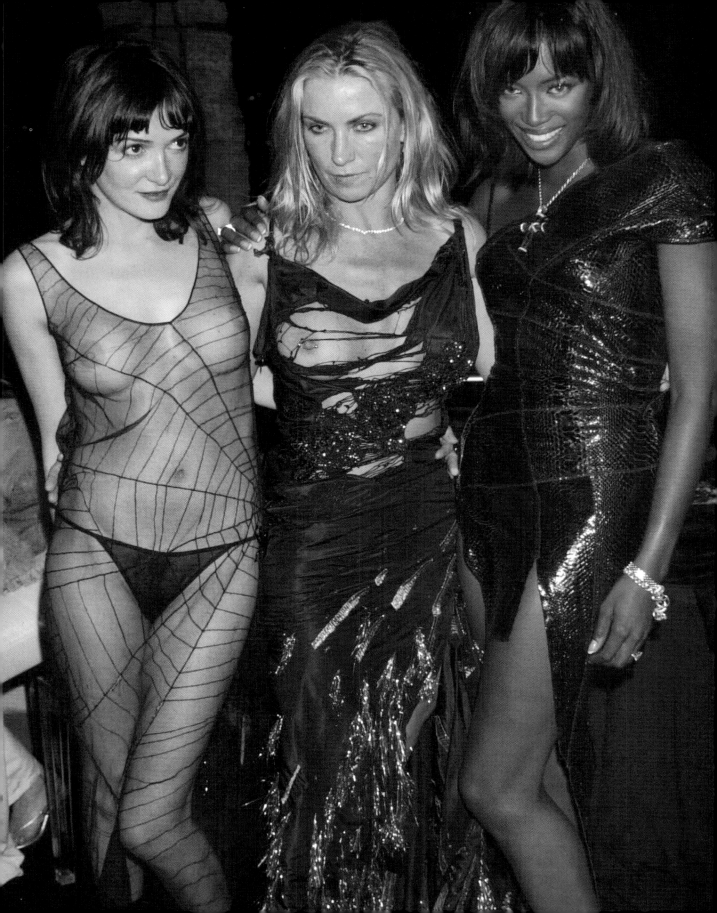

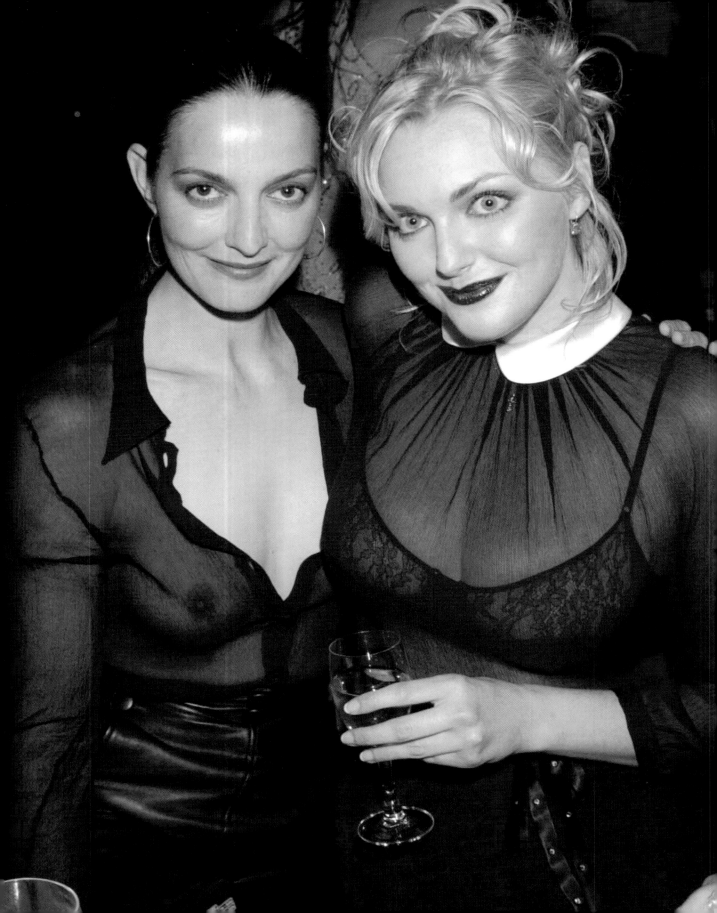

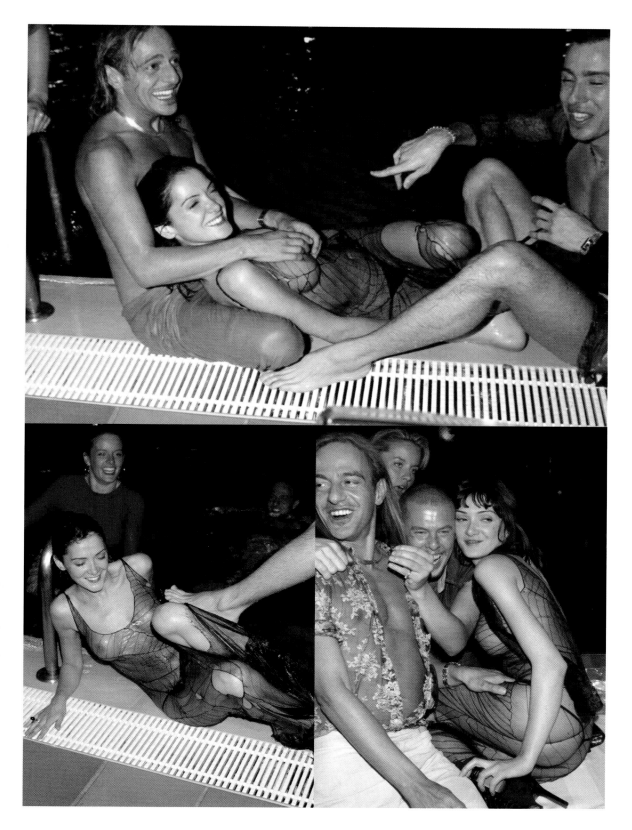

217

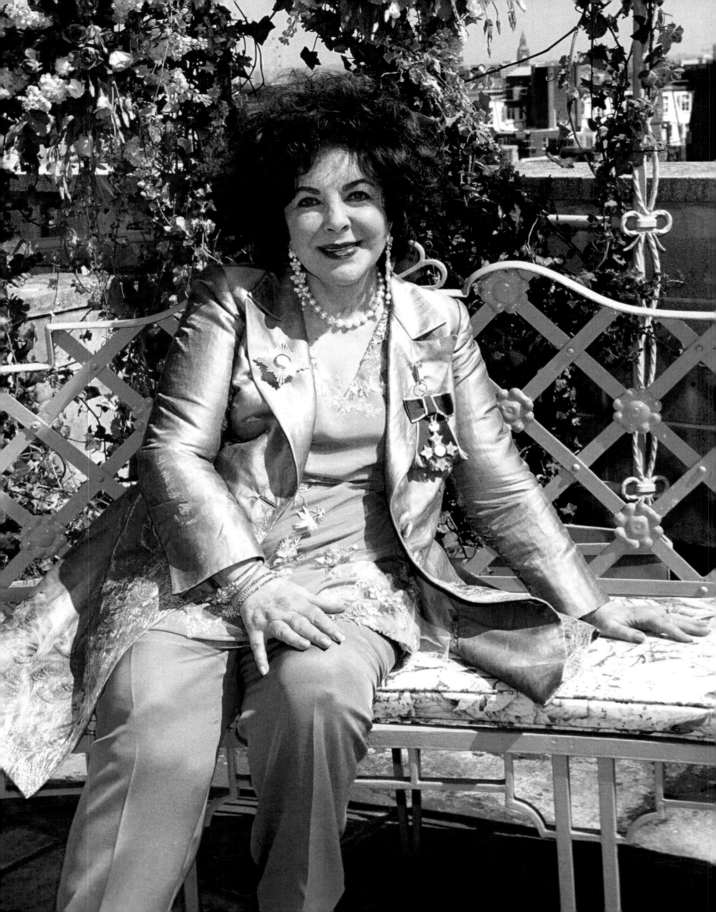

elizabeth taylor

the dorchester, london

A S YOU WILL HAVE READ EARLIER, I have been photographing Elizabeth Taylor since 1974. One of my first exclusives involved gatecrashing Richard Burton's fiftieth birthday party that Elizabeth had hosted for him.

So, you can imagine how thrilled I was to be asked to photograph her and her family on the day of her investiture as a Dame. I arrived at the Dorchester and was ushered up to the beautiful Oliver Messel suite. Inside, a small reception was being held for her immediate family and close friends. We said hello to each other, and she seemed happy to see me. I remembered the first time that I had photographed her twenty-five years before, when she demanded that I leave. She still remembers that night as well – thank goodness I was invited this time. I led her through the French doors on to the terrace which was decorated with all her favourite-coloured roses. I was holding her hand and accidentally pulled on her diamond ring – she turned to me and said, 'No, no, you can't have it!' I tried to explain I was only trying to help her through the door.

Once on the terrace I posed Elizabeth up, and she looked so radiant and happy. And, when all her family came and joined her, I have never seen her look so contented. It was a beautiful moment.

whitney houston and bobby brown

ocean club, bahamas

OVER THE YEARS, I HAVE COVERED MANY EVENTS for Sol Kerzner. Sol is a colourful character and self-made billionaire. My first assignment for him was in 1979 in South Africa, in the independent homeland of Bophuthatswana for the opening of Sun City. We flew to Johannesburg where we got connecting flights to Bophuthatswana where we landed on a makeshift airstrip. This was Sun City. I was on a press junket to promote the hotel and resort. In those days it was one main hotel, now it is three.

Sol has moved on a long way since 1979, and now has a huge business empire which not only includes wonderful hotels and resorts, but casinos too. I've been to the openings of Le Touessrok and Le Saint Géran in Mauritius, and his hotels are all fabulous. But my favourite assignment was the opening of Ocean Club in the Bahamas. We were very well looked after: we could have played golf on the same course as Emma Bunton, sat on the beach or made use of the spa treatments. As I may have mentioned before, this is a very tough job! On the last night there was a gala dinner. Stevie Wonder had been flown in, and so too had Whitney Houston and Bobby Brown – the show was outstanding. Whitney and Stevie performed together, and then Bobby got up and joined them. Although there had been some bad press about Whitney and Bobby, I found them to be friendly and very loving with each other.

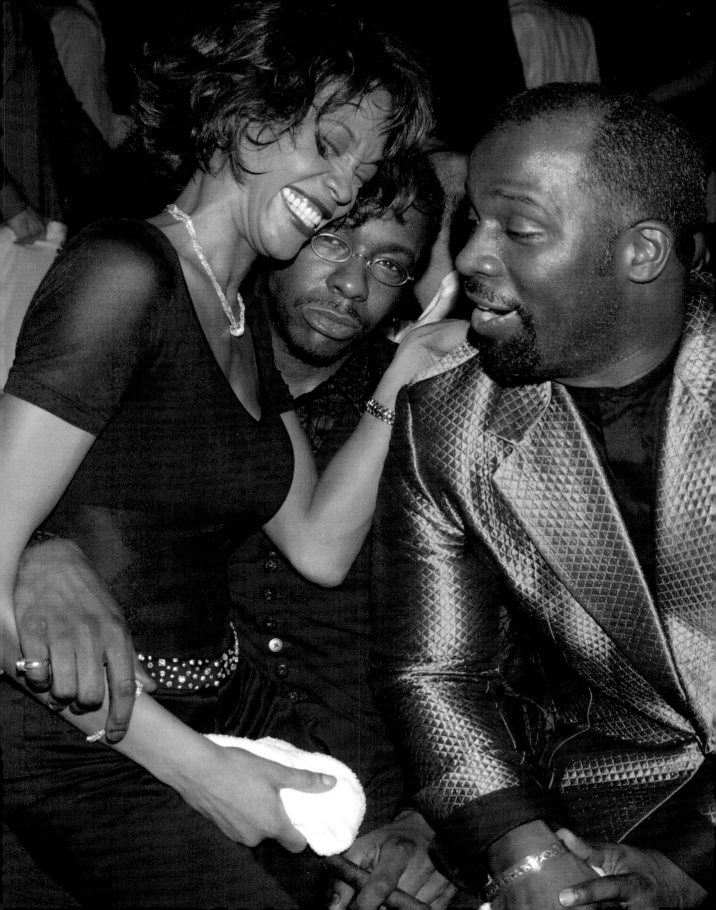

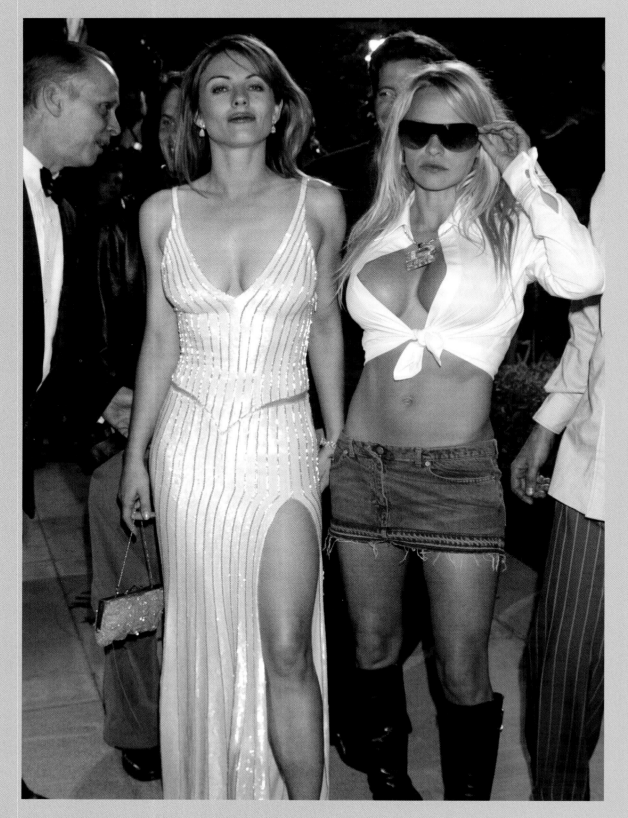

elizabeth hurley and pamela anderson

vanity fair oscar party, los angeles

THE *VANITY FAIR* OSCAR PARTY is my absolute favourite. This year was no different. I usually arrive at Morton's, the restaurant where it is held, with all my equipment at around half-past three in the afternoon. As you can imagine, security is very tight, but thankfully I have all the right passes. There is a lot of activity inside and out – people rushing around with flowers, sweeping floors, checking the sound system. All the media will be in place outside Morton's on bleachers, each position marked up with the names of whom they represent. There will probably be about sixty TV crews on one side and sixty invited photographers on the other. The whole road is cut off to the public and you can only get access with the right passes. Access All Areas passes are very, very important. The number-one rule? *Don't lose them!*

I will wander around taking pictures of tables and the general set-up. At about five the invited dinner guests will start to arrive for a sit-down dinner hosted by Graydon Carter, the editor of *Vanity Fair*, and Si Newhouse, the chairman of Condé Nast, to watch the ceremony on the numerous monitors scattered around the rooms. The atmosphere is electric and exciting. During this period I will take lots of pictures of people at the tables, and in particular their reactions when the awards are being announced.

After dinner, at about ten o'clock, the dining room is broken down and everyone starts wandering into the main party area. Once the Oscar ceremony finishes, the stars

who have attended the ceremony make their way to the Governors Ball for a sit-down dinner; once that's finished, they come along to the *Vanity Fair* party. As these people start filtering in, my work starts in earnest. Suddenly, someone will arrive with his or her Oscar, and then the party starts rocking. Nothing gives me more pleasure than someone walking towards me with a gold statue in his or her hand; it is the pinnacle of the whole showbusiness world.

This particular year, Pamela Anderson arrived in her usual style, as you can see from the picture.

All the media went into overkill when they saw her. Elizabeth was on her arm, and together they made a real Hollywood entrance. When the girls went inside, I left them to it as more people were now pouring into the party. Julia Roberts arrived with her Oscar in hand with her then boyfriend Benjamin Bratt, so I was kept quite busy with them. Some time later I caught up with Elizabeth and Pamela sitting on a banquette. I went over to have a chat, but they were so engrossed with their make-up, I decided to take a picture instead!

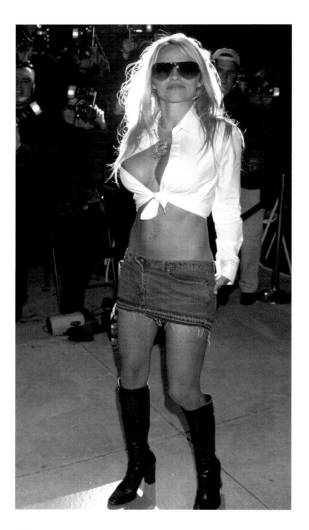

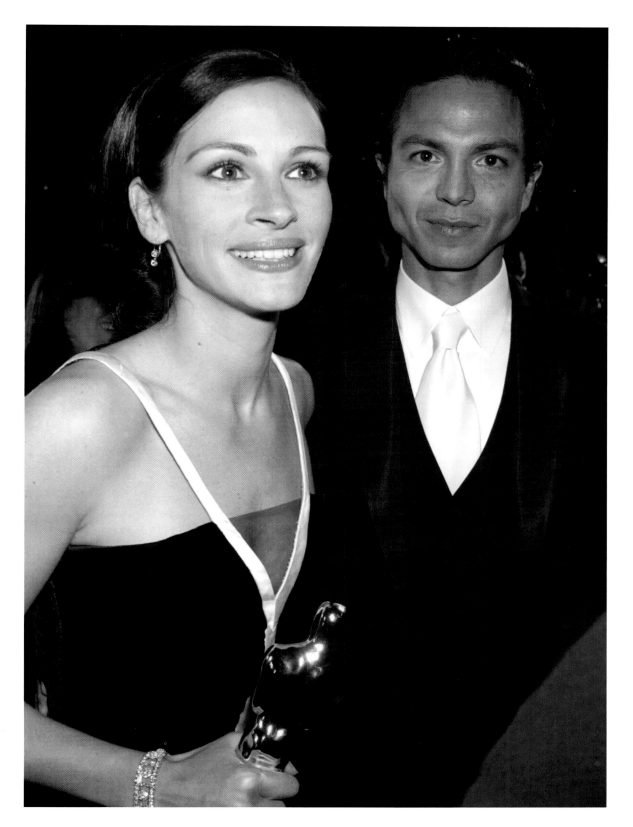

bill clinton and joan collins

the ritz, london

THE PRESS OFFICE OF THE RITZ asked me if I would like to photograph a charity lunch hosted by Bill Clinton. I'd only photographed him once before, and that had been when he had gone shopping with Hillary in Portobello Road, so I was really looking forward to meeting him personally.

Bill got up and spoke about the AIDS problem in Africa, an issue that is also very close to my heart. As lunch was breaking up Joan and Bill greeted each other. I have photographed Joan since the beginning of my career – she is a real professional who knows how to play the game and I have taken some really fun pictures of her. Somehow she always manages to turn it on for the camera, and I always enjoy seeing her at any event.

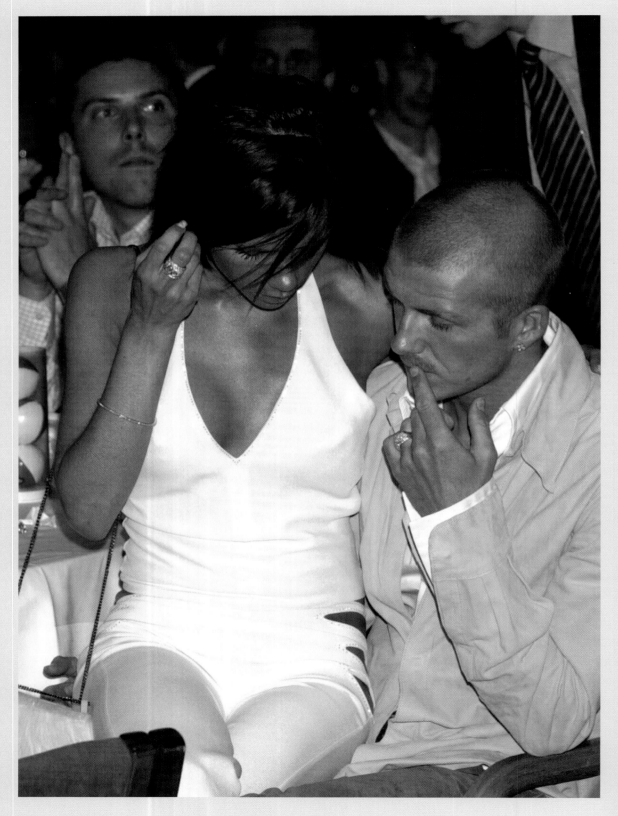

victoria and
david beckham

nordoff-robbins music therapy lunch, the intercontinental, london

NORDOFF-ROBBINS MUSIC THERAPY is a charity I have supported for over twenty-eight years. The approach was developed by Paul Nordoff and Clive Robbins in the fifties and sixties, and is based on the belief that everyone can respond to music, no matter how ill or disabled, and that music as therapy can enhance communication. Over the years Nordoff-Robbins has gone from strength to strength, and now it has centres all over the world. The charity obviously attracts many supporters from the music business, and every year it holds a number of fund-raising events. The Music Therapy lunch is the major event of the year; during the lunch various awards are given to celebrities in the music industry, so you are always guaranteed a good turnout of stars.

This particular year they managed to get Victoria and David along. They are constantly in the headlines and every event that they turn up at is sure to become a media frenzy. I actually haven't photographed them together more than half a dozen times, as you don't get to see them out together at official engagements – usually you just see paparazzo shots of them shopping or leaving restaurants. I haven't had much contact with David, but Victoria and I have had a friendly relationship since her Spice Girls days. I also get on rather well with her mum!

vanity fair oscar party

los angeles

THIS WAS MY THIRD YEAR OF BEING INVITED to cover the *Vanity Fair* Oscar party at Morton's. For me this is the highlight of the year. Forget about photographing reality TV people and girls who turn up at premières with no clothes on. This is the only party of the year, anywhere in the world, where everyone is a top international star.

This year I had flown over my technician. I had learned my lesson from previous years, having missed the deadlines as I could not download and select my images quickly enough. On the night, my technician was based at a nearby hotel with people from Rex Features, my agency. A courier would pick up my digital card from the party and take it to the hotel; this meant that, as the party was going on, my images were being downloaded, edited and pinged to London. No excuse for missing deadlines any more.

This year Sidney Poitier was an Oscar winner; other guests included Hugh Grant, Sandra Bullock, Mel Gibson, Warren Beatty, Cuba Gooding Jr, Cameron Diaz and Puff Daddy. Paul and Heather McCartney turned up after the Oscar ceremony; Paul had been nominated for an Oscar for best soundtrack for *Vanilla Sky*.

They found themselves an area inside the restaurant, which was being guarded by his people. I went over and said hello to them both, and I think Paul was a little surprised to see me there. I left them alone and went off to work the room; everyone was arriving now, so there was plenty of photographing to be done. I came back about half an hour

Ellen Barkin and Warren Beatty ▶

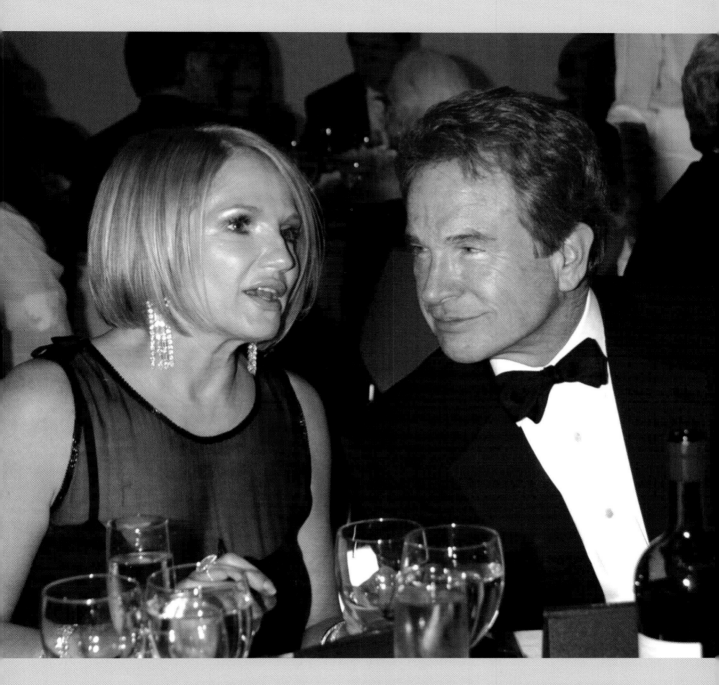

later and was surprised to see that they had decided to get up and dance, particularly as they weren't on the dance floor and I had never seen Paul dancing in public. He had two lots of security with him: his two regular English guys, who know me, and two American backups. They tried to stop me photographing them, as they didn't know me, but the English guys said, 'Leave him alone, he's OK.' I kept a good distance, as they were the only ones dancing. They were really getting into the music and seemed quite happy to have their picture taken.

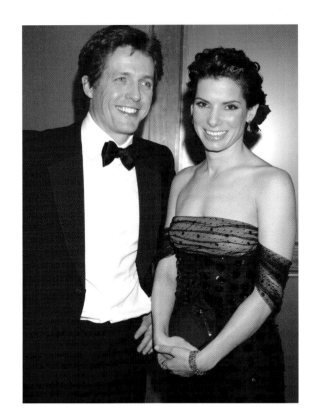

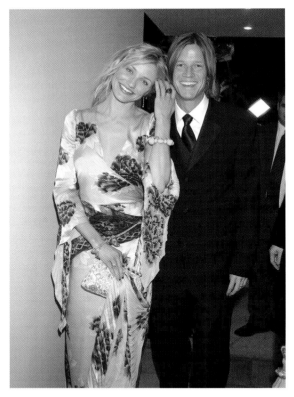

This page, clockwise from above left: Hugh Grant and Sandra Bullock; Cameron Diaz; Sean Coombes; Mel Gibson ▲

Opposite page, clockwise from above left: Sidney Poitier with his Oscar; Nicole Kidman and Gwyneth Paltrow; ▶
Cuba Gooding Jr; Paul and Heather McCartney

david bowie

hammersmith apollo, london

IN 1964, WHEN I WAS SIXTEEN, I used to hang out in the Bataclan club in Princes Street near Oxford Circus. It was a French club owned by Louis Brown. At that time I loved anything French – food, clothes, music. I smoked Gitanes, and I particularly adored the French au pairs who hung out in the club with us. They used to play a lot of soul music: James Brown, early Motown, Françoise Hardy and Jacques Dutronc. I used to feel very grown up and sophisticated, wearing my short cable-stitch Shetland sweater and puffing away on my Gitanes.

It was there that I first met a guy called Jeff; we became friends through our love of music and French girls! Very often on Sunday afternoons a group of us would make our way to Jeff's place in south London where we would listen to soul music till the early hours. Occasionally a guy called David Jones would come over and hang out. Sadly, as it was over forty years ago and we were all in a psychedelic haze, I don't remember much else of what went on. Little was I to know who David would become. I think that Jeff became Bowie's drummer in his first band. Recently I chatted with Bowie about the old days, and he couldn't remember much about it either!

I have photographed David many times over the years and I try never to miss an opportunity to see him perform. To me, he's the most stylish man in music – his taste in clothes is impeccable. Not only that, he is one of the nicest people in the business.

fidel castro

havana, cuba

MY FRIEND SIMON CHASE AT THE CIGAR COMPANY Hunter and Frankau invited me to celebrate the Festival del Habano in Havana. As a fellow cigar smoker I jumped at the opportunity of five days in Cuba. It could not have been a more perfect invitation. I was flown business class and put up at the Hotel Nacionale de Cuba, which is the equivalent of the Grosvenor House in London.

On my first evening I was whisked off to a party in a castle in old Havana where I met up with the rest of our party. I'd arrived so late everyone decided to go back to the hotel. We went back and I had my first cigar of the trip – a Monte Cristo Number 2, my favourite. It was wonderful to smoke such a delicious cigar in such beautiful surroundings and, of course, accompanied by exotic rum cocktails.

Next day, we were whisked off to the Partagas factory where they make the cigars. At the end of the tour we were taken into the VIP room and given samples of the various cigar brands, and again a few large rums. The atmosphere was fantastic; our group included restaurateurs, front-of-house managers and people from the whisky and cigar press. It was mostly blokes, so you can imagine the scene – shacked up in Havana with lots of booze and cigars. That afternoon after lunch, coaches took us to Pinar Del Rio, 120 miles west of Havana. This is where the tobacco is harvested, and we spent a couple of days there before coming back to Havana for the main party and reason for the trip.

Each year a major cigar festival is held in Havana, and cigar dealers from all over the world congregate for a gala dinner at Havana's Museum of Fine Arts in the old town. Five hundred people had been invited for the dinner. I had been told there was a chance that Fidel Castro would turn up, but I wasn't holding my breath. As we sat down for dinner I sensed a lot of activity by the foyer – flash bulbs going off, and the shuffling of security. Then everyone stood up and applauded as the man himself entered the room. He was surrounded by his own personal security (including the man in the blue jacket in the photo). Believe it or not, Fidel was seated at the next table to me. I just laughed – talk about luck!

I waited until all the craziness had calmed down and his security had moved away from the table. I stood up, moved towards Fidel, camera in hand, asked no questions and just aimed and fired. Immediately his people came over, put their hands up and said very politely, 'Please, no photos.' I went back to my seat. About fifteen minutes later I got up again and did the same thing. Again his men came over. 'Please, no photos.' I did this four or five times, by which time they were so fed up they decided to let me get on with it.

The last opportunity I had to photograph Fidel, he was standing up chatting with friends. I was standing right next to him and couldn't believe how tall and stocky he was – for a man his age he seems very sturdy and strong. At this point I decided to introduce myself. I put out my

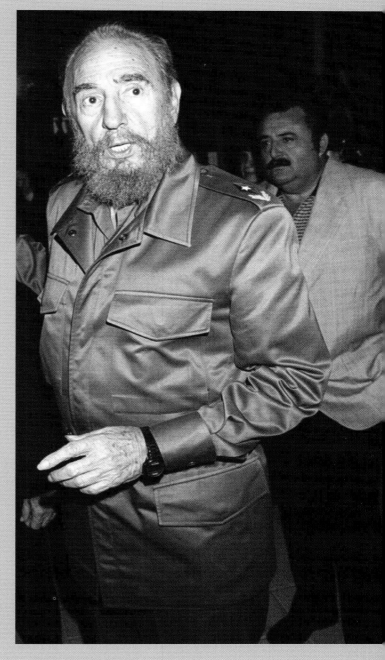

hand and he shook it. 'Hello, my name is Richard Young. I am from London and it is a pleasure to meet you.'

'Thank you,' he replied, and that was that. I stepped back and absorbed the scene around me. What a night.

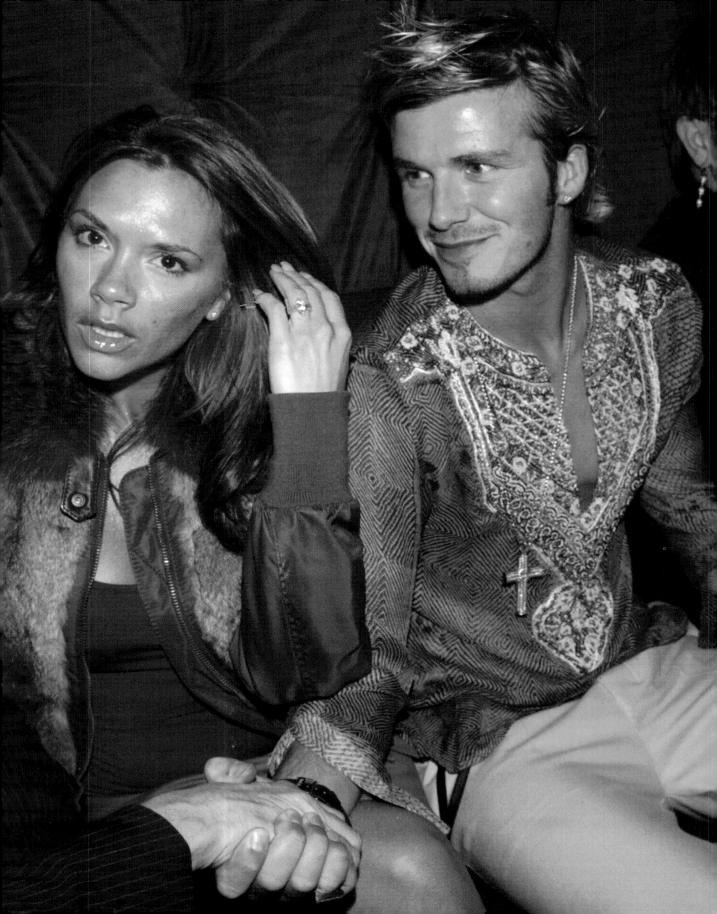

victoria and david beckham

jewel, london

DAVID FURNISH WAS CELEBRATING HIS FORTIETH BIRTHDAY at a new club in London called Jewel. Elton, Victoria and David arrived together and were ushered into the VIP area. David's birthday cake was carried out by four topless waiters, and everyone sang 'Happy Birthday'. Soon afterwards, the party moved on as the club had become extremely busy. I took a couple of frames of Victoria and David, and everyone loved the pictures, and particularly his kaftan top. Come to think of it, whatever David wears makes front-page news …

'There are few things more heartening than seeing Richard when you turn up at a party. Not only are you immediately assured that this is definitely an A-list event (ie you haven't wasted your time), but you're also guaranteed a friendly smile. I've been seeing Richard at parties for 20 years now – in London, New York, Milan, Cannes, Monaco, all over the damn place – and in all that time I don't think I've ever seen him in a bad mood. He must be hell to live with.'

DYLAN JONES, *EDITOR, GQ MAGAZINE*

beyoncé

party in the park, london

PARTY IN THE PARK IS A PERMANENT FIXTURE in my social calendar. It is a Prince's Trust event and always attracts a good cross section of young up-and-coming artists and a few established headliners. I always arrive early so I can set up all my equipment in the press tent: these days that means computers, technicians, ADSL lines and the like. Then I spend the rest of the day cadging the right passes for the right areas: this is one of the few events where I rarely get the right accreditation, so I have to go around borrowing other people's passes. It is always good to have friends in high places in these situations. This particular year belonged to Beyoncé; the crowd went wild for her. I have photographed her many times since, including Fashion Rocks and 46664 in Cape Town, but this picture remains my firm favourite – she is bootylicious!

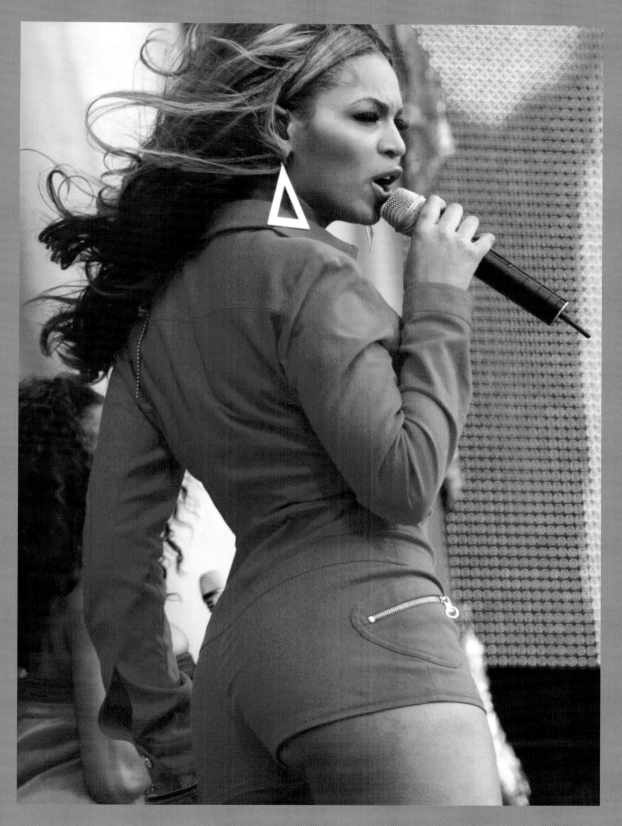

fashion rocks

royal albert hall, london

PRINCE'S TRUST EVENTS ARE ALWAYS STAR-STUDDED, and this was no exception The fashion world pulled out all the stops and created something spectacular; I have never seen anything like this in London before.

Nicholas Coleridge, managing director of Condé Nast, organised one of the most interesting fashion evenings ever staged in London. Each designer was assigned a musician or band to play while models strutted around the stage. It made for great pictures. Elizabeth Hurley had nineteen different dress changes, and everyone went mad for the images.

I was the only photographer invited in to cover the show. It was a long day and a lot of running around. The first part of the day was spent shooting the models having their hair and make-up done; the second part was backstage; the third part involved taking pictures of the guests arriving on the red carpet; and then I photographed the whole show.

The photographs were published in magazines and newspapers all over the world, everyone loved Elizabeth Hurley's dresses. Now that is what I call a well-organised event. It was glamorous, colourful and enormous fun.

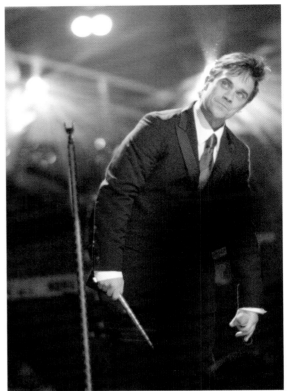

Opposite above: Beyoncé ▶

Opposite below: Georgio Armani, Richard Gere and Joaquim Cortez

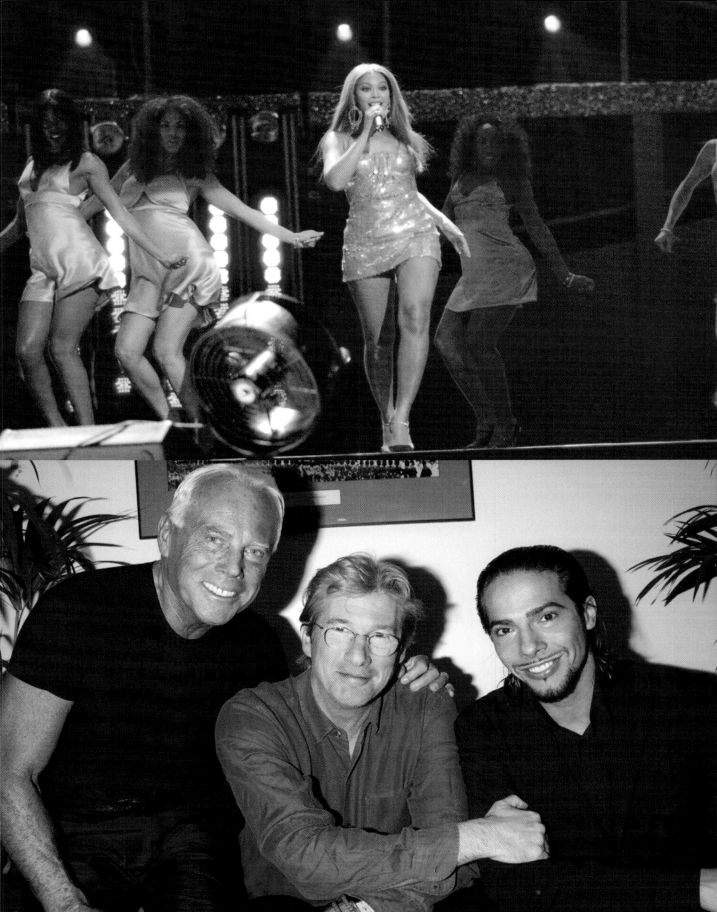

vanity fair oscar party

los angeles

BACK AGAIN IN LOS ANGELES FOR THE OSCARS – but this year was different. The day I flew out was the day the coalition forces entered Iraq. War had broken out. The mood was very sombre and there were lots of rumours flying around that the Oscars would be cancelled or delayed, or that they would be downplayed and there would be no red carpet. I couldn't do anything other than wait and see. I spent my days watching all these images on the TV of what was happening in Iraq. It was very sad, and no one felt much like partying this year. I decided to cancel my technician; my feeling was that, even if the party went ahead, I would not be able to use my images anyway.

Vanity Fair decided at midday on the day of the Oscars that we could use the pictures worldwide. I frantically called around trying to find a technician to transmit my images, and checking that Rex Features were in place. It was decided that there would be no red carpet. No media were allowed outside. Only three or four photographers were allowed to cover the event, including me and my mate Patrick McMullan.

The evening was, as ever, fantastic; but it was much more subdued as many of the stars decided to dress down. Nevertheless it was still only A-listers: Adrian Brody (armed with his Oscar), Nicole Kidman, Cameron Diaz, Meryl Streep, Peter O'Toole, Richard Gere, Colin Farrell. J Lo and Ben arrived at about ten o'clock; I was very excited to see them, as I hadn't ever photographed them together.

◀ Bono with his wife

They looked fantastic, really glamorous – very Cary Grant and Grace Kelly. The crowd parted for them as they walked over to the sofa and sat down. About half an hour after they arrived I was working the room as usual and I noticed them sitting close together and being very affectionate. I got a little closer; J Lo looked at me as if to say to me, 'Hang around!' They started cuddling and kissing. None of the other photographers got it. As quickly as they had got together, they separated, which I was very happy about as it meant no one else got the photograph. This picture made the front cover of magazines throughout the world. I heard through Rex Features USA that Jennifer had loved the picture so much her people had obtained copies. Apparently, it now sits on her mantelpiece.

Above: Colin Farrell. *Below left:* Angela Basset and Adrien Brody ▲
Below right: Tim Robbins and Susan Sarandon with her daughter

kuwait city;
doha, qatar; talil, iraq

2
0
0
3

MY GOOD FRIEND SARA MARKS called from *Vanity Fair* magazine in New York and wanted to know if I would like to get involved with a project she was working on. She was helping to organise a tour of the Middle East to pay tribute to the men and women of the United States armed forces and the coalition forces. There were various organisations involved in Project Salute, including the USO, MTV, the NBA and the Tribeca Film Institute. The troops were to be entertained by various artists and she wanted me to cover the event. So I got my hard hat out, put my army fatigues on and off I went to Kuwait City.

I was met by a colonel from the US army and whisked straight through immigration; I was put up at the Hilton Kuwait Resort, which was very comfortable. The next day we were flown to Talil in Iraq. We were in the middle of nowhere and the temperature was 120°F – how the hell anyone can work in that heat, I'll never know. The secret is to drink lots and lots of water. There was an impromptu concert for about 7,000 troops in the desert; later that afternoon we were flown back to Kuwait City. The next morning we went to Camp Doha in Kuwait where a show was performed in the open air for about 6,000 American servicemen and women. Kid Rock was performing along with Brittany Murphy, Wayne Newton, Bubba Sparxxx, Lee Ann Womack and the Roots. The Dallas Cowboy cheerleaders also performed. The atmosphere was electric and very emotional.

Robert de Niro (*left*) with General Tommy Franks ▶

The next day a group of us went to visit the *USS Nimitz* where another show had been scheduled for about 5,000 naval troops. This was a hell of a gig; I'd never shot a concert on one of the world's largest aircraft carriers. Lunch was served in the officers' mess – burgers, steak, salad and beer – and this is where I first met General Tommy Franks.

I was given a tour of the ship. It is massive: the flight deck is the size of four American football pitches, and it is eighteen storeys high. It carries eighty aircraft, as well as nuclear warheads. It is like a floating city. There is everything you could want there – hospitals, post offices, chapels, a barbershop, restaurants – and the chefs prepare 20,000 meals every day. I had my photo taken on the flight deck and in various other army poses. We were then helicoptered back to Kuwait City.

On the last day we flew down to Doha in Qatar to the American Central Command, which was also very impressive. It is the heart of the whole American operation in the Middle East. Most of that afternoon was spent hanging around central command and it was at this time that I ran into Robert De Niro and famous hotelier Ian Schrager. I was sitting outside having a quiet puff on my cigar when through the gates came three land cruisers with blacked-out windows; out they stepped with various other American businessmen. Robert caught sight of me out of the corner of his eye, came over to me and said, 'Hello, Richard. Boy, you sure do get around!' The last time I had seen him was in New York a few weeks earlier at the *Vanity Fair* Tribeca Film Festival Dinner. He started signing autographs for the troops on bits of paper, T-shirts, caps,

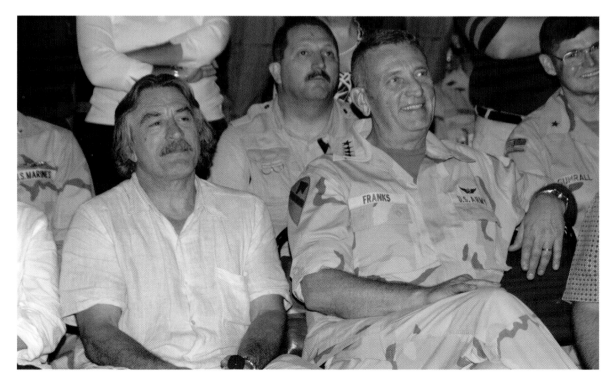

anything anyone could get hold of. He was very
patient and kind.

I wandered off and someone told me it was
General Tommy Franks's birthday that day, so I got
one of the colonels assigned to me to get me into
the general's office as I wanted to give him a
birthday present. I knew he was a cigar smoker like
myself and I wanted to present him with a couple
of Monte Cristo Number 2s. I entered his office, a
very elegant and classy room with lots of
mahogany and leather, and in the middle of the
room there he was entertaining some people.

I walked over and said, 'I think you might like these.

He opened up the pouch and said, 'These are very fine cigars. I will enjoy them.' I wished him happy birthday, and off I went.

The concert that night was fantastic. Robert De Niro came on stage and introduced Tommy Franks, who came on and sang to the troops. After the concert we all had dinner in the mess and at one in the morning we were all taken out to the airfield to catch our flights back to Europe and America.

This was one of the most exciting and thrilling experiences of my life. I will never forget it.

2003

johnny depp

bafta film awards, london

JOHNNY DEPP IS ONE OF THOSE STARS that tends to shy away from being in the public eye. I have only ever photographed him four or five times over the last twenty years. I think he is a really special guy, he's individual and always chooses quirky film roles. He's incredibly stylish and I don't think I've ever seen a bad image of him.

I can't believe that Johnny is over forty now. Nearly all of the Brat Pack boys of the eighties and nineties have grown up, settled down and left their bad boy images behind. Sooner or later we all have to grow up – well, that's what Susan keeps telling me!

Johnny now lives quietly in France with his beautiful long-term partner, Vanessa Paradis, and their children. It goes to show that if a celebrity wants to remain private, it's possible – there are many stars that continue to lead relatively normal lives, without being followed by photographers. It's quite easy, really – if you don't want to have your photograph taken, don't go to the faces places!

'Richard Young is not only a great photographer, but makes his subjects feel at ease. I am always happy to see him – making it easy to turn and smile at the camera.'

TOM FORD, *FASHION DESIGNER*

sharon and ozzie osborne

daily mirror pride of britain awards

EACH YEAR, THE *DAILY MIRROR* SPONSORS The Pride of Britain Awards, a special awards ceremony that honours people who have shown great bravery and courage under adversity. For example this year Ali, the little boy who lost both arms at the start of the war in Iraq, was honoured.

It is always an extremely moving and emotional day and there is never a dry eye in the house. It is a very big celebrity event, this year amongst the guests were Tony and Cherie Blair, Diana Ross, The Duchess of York and Sharon and Ozzie Osborne.

It was great to see Ozzie and Sharon. Sharon is an old mate of mine and I've been photographing her since the mid 70's. Many years ago I had taken a picture of her and Britt Ekland kissing at a party and the papers used it in quite a big way. The next day, I got a call from Sharon's dad Don Arden who didn't sound too happy! Don was one of the biggest music promoters of the 60's and 70's and had looked after all the top bands at one time or another. He was a real character and had earned himself a tough reputation. It was understood that he was not someone to mess with.

He asked me to come to his office, as he wanted to have a little chat with me. I knew I didn't really have a choice and was a little nervous. When I got there, he asked me to sit down and told me he wasn't very happy seeing pictures of his little girl kissing Britt plastered all over the press. He told me he would prefer it if I refrained from photographing her

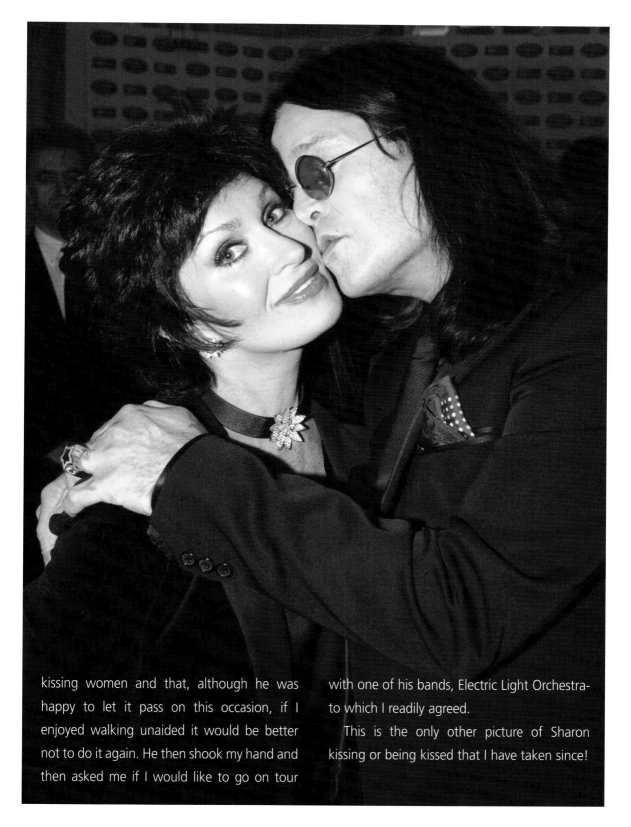

kissing women and that, although he was happy to let it pass on this occasion, if I enjoyed walking unaided it would be better not to do it again. He then shook my hand and then asked me if I would like to go on tour with one of his bands, Electric Light Orchestra- to which I readily agreed.

This is the only other picture of Sharon kissing or being kissed that I have taken since!

epilogue

WELL, HERE WE ARE IN 2004 AND I can't believe that thirty years have passed since I took my first photograph of my dear friend Paul in London. Little did I know then what a journey that first photograph would take me on.

I started out as a paparazzo, which seemed a much gentler profession in those days. Most of the boys on the streets these days are gentlemen, however there will always be one or two who spoil it for the rest. As long as the public are in love with celebrity and continue buying magazines and newspapers this will not stop. I still think that street photography is some of the most vibrant and interesting material around.

Even though I am the one who is invited into all the parties these days, I still think my early photography is the most interesting. Don't get me wrong, I love having access to the parties, however managers, publicists and ultimately the stars themselves control so much of what we do now. The images you see in magazines are all controlled situations, put together with a team of professionals: lighting, stylists, hair and makeup artists. Of course, once the images have been shot, any flaws or wrinkles are removed by computer technology. These controlled images don't necessarily show the real people. Of course, we all want to look our best but it is important to remember that in real life no one looks like the front cover of a magazine. My work is very earthy and honest. I love to capture the real person.

These days, it's sometimes alarming covering film premières; everyone seems to be

cloned: perfect teeth, perfect body, and perfect image. Even I have become swept up in the whole image thing; whereas in the old days I would go to work in a biker jacket, jeans and cowboy boots, I now make an effort to look the part in Armani suits and John Lobb shoes. I guess I've become establishment, and I too play the game. I thought after all these years everyone would have got fed up with me, but it's incredible, I am busier and more in demand than ever before and still to this day it thrills me to be doing what I love best – shooting stars!!

exhibitions and publication chronology

RICHARD YOUNG'S PHOTOGRAPHS are sought after in publications throughout the world. His work ranges from the classic 'party shots' to specially commissioned pieces.

He has published two books of his work, *By Invitation Only* and *Paparazzo*, featuring a unique collection of some of Richard's most famous and candid photographs.

Richard was also a guest contributor to *A Positive View* published as a 'showcase of international creative photographic works' and *Four Stages Of Innocence*, an exhibition and book featuring work from 'the world's most famous photographers'.

His exhibition, *Bad Behaviour*, was a retrospective chronicling the heady party days of the 1970s. His last project, *Richard Young Two Thousand*, was a collection of twelve defining images of late-20th-century icons. The images were presented in a limited edition calendar.

1981	BY INVITATION	Book & Exhibition	Hamilton's Gallery
1986	ALL HOURS	Exhibition	Olympus
1989	PAPARAZZO	Book & Exhibition	Hamilton's Gallery
1993	FOUR STAGES OF INNOCENCE	Book & Exhibition	Royal College of Art
1993	POSITIVE VIEW	Exhibition	Brasserie du Marche
1995	THE NIGHT IS YOUNG	Exhibition	Grosvenor House
1998	BAD BEHAVIOUR	Exhibition	Well Hung Gallery
1999	RICHARD YOUNG TWO THOUSAND	Calendar and Exhibition	Blains Fine Art
2004	Fifteen Minutes	Exhibition	The Hospital